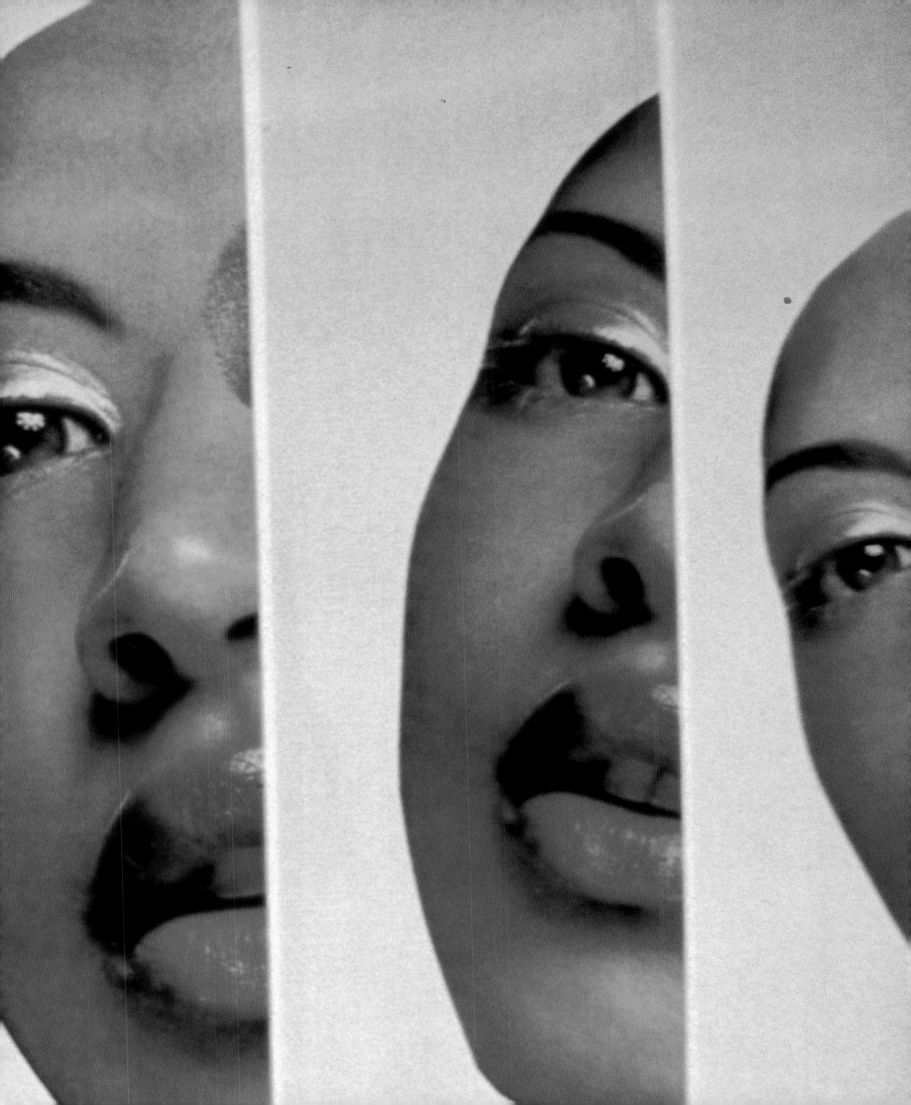

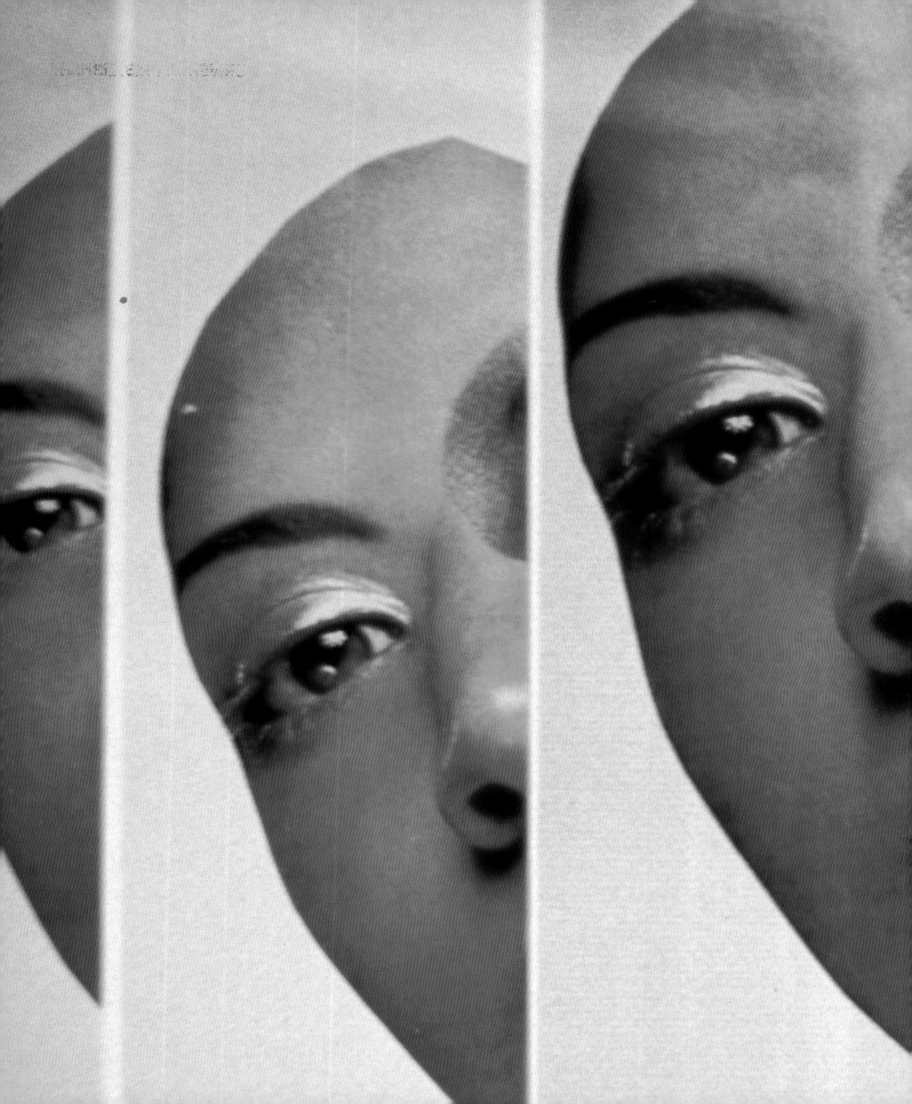

AMALIA AMAKI

Boxes,

Buttons

and the Blues

· ·

foreword by

Judy L. Larson

essays by

Andrea D. Barnwell

Gloria Wade Gayles

Leslie King-Hammond

· ·

National Museum of Women in the Arts
Washington, D.C.
and
Spelman College Museum of Fine Art
Atlanta

in association with

University of Washington Press
Seattle and London

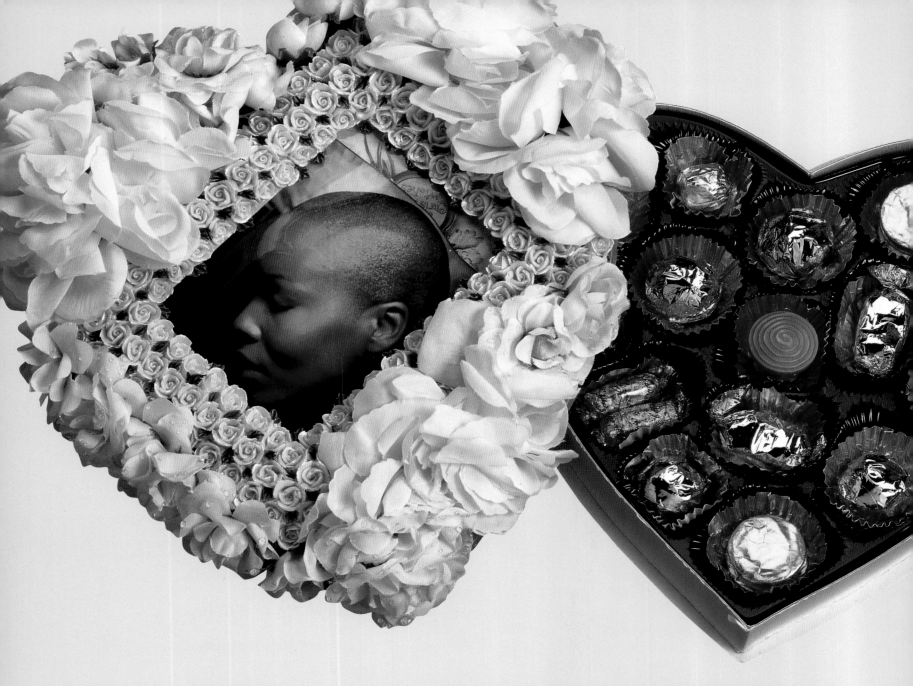

Amalia Amaki: Boxes, Buttons and the Blues was on view at the National Museum of Women in the Arts June 10–September 25, 2005, and at the Spelman College Museum of Fine Art January 26–May 13, 2006.

Library of Congress Control Number: 2005924589
ISBN: 0-295-98541-0

National Museum of Women in the Arts
1250 New York Avenue NW
Washington, D.C. 20005-3970

Spelman College Museum of Fine Art
350 Spelman Lane SW
Box 1526
Atlanta, Georgia 30314-3399

University of Washington Press
P.O. Box 50096
Seattle, Washington 98145-5096
www.washington.edu/uwpress

Endsheets: *Three Cheers for the Red, White and Blue #7 (I Guess That's Why They Call It the Blues)*, 1995 (detail, cat. 10)
Pages 1–3: *Looker*, 2002 (detail, cat. 59)
Pages 4–5: *Golden Nuggets*, 2001 (detail, cat. 47)
Page 6: *Three Cheers for the Red, White and Blue #9 (Bessie Remembered)*, 1996 (detail, cat. 14)
Page 9: *Sisters (Duet)*, 1998 (detail, cat. 22)
Page 10: *Three Cheers for the Red, White and Blue #15*, 1993 (detail, cat. 4)
Page 12: *Three Crosses*, 2000 (detail, cat. 38)
Page 16: *Dollhouse*, 2001 (detail, cat. 45)
Page 24: *If Wearing Feathers Does Not Make You Indian, Does Drinking Coffee Make You Black?*, 2002 (detail, cat. 58)
Page 32: *Buffalo Soldier Fan #2*, 1995 (detail, cat. 7)
Page 41: *Kids Dancing in a Red Knowing*, 2003 (detail, cat. 66)
Page 42: *Three Cheers for the Red, White and Blue #7 (I Guess That's Why They Call It the Blues)*, 1995 (detail, cat. 10)
Pages 126–127: *I'd Rather Two-Step Than Waltz*, 2001 (detail, cat. 50)

Principal photographer, Michael McElvey

Edited by Nora Poling Bergman
Proofread by Anne Moreau
Designed by Susan Kelly with assistance by Zach Hooker
Color separations by iocolor, Seattle
Produced by Marquand Books, Inc., Seattle
www.marquand.com
Printed and bound by CS Graphics Pte., Ltd., Singapore

Contents

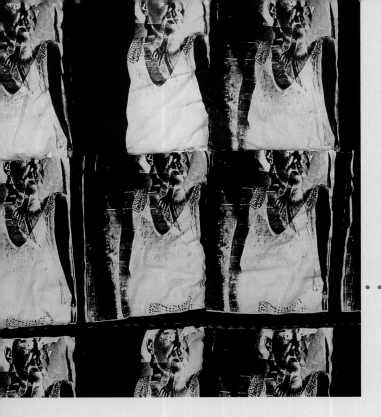

Foreword

I first met Amalia Amaki when we were graduate students at the Institute of the Liberal Arts at Emory University. The Institute is among the oldest interdisciplinary graduate programs in the United States that encourage independent and innovative studies in culture and society. In the 1990s at the Institute, I discovered a remarkable group of creative individuals who were interested in many different subjects yet formed a scholarly community around shared concerns in comparative and interdisciplinary studies. Amalia was about a year ahead of me, working on a dissertation entitled "The All-Black Exhibition in America, 1968–1976: Its History, Perception, and the Critical Response." As part of my dissertation involved exhibitions held in the Negro Building at the Atlanta World's Fair of 1895, Amalia and I soon found common ground.

Emory's Institute of the Liberal Arts encouraged doctoral candidates to form accountability groups as we wrote our dissertations. We read each other's drafts and gave comments and criticism, but, equally important, we encouraged each other to *finish*. Although Amalia was not part of my group, she was a tremendous source of encouragement to me as I wrote. "Just imagine yourself in that cap and gown—with all the writing and editing and revising and defending behind you," she would say.

Our paths crossed again during my tenure as Curator of American Art at the High Museum of Art in Atlanta. Community leader and art collector Paul R. Jones was an active member of the collectors' group at the museum. He had a fine collection of African American art, and Amalia was its curator. Recently Paul donated the collection to the University of Delaware, and Amalia continued as its caretaker and interpreter through her professorship in the department of art.

Amalia and I were once again destined to rendezvous when, to my delight, I found her name on the exhibition schedule of the National Museum of Women in the Arts when I began as director more than two years ago. I had known Amalia first and foremost as an art historian, yet since graduating from Emory she had achieved an equally stellar reputation as an artist. I ought not to have been surprised; Institute students seem to "pop up" whenever there are new issues in visual culture, especially if those issues involve the ethnography of everyday life, religion, ritual or popular culture. Amalia's art examines all these topics.

Amalia's work responds to memory, music and the everyday lives of women. Her medium is photography, often combined into boxes, fans, quilts and two-dimensional collages embellished with buttons, simulated pearls, jewelry fragments, beads, bows, flowers and bits of fabric. At first

blush these works have a tactile pleasantness, but upon deeper reflection her assemblages and photographs reveal a range of complex perceptions about family, marriage, children and the cultural rituals and traditions of African Americans.

I am so very pleased that the National Museum of Women in the Arts and the Spelman College Museum of Fine Art are working together to organize *Amalia Amaki: Boxes, Buttons and the Blues*. Focusing on her career from 1993 through 2005, this midcareer survey is Amaki's first solo museum exhibition and includes more than seventy wonderful, engaging and accessible works of art. The exhibition also represents a flagship partnership between the National Museum of Women in the Arts, which brings recognition to the achievements of women artists, and the Spelman College Museum of Fine Art, the only museum in the nation that emphasizes works by and about women of the African Diaspora. I wish to thank Spelman College Museum of Fine Art Director Andrea D. Barnwell, who curated the exhibition, for her dedication and professionalism in developing such an important and meaningful exhibition. Curator of Collections Anne Collins Smith also lent invaluable assistance. I would also like to recognize the contributions of National Museum of Women in the Arts Deputy Director and Chief Curator Susan Fisher Sterling, whose involvement in this project has helped bring it to fruition, and the Museum's National Advisory Board member Kenneth P. Dutter, who initiated this collaboration.

I wish to thank The Coca-Cola Company for its timely and most generous national sponsorship of *Amalia Amaki: Boxes, Buttons and the Blues*. Over the years the Women's Museum and Spelman College have received important program support from The Coca-Cola Company as well as encouragement from The Coca-Cola Foundation, led by Ingrid Saunders Jones, Senior Vice President, Corporate External Affairs; and Helen Smith Price, Assistant Vice President, Corporate External Affairs. We also appreciate the splendid efforts of Sallie Adams Daniel, Director of Community Affairs and Pro Bono, Troutman Sanders LLP; Joe B. Massey, MD; and NMWA Board member and Spelman alumna Alexine Clement Jackson on behalf of the exhibition.

I thank, as well, all of the lenders who supported this exhibition: Ben Apfelbaum; Florence B. Bonner; Barbara Boone; Charlotte Allegra Clark; Mr. and Mrs. Curtis Crockett Jr.; Thomas DiLorenzo; Raquel Gayle; Hammonds House Galleries; Michael Harris; High Museum of Art; Jeff and Sivan Hines; Debbie and Paul Hudson; Ann and Ben Johnson; David and Robin Jones; Paul R. Jones; Karol Mason; Preston McKevers-Floyd; Minnesota Museum of American Art; Louis Tanner Moore; Museum of Fine Arts, Houston; Donna Jones Northington; Paul R. Jones Collection, University of Delaware; Mario and Susan Petrerino; Benno and Babette Rothschild; Sandler Hudson Gallery; State University of West Georgia; Louise Davis Stone; Ruth West; and Ed and Joan Wolf.

Amaki's work is sophisticated, innovative and awe-inspiring for its ability to incorporate art and traditions from so many sources. At the same time, it will touch your soul, make you laugh, sometimes cry and always challenge you to think about African American love, loyalty, pride and survival throughout American history.

Judy L. Larson
Director
National Museum of Women in the Arts

Sponsor's Statement

The Coca-Cola Company is proud to serve as the national sponsor of *Amalia Amaki: Boxes, Buttons and the Blues*. This innovative collaboration with the National Museum of Women in the Arts and the Spelman College Museum of Fine Art is a celebration of the expressive, engaging and unconventional works of one of Atlanta's most accomplished artists and art historians, Amalia Amaki.

Amalia Amaki: Boxes, Buttons and the Blues is a unique, sophisticated treasure of artistic renderings and images of African American life and culture. Amalia's renowned works, crafted over a period of more than thirty years, leaves us with a vivid reminder of the bold and uncompromising contributions African Americans have made to the arts. Through this exhibition, focusing on her works from the last decade, you will come to appreciate the woman and the contribution her work has made toward enriching our understanding of art—both past and present.

The face of American art and culture continues to evolve into a dynamic, multicultural medium for everyone to enjoy. That is why The Coca-Cola Company is proud to be a part of an ever-changing landscape that helps educate and prepare aspiring minority artists to be seen and appreciated the world over. To the National Museum of Women in the Arts, we applaud

you for recognizing the achievements of a truly gifted individual and for bringing her story to the forefront in this project. To our partners at Spelman College, we thank you for your vision to create the first *and only* museum in the nation to emphasize works by and about women of the African Diaspora. You make us proud.

Last, but definitely not least, to Amalia Amaki, congratulations and thank you for sharing this timeless gift that is sure to enlighten, inform and educate audiences for many years to come.

Ingrid Saunders Jones
Senior Vice President, Corporate External Affairs
The Coca-Cola Company

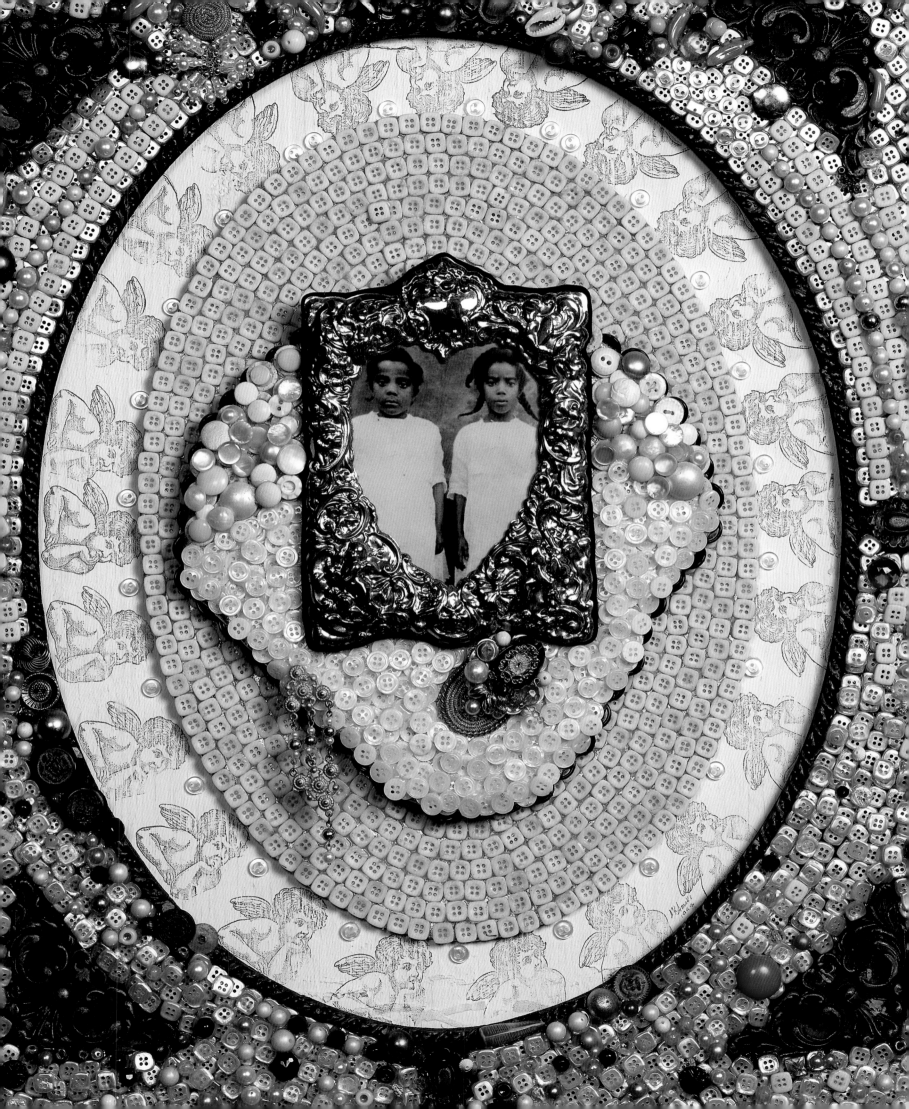

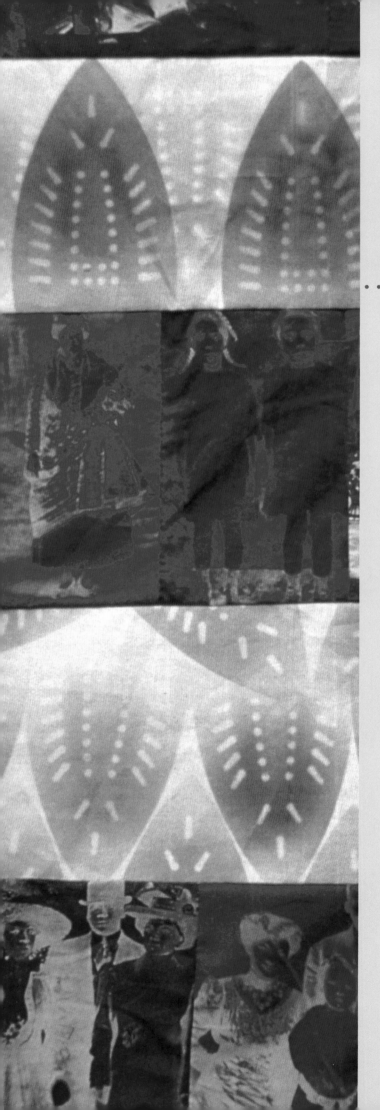

Acknowledgments

\mathcal{The} primary aim of this project and accompanying catalogue is to examine the differing bodies of work that Amalia Amaki has created since 1993. I am grateful to Ken Dutter for his foresight, tenacity and ability to bring two women's institutions together to explore the possibilities, the power of partnership and the art of Amalia Amaki. I am indebted to Judy L. Larson, the Director of the National Museum of Women in the Arts, and especially to Susan Fisher Sterling, its Deputy Director and Chief Curator, from whom I have learned much.

The Spelman College Museum of Fine Art is part of the Academic Affairs Division at Spelman College. I am grateful to Spelman College for offering me the support and respect to explore the ideas in this exhibition and catalogue. The endorsement of Dr. Beverly Daniel Tatum, President of Spelman College, Dr. Sharon Washington, Provost of Spelman College, and Dr. Myra Burnett, Vice Provost of Spelman College, has been essential to the project.

Amalia Amaki: Boxes, Buttons and the Blues would not have come to fruition if not for the support of Anne Collins Smith, the Curator of Collections at the Spelman College Museum of Fine Art, who is an invaluable asset to every project with which she is involved. She was an

essential participant in every phase of this project's development. Helen Ferguson and Chrystal Baylor, the Museum of Fine Art student assistants, have made important contributions.

The catalogue is especially indebted to Gloria Wade Gayles, a wordsmith whose insightful interview brings Amaki's own voice to this project. I am also grateful to Leslie King-Hammond, whose perspectives and commitment to placing Amaki within a rich dialogue with other artists are invaluable. I extend sincere thanks to the entire staff at Marquand Books, especially visionary Ed Marquand, Susan Kelly, Zach Hooker, Marta Vinnedge and Marie Weiler. The involvement and expertise of Nora Poling Bergman was critical to the editorial phase of the project. For his beautiful photographs of Amaki's work, I am also grateful to Michael McElvey.

My parents, Col. (Ret.) Isaiah E. Barnwell Jr. and Beatrice W. Barnwell, and siblings, Isaiah E. Barnwell III and Jennifer E. Barnwell, have, as always, been staunch supporters throughout the formidable stages of this project. I am grateful to friends and confidants who have traveled this exciting journey with me: Bill and SueSue Bounds, Edward L. Brownlee, Kirsten P. Buick, Rhea L. Combs, Arnie Epps, Bill Gaskins (who also lent his help as a photographer), Gretchen Generett, Valerie Cassel Oliver, Maranda Randolph and Howard W. Sterling. Through a residency fellowship during December 2004, the Hambidge Center also afforded me the space and support to explore, challenge and develop these ideas. Kim Waters, the Executive Director, Fran Lanier, the Residency Director, as well as Hambidge fellows Ann DeRosa, Barbara Hadden and Cheryl Stiles were particularly encouraging.

Lucinda Bunnen and Joe B. Massey, early champions of this project, have always valued the Museum's unique mission and understood the significance of creating a lasting catalogue of this endeavor. The project has also benefited from the support of the Sandler Hudson Gallery, especially Robin Sandler, Debbie Hudson and Beth Woiccak.

My most heartfelt gratitude is to Amalia Amaki, an exceptional human being with an uncompromising commitment to the field of visual culture, who delves into art and into life with vigor, intelligence, character and passion. As one of her former students who has always been compelled and encouraged by her background, spirit and ability to accomplish mammoth tasks, I am doubly humbled by the opportunity to examine her work in detail. A consummate professor, she compelled me to reach beyond expectations, traditional boundaries and the confines of art history. By her art, willingness to except the invitation and this journey, I am changed exponentially and ever grateful.

Andrea D. Barnwell
Director
Spelman College Museum of Fine Art

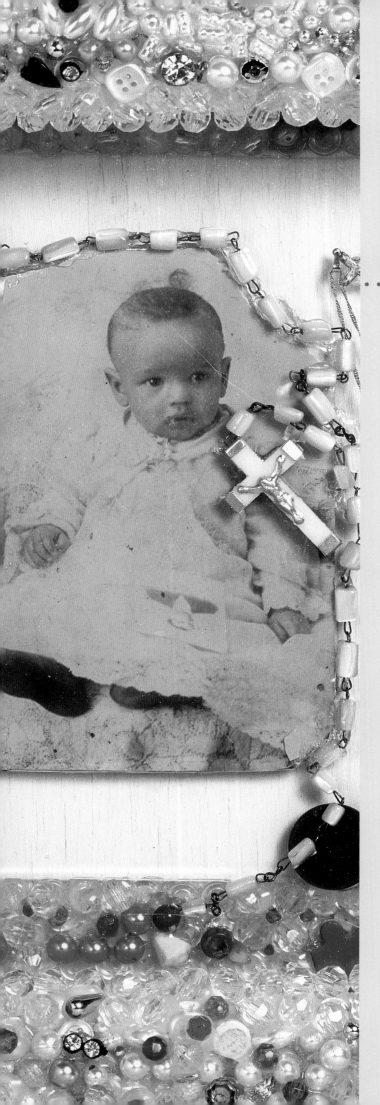

Introduction

Andrea D. Barnwell

Amalia Amaki (b. 1949) is an accomplished artist, art historian, curator and scholar of American art and culture. Excelling in many areas with seemingly easy dexterity—a tremendous feat that only few can boast of—she has produced a significant body of art. For more than three decades she has garnered acclaim, especially in the Southeast, for her art, which is loosely divided among three central themes or subjects: mixed-media quilts, button-encrusted souvenirs and manipulated photographs. Her work exemplifies highly informed, varied and sophisticated approaches to art-making. Incorporating engaging themes, accessible images, common materials and wise humor into her work, she disrupts and challenges conventional ideas about sociocultural trends, race and American history.

Amaki has completed corporate commissions for Atlanta Hartsfield-Jackson International Airport (fig. 1), The Coca-Cola Company, Absolut Vodka and Seagram's Gin. Her work is also in major museum collections and has been featured in several group shows and in solo exhibitions. *Amalia Amaki: Boxes, Buttons and the Blues,* however, is the artist's first major one-person exhibition. Discussions about Amaki's work often focus on her quilts of African American women blues singers and button-based work. This project builds upon these discussions, highlights several of her series and provides a broader context for her life and art.

Amaki was the fourth of six daughters born to Mary Elizabeth and Norman Vance Peek.[1] Born and raised in Atlanta, Georgia, she has fond memories of growing up in the mecca of the South. While a host of experiences helped her evolve into the artist that she has become, two childhood activites contributed directly to her artistic vision. Growing up she enjoyed playing marbles and running with boys in the neighborhood. Her mother, contending that playing marbles was too tomboyish, insisted that she begin playing with buttons because they were more ladylike. Gatherings in the living room with her entire family to listen to her father's favorite blues vocalists are among Amaki's fondest memories of childhood. At a very early age she adopted her father's appreciation for Bessie Smith's "naturally raw, God-given voice that defied coaching"[2] and developed a penchant for other blues women including Billie Holiday, Alberta Hunter and Gertrude "Ma" Rainey. No one could predict at that time that blues women and buttons would eventually become her artistic signatures.

Figure 1 Amalia Amaki, *Sojourners* (detail), 1996, mixed media, Atlanta Hartsfield-Jackson International Airport, gate E5.

Bessie Live! (fig. 2), a work that precedes the scope of this exhibition, exemplifies the work for which Amaki is recognized. It attests to the idea that Bessie Smith never received adequate recognition in the United States, during her lifetime, for the indelible contributions that she made to American music and culture. The popular press printed erroneous information and depicted Smith as an alcoholic and an adulterer. In the six years that preceded her death, the press neglected her altogether. Amaki, in contrast, rendered her as a woman who literally gave her life to and for her art. Smith traveled thousands of miles by car and performed throughout the nation. In 1937 at the age of forty-three, she died as a result of injuries sustained in an accident on a dark Mississippi road.

There is ample speculation about the circumstances of her death. While some suggest that her injuries were too severe for her to endure, others explain that she was turned away from a local hospital that refused to treat her because she was black.[3] Amaki, uninterested in the rumors that surround her death, created a cyanotype that announces her presence and recalls a marquee or a billboard. The bone buttons that encrust the surface of *Bessie Live!* refer to Smith's bones, which were literally exposed that fateful night.

An examination of a cross section of the work that Amaki has created since 1993 underscores that it is an optimal time for this exhibition. Bringing together more than seventy works for the first time, *Amalia Amaki: Boxes, Buttons and the Blues* foregrounds the exciting intersection where her penchant for the blues, drive to blur boundaries and ability to challenge perceptions meet.

Amalia Amaki: Boxes, Buttons and the Blues, an exhibition divided into three sections, examines a diverse group of work that Amaki created from 1993 through 2005. Sweets for the Sweet, section one, explores how humor plays a significant role in Amaki's series inspired by decadent desserts. From *Bon Bon* (cat. 41) to *Candy Box II* (cat. 31), Amaki's candy boxes resemble a selection of the most ornate handmade Belgian chocolates. Heart-shaped lids encrusted with buttons safeguard assortments of milk, white and dark chocolate truffles and caramels. While these creations seem to exude sweetness and caloric temptation, they are made entirely of buttons. Amaki's candy boxes are inventive works that prompt a second and closer look. Because they are beautifully presented and intriguing in their own right, it is easy to become preoccupied with their construction. While some are compelled to investigate how the candy boxes were executed, others are embarrassed because they, like so many before them, thought they were reaching for real chocolates. Amaki has described her candy boxes as "traps," explaining: "If you reach for the button thinking you're getting a piece of candy, and you reach to get it, you can't go back and wipe out that moment when you felt embarrassed. The whole idea of looking at something and it turns out to be false. The buttons don't lie. It's how they're perceived."[4] While these lighthearted keepsakes exemplify sweetness and decadent elegance, they are playful reminders of the adage that things are not always as they seem.

Like the candy boxes, other works by Amaki such as *Caramel Apple* (cat. 43) and *Coconut Cake* (cat. 68) are lighthearted and rooted in frivolity. In contrast, works such as *Golden Nuggets* (cat. 47) and *Nuts and Chews* (cat. 51), which incorporate photographs, seem to suggest more serious themes. To create these photo-based works, in most instances, Amaki finds pictures of anonymous African American subjects at flea markets. While she does not have any information about the identities and biographies of the subjects, specific characteristics such as facial expressions, attire, poses or hairstyles might compel her to incorporate certain photographs into her work. The unknown sitters inadvertently represent the ordinary lives and generic experiences of everyday people. While the popular media more often than not suggests that interactions among African Americans are dysfunctional and compromised, Amaki's mixed-media mementos, in contrast, posit that black life and love are also about sweetness, desire, delicacies and pleasure. To that end Amaki's candy boxes are metaphors for the collective lives of African Americans as well as the relationships between and among them, which have historically been complex, underexamined, undervalued, often misunderstood and, like the faux chocolates, not always as they seem. In other words these intentionally tantalizing works—an assortment of visual puns and optical illusions—are symbols for the bittersweetness of African American life and cultural history.

The second section, Wild Women Don't Wear No Blues, inspired by the anthology edited by Marita Golden, focuses on Amaki's signature series of cyanotype quilts and jewel-encrusted fans that emphasize her admiration for women of the blues, including Billie Holiday, Gertrude "Ma" Rainey and Bessie Smith. Biographies of these and other African American women blues singers typically have focused on the extramarital affairs, crime, domestic violence and overt sexuality that are often the source of lyrics in their songs. Amaki's objects focus instead on the innovative nature of their art—the skills, talents and passion that were their genius. With their indigo hues and iron-burn marks, which recall the trauma of branding, these richly textured quilts are alternative images of the flag, fortitude, self-preservations, pride and Americana. They trace how the blues evolved from being at odds with mainstream culture to a respected phenomenon that distinctly defines America. Moreover, the quilts, with their manipulated images of press photographs, convey that there is something extraordinary beyond the pain in the voices of blues women.

The final section, Your Blues Ain't Like Mine, features many of Amaki's most self-reflective works to date. From mixed-media photographs, based on vintage postcards, to digitally manipulated photographs, which cross-examine myths about black beauty and ethnicity, this section highlights innovative recent work.

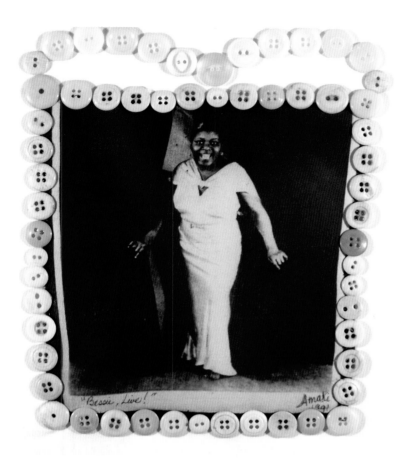

Figure 2 Amalia Amaki,
Bessie Live!, 1991, cyano-
type on cotton, stitched
with bone buttons, 13⅝ ×
11⅛ inches, Museum of
Fine Arts, Houston, gift
of Clinton T. and Dortha
Willour in honor of
Young T. Hughley Jr.

A first examination suggests that Amaki's recently completed manipulated photographs are dramatically different from her previous work. Unlike her quilts and button-encrusted souvenirs, they engage representations of ordinary black women in popular media and advertising and the social constructs of beauty. On the other hand pieces such as *Purple Lady* (cat. 72), *Blue Lady* (cat. 69) and *BLUE Gold Lady* (2005) demonstrate Amaki's ongoing investigation into the history of image-making. While they may not initially appear to be associated with her oeuvre, a second reading reveals that they are intimately linked to images and ideas that she has explored throughout her career. Through her manipulated photographs Amaki furthers her investigation of cyanotypes, the blues and social perceptions.

Amaki is currently Curator of the Paul R. Jones Collection and an assistant professor of art, art history, and black American studies at the University of Delaware. Her acute understanding of Western and non-Western art heightens her ability to excel at various disciplines within the field and affords her the freedom to comment upon works by other artists and to incorporate a limitless array of subjects. Informed by her observations about contemporary culture, Amaki, like contemporaries David Hammonds (b. 1943), Adrian Piper (b. 1948) and Carrie Mae Weems (b. 1953), does not feel limited by what her work can or cannot be. It is illuminating that Man Ray (1890–1976) and Marcel Duchamp (1887–1968) are among the artists that Amaki admires most. Like these internationally acclaimed surrealists she values and naturally puts into practice traits essential to avant-garde artists such as inventiveness, audacity, an effervescent imagination and a continual willingness to call traditional notions of art and culture into question.

Notes

1. I have drawn the biographical information in this introduction from interviews and conversations I have had with Amalia Amaki over the past three years.

2. Amalia Amaki, interview by Andrea D. Barnwell, August 12, 2003, Atlanta, Georgia.

3. See Chris Albertson, *Bessie* (New Haven: Yale University Press, 2003).

4. Amalia Amaki, telephone interview by Andrea D. Barnwell, December 14, 2004.

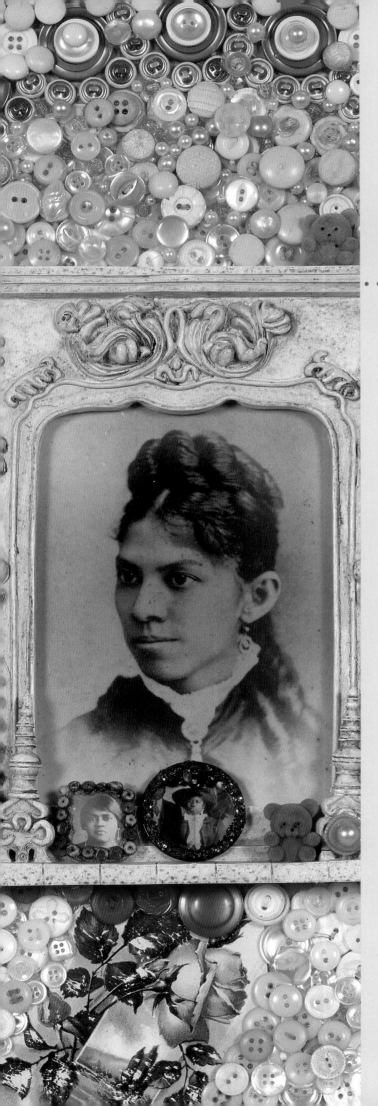

My Mother, My Father, My Art: Genetic Links to Boxes, Buttons and the Blues

An Interview of Amalia Amaki
by Gloria Wade Gayles

Gayles I consider it a privilege to talk with you and to celebrate with you the forthcoming exhibition of your works at the National Museum of Women in the Arts. Of course, this is not the first exhibition of your works, but, as you have said in previous conversations, NMWA has special significance for you.

Amaki Very much so. NMWA is quite an amazing institution. It is a woman's space, and that makes it a very special space. So I feel honored, profoundly honored, that my work will be exhibited there.

G And we feel honored, profoundly honored, that the show will travel from NMWA to another "woman's space": Spelman College.

A Having the show exhibited at Spelman is like a homecoming for me because I spent many wonderful years there working with very talented students. I can't begin to tell you how proud I am that the show is being curated by Andrea Barnwell, whom I taught at Spelman. This show is such an honor for me on many different levels.

G And it is an honor you deserve, Amalia.

A You know, I am reminded of something Georgia O'Keeffe told me about deserving honors. She said that there might be people more

talented than you, and more deserving, but opportunities can come to you when you have the work. I always remember that.

G Let's begin at the beginning with the making of Amalia the artist.

a How far back do you want me to go?

G It is your journey, Amalia. You are in charge.

a Well, my journey begins at home (fig. 1). Both of my parents were creative. My father made things. He made shopping bags out of fabric and Halloween costumes out of brown laundry paper and burlap. I think flour came in burlap bags. I really don't know where my father got the burlap. I just know that it was always there—so were buttons and beads and yarn, which my mother used when she sewed and when she quilted. I grew up in a very creative environment. I can remember drawing and having family members "ooh" and "ah" over my drawings. It was just natural for me to draw, and the way my mother responded to my drawings encouraged me to draw more. She actually showed my drawings to insurance men and milkmen and people in the neighborhood. And I want to tell you, she didn't just show them. She sold them. I'm sure the money ended up in an account that supported my education, but what was important for me at the time was that my drawings had value. They were not just lines and circles of a little girl. They were art.

G That is an incredible story.

a My mother was an incredible woman (fig. 2). I remember one day fooling around with yarn and burlap. I took one of my father's burlap bags and cut it up, and then I took some of my mother's yarn, and I created a still life. I was so impressed with it that I created a second one. Those yarn images ended up somehow in a furniture display at the downtown Rich's Department Store here in Atlanta, and they were transformed when the decorator at Rich's framed them. I think the framing gave me the message that this wasn't just some crafty thing I had done with yarn. It was art. A customer purchased the furniture but only with the understanding that my work would be included. That was my first really big sell. When you are supported early and rewarded with money for your efforts, you are given an

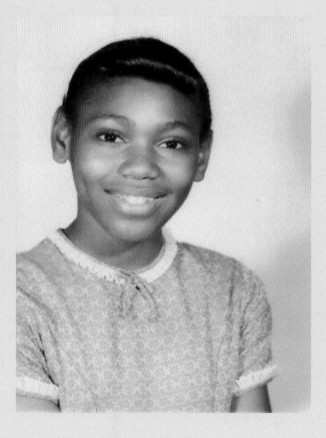

Figure 1 Amalia Amaki, 1955 or 1956.

incentive to continue working. And that's what the Rich's experience did for me, but it did more. It encouraged me to continue exploring materials that weren't always considered to be fine art materials. And I attribute that exploration to both of my parents.

G How old were you when you created the still life?

a I was about thirteen at the time.

G So at an early age you had a knowing that you would be an artist?

a Knowing. That is a good word. Yes. Thanks to my parents, and to others in my life, I began my journey at an early age, and I began with a knowing that I was going to be an artist. Actually, I can't talk about my journey without remembering the encouragement I also received from Rev. William Holmes Borders. He was a very close family friend and pastor of my family's church, Wheat Street Baptist Church here in Atlanta, and it was because of Rev. Borders' belief in me that I met Hale Woodruff when I was around ten years old. Rev. Borders took me into the church sanctuary, and, with me in his lap, he sat next to Hale Woodruff. I remember this as if it happened yesterday. Rev. Borders literally took my face into his hands and said, "You should know this man. He is a very important artist. His name is Hale Woodruff." He repeated the name slowly: "Hale Woodruff." And of course when he introduced me to Mr. Woodruff, he said proudly that I was a member of his church, and I was going to become an artist.

G So when you began your journey, at a very young age, you received validation and praise from your parents and from others in your life. You never doubted that you were going to be an artist.

a I don't think there was a time in my life when I didn't know I was an artist. Even before I knew what an artist I was, I had a sense that I would be connected in some way with creativity. And I say that because of a bathtub experience I had when I was four, certainly no older than five.

I was sitting up in the tub, and my mother was bathing me. When she left the room briefly, I lay down in the tub. I immersed myself in the water because I wanted to be one with the water. And the strangest thing happened. The water suddenly changed colors. I saw the colors change! I was one with the water, and I actually saw the colors change! I came out of the water only because I heard my mother screaming. If you ask me when I knew I was going to be involved with something creative, I would have to say I had a knowing in that experience.

G Your stories, Amalia, are priceless. In fact, as I have said on several occasions, you are a gifted storyteller. You speak in metaphors, and the metaphors are full of color and sound, full of meaning and memories from your journey.

a Well, I am fascinated with words and with the sayings from my mother I heard when I was growing up. My mother speaks through my work. In fact the titles of some of my works are direct extractions from her sayings. She's a collaborator in my work. My mother is the genetic link to my interest in words. My father is the genetic link to my interest in visual images.

G And the media you use are inspired by this connection to your parents. Let's talk about your use of media. Fans, postcards, photographs and, of course, *buttons*. Is that medium an Amalia Amaki signature?

a Yeah. I'm the button lady. I grew up around buttons. My mother kept them in tins, and I would shake the tins just to hear the sound of buttons moving around in there. I loved that sound.

G Tell me about your first experience with buttons as a medium for your art.

a I was working on the fabric blues images somewhere in the late eighties, and I had done a triangular form, a piece on Bessie Smith, and in my mind's eye I saw her in a huge car coat. You know, car coats had big, oversized buttons, and I saw a big button in this piece. So, being true to this sense of adventure in me, I stuck on a button,

and I liked it so much that I added another button and then another and another until all that was left of Bessie Smith was the face and the shoulder and the torso. Really, the buttons just took over the piece. And I loved it! I especially loved it when the piece was installed in the exhibition, and I could see how light was playing off the buttons. Well, there was just no turning back! I love the tactility of buttons, and I love buttons that have been touched, buttons that have had various interactions with the human hand. I'm a recycler. I like putting things back into what I call the cycle of existence.

G You laughingly called yourself "the button lady," and I'd like to know if that is your favorite medium?

A You know, Jacob Lawrence asked me that same question when I met him at Spelman College when I was a teenager. He was there to give a lecture in conjunction with a show of his work, but the lecture was canceled, and he was free, and this gave us an opportunity to talk one-on-one. Of course I told him that I was an artist. In the course of talking about his work, he said that he didn't like oils. He preferred tempera and gouache, and those were the only paints he used. When I told him I didn't have a favorite medium, he asked, "Why don't you?" I couldn't answer him at the time—I was early on my journey—but years later, I wrote him the answer that I will give you today: I don't have a favorite medium. My media are my children. How can you choose one child over another? I don't think you can. I love all the media I use. I love taking the unexpected object and redefining it in the context of art— like a button, a fan, a faded photograph. If there is one thing that has remained constant in my approach to my art over the past twenty years, it is my desire to tear down boundaries or sort of blur boundaries between so-called craft and so-called high art.

G And you blur that boundary in your use of photographs, which are as much your signature as are buttons and fans. What look, statement or mood are you seeking in the photographs you select for your art? All of them have a certain look, and that look becomes a part of your signature.

Figure 2 Mary Elizabeth Peek, ca. 1935.

A Yes. That's true. I particularly like photographs from the twenties, thirties and forties. I love the clothes, the hairstyles, the body language, the fake scenery and the fake environment of those decades. The painted backdrops allowed the sitters to go where they wanted to go. I like the way people posed for photographs. And, you know, it's really not about the face. It's about the expression. I deliberately use photographs that are a bit defaced, cracking or fading. That's survival, you know. If you've ever had a flood or a fire or anything like that in your home, you can understand the look I'm seeking. It's a look that says they survived. Actually, my work is often triggered by a photographic image. That can be a postcard. It can be somebody else's photography. It can be older photos I purchased at flea markets, as I often do. It can be something I see for just a fleeting moment. I love photography, and I'm only at the midpoint of exploring it in ways I want to.

G Do you begin working in one medium or using one technique but, in the process of creating a work, find it necessary to change the medium—to use a different technique?

A Yes. I often begin with a photograph, and sometimes, in order to sail the course the photograph started me on, I have to make a shift. My choice has to be true to the directive of that photograph. To answer your question, I do shift. I can begin with an image that I think will be basically two-dimensional, but in order to complete the piece, I might end up creating a box or a case or a three-dimensional fan. That's exactly what happened with *Holiday Sweets* (cat. 49), which is one of the button boxes. My initial thinking was to put the postcard image of Billie Holiday in a sea of textural white buttons, but Billie Holiday suddenly became the perfect top for a candy box. I thought about the more tender side of her as a person and as a woman and about her beauty and her love of things sweet and pleasurable. So I had to make that shift, and I know the work would not have been successful in any other format.

G I know there is a story about your discovery of fans as a medium. Would you share it with us?

a You know me too well. Yes. There is a story, and, of course, it's connected to my family or, more specifically, to the church I attended with my family. Church images in my memory find their way to my art. I can remember sitting in church and being intrigued by shapes and colors of fans and by the rhythm of fanning when the sanctuary was warm from summer heat. The fans had religious messages—praying hands and other poses of reverence—on one side and on the other side Jake's Barbecue or, what's more ironic, Haughabrooks Funeral Home. I was intrigued by the irony of those contrasts and also by the double sides and the shapes of the fans. In some pieces I use actual fans. In other pieces I trace the fans in order to capture their shape. Sometimes I emulate the shape of fans on a much larger scale. That's very reflective of their importance to me. My first large-scale fan was actually an image of Billie Holiday on fabric, and it was a blues fan. I called it *Number One Fan #1*.

G That takes us to the blues quilts, which many people consider to be your most celebrated work. At what point in your journey were you inspired to do the quilts, and who was your inspiration?

a Now that will mean talking about my parents again. In fact I can't talk about my art without talking about the inspiration I received from my mother and my father. From each of them, I received special gifts. My mother is central to the blues quilts because she quilted, and I want to emphasize that she quilted by hand. I think she quilted because it was just in her to do so. I loved the beauty of her quilts and the way they felt against my body. I dedicated my first blues quilt to my mother, which I made as a photography student at the University of New Mexico. I have to say something about my teacher, Betty Hahn. She was a tenacious critic who insisted that each image on every patch of the quilt be perfect. She didn't let me get away with anything. Everything I did had to be perfect. At the time I didn't understand her commitment to my personal feelings about the images. It was as if she knew my objective was to make something that reflected my love for my mother. That is why when I talk about the blues quilts, I have to talk about my mother.

My father is central in a different way. He brought me to the women. You see, my father was a singer (fig. 3), and he loved blues women. He literally etched their names into my memory. Even when I did not remember their voices, I knew their names. And so I went on a journey of discovery of the music. I would play their music while I worked on the quilts. The sounds the women made had a direct influence on the creation of the quilts. So, in different ways, both my mother and my father influenced me in the making of the blues quilts.

G Amalia, you are such a spiritual person that I'd like to know whether you think there is a spiritual sensibility in your work?

a Well, creating art is itself a very spiritual experience. The insistence of an idea to come out, not to be put on hold—that's spirit-based. An image I have in my mind's eye—that's an idea that can't be put on hold. I mean, it literally resists being put on hold, which is why my sleep is interrupted at two, three or four in the morning. I'm telling you, this happens. I can be so exhausted that I can barely focus, but I have to get up. I am compelled, beyond my abilities to resist, to get up and make a sketch of the idea, make a notation. I have no choice. That's spirit-based. The creative process is a spiritual process.

G Does spirituality in the creative process result in a spiritual work of art?

Figure 3 The Deep South Boys, Norman Vance Peek at far right, ca. 1930–1940.

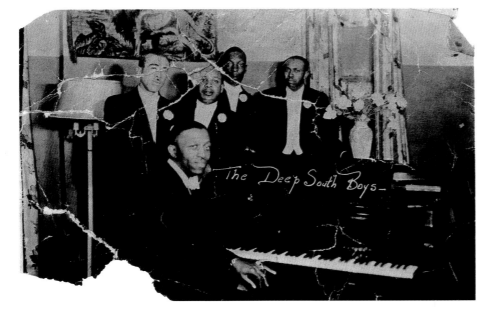

a I think all of my work is spiritual. Yes. All of my work is spiritual. I think the spirituality is rooted in the overall appearance of the work, how it responds to light and its fixture in space. Sometimes I think a portion of the image itself will speak to that. Sometimes the spirituality is quiet, and other times it is not so quiet.

G Can you give me an example of a work in which the spirituality is quiet and one in which it is not so quiet?

a I think it's very quiet in *Dream Fan* (cat. 55), and it's screaming in some of the blues quilts.

G Do you have a favorite work?

a You know, I once asked that question of an actor friend, and he said, "My favorite is always the one I am working on." I can relate to that. My favorite work is always the one I am working on, but certain works are more successful than others.

G What makes them more successful?

a It's difficult to put success into words. There is a point in the creation of a work when you hear it dictating you to stop. When I am working on a piece, I know when I have finished it because every fiber of my being says, "Stop. Leave it alone."

G When you see your work exhibited, do you ever think that you didn't stop when you heard that voice? Do you rethink an artistic decision you made?

a Oh, yes! And, really, one of the reasons I love exhibiting my work is that I can see how it looks somewhere else. I'm always intrigued to see how someone else gathers up this family of work and how they see the various parts interacting with one another. The work looks very different when it's not with me. So I get to see a different side of the work when it's in an exhibition, and I love that. And I talk to myself. I will say, "You know, I should have done blue. I put brown there and my spirit was saying blue, and I should have gone with blue." Often, when I have

that kind of interaction with a piece, I don't know why, but nine times out of ten it's a color issue. If it's not about color, then it's about size. You know, "That's too small." Yes. I critique my work. And let me say this about exhibitions. I don't like it when people stand way back and look at a work, even if it's a large piece. They can start back from the work, but by the end of the viewing, they should be very close, as if they are sticking their nose into the piece. And let me say also that I am not at all intimidated by flaws. Flaws give testimony to the fact that a human being created the work. If I get up on a piece and I see that the glue is showing, unless it's really distracting and taking away from the bigger message, I'll leave the glue out there because it reminds the viewer that a machine didn't make the work. I made it.

G Have you faced challenges because you are an African American, because you are a woman, because you are both?

a Both, of course. Sometimes the challenge has been about race more than about gender. Other times, gender bias has kicked me in the face with more severity than race issues. Only black women artists can tell you that. I shouldn't say only black women artists because all women of color, I think, face these challenges. But race and gender issues can also be wonderful sources for lemonade. Because I am an African American woman, I have so much material, so many ways in which to fashion my voice as an artist, and I try to turn the challenges of race and gender into assets. When my true voice is out there, it's an opportunity for others, who are not African American women, to hear themselves.

G How would you define yourself as an artist? I ask fully aware that you do not like labels.

a I'm a renegade. I'm a rebel. I break the rules as an artist, and I break the rules deliberately. My materials are not orthodox. I see a button with a painter's eye. I see the relationship between buttons, photographs and other objects with a collage or assemblage artist's eye. I see photographically with a photographer's eye. I know it is not typical for someone to add and subtract

at the same time. I build the images as a painter, but at the same time I am editing out as a photographer would. So, how would I define myself? I would call myself a rebel artist working with materials not traditionally considered high art. You asked me about my journey. Let me tell you this way: I started out as a painter, but somewhere along the way I turned in my painter's tools for a hot glue gun.

G What artists, past or current, have influenced your work or your life as an artist?

a Nancy Elizabeth Prophet, Georgia O'Keeffe, Joseph Cornell, Man Ray, Betty Hahn and, of course, Hale Woodruff. I know you asked specifically about artists, but I must include Harriet Tubman.

G Can you be specific about the nature of their influence as individuals or as a group?

a Actually, none of my work looks like the work of these artists, but I mentioned them for very specific reasons. Prophet's influence is her deep passion for her art. She insisted in the face of incredible obstacles on being an artist, and she would not define herself in any other way. O'Keeffe blessed me tremendously with her words. Her advice to me when I was in New Mexico was impeccable, and she was such a pioneer. Cornell, through his work, taught me that art does not have to be large in scale or consume a tremendous amount of space in order to fill a room. Man Ray is amazing. He is the artist among them whose work invites me to think in unlikely ways about who I am as a physical, psychological and surreal being. Betty Hahn introduced me to cyanotypes and other non-silver photographic processes. Woodruff is like a grand, wise muse who inspires me with his way of being, his way of talking. I read his words, and I am covered with inspiration for weeks. And I am drawn to the very idea of Tubman as a person, a legend and an icon. I know that my fascination with her has something to do with her spirituality, her militarily strategic mind, her cleverness, her sacrifice. I really think Tubman and I share this thing with water. You can't think about Tubman without seeing water.

G I want to ask you to explain the phrase "de-racing of African American art," which you used in the introduction to the book you recently edited, *A Century of African American Art: The Paul R. Jones Collection.* But, first, let me commend you on the book itself and on the extraordinary work you have done as curator of that extraordinary collection. Given the fact that everything about your work speaks to your identity as an African American woman and, I might add, as a Southerner, why would you want your work "de-raced"?

a De-racing African American art is a campaign with me, but it doesn't mean stripping our art of its uniqueness, of its fundamental rootedness. It doesn't mean any of that. Rather, it means removing racial barriers and language that defiles. I believe that when we say American art and when we talk about American expression, the work of African American artists should be present and, actually, should be in the center of that discussion. And I say that because African American art is homogeneous. It is accepting. It is inclusive. It is not a subcategory. It is indeed and authentically American. That is what I mean by de-racing.

G You teach. You write. You curate. You travel. I understand you recently returned from a month of lecturing in Florence, Italy. According to my count, you have created more than several hundred works of art, and you have had twenty-seven solo exhibitions and more than a hundred group shows. What drives you?

a You know, there's so much I want to say. There is so much I want to do. There are so many other voices I want to facilitate. There are so many people I want to teach and learn from. I guess my passion drives me, and my commitment sustains me.

G I love all of your work, but my favorite is *Kids Dancing in a Red Knowing* (cat. 66). I know there is a story about its creation. Would you share it with me?

a The key to that body of work is the little girl. Her verve, her gutsy showmanship and her poise

speak to her own little brand of wisdom and control. She found herself in a situation that could have manipulated her, but it didn't because—well, she is what my father called an "it" girl, and an "it" girl does not permit herself to be manipulated or silenced or marginalized or kept in artificial boundaries. The red in the work speaks to all of that. The arrangement of the buttons speaks to that. And the shoes, of course, emphasize that her steps are ordered by her ability to go beyond false appearances.

𝒢 Are you that little girl?

𝒶 Yes. In some ways I am.

𝒢 If you tell me what you are working on now, I will know what your favorite work is.

𝒶 My favorite work is a surprise.

𝒢 Why do you make art?

𝒶 I have to. There is no other way I can answer that question than to say I have to. Art-making for me is a lifeline. I am convinced that it is what I was put here to do. I was created to make art.

𝒢 You said in an earlier conversation that the NMWA exhibition gives you a forum at which you can speak out of your own voice. When people see the exhibition, what do you want them to hear? What do you want them to see? And when they leave, what do you want them to take with them?

𝒶 I want them to hear and see something they have not heard or seen before that, in fact, has to do with themselves. Also, I hope that in every exhibition, and this one in particular, people will have reason to say, "Oh, I didn't know she did that."

𝒢 What would your mother say about the exhibition?

𝒶 My mother would say, "I knew it."

𝒢 And your father?

𝒶 He would say, "This is great. Now what's next?"

𝒢 And how would you answer him?

𝒶 I would say, "You'll have to wait and see."

Note

Throughout the interview, Amalia Amaki journeyed to many sites of memory, painting each one with words that were colors, sounds and textures. Her mother and her father were present at each site, "directing" her to non-traditional materials that make her art so rich and distinctive. In this abbreviated transcription of the interview, Amalia crafts stories with the same brilliance with which she creates art. The interview, two hours in length, was conducted on December 15, 2004, in Atlanta, Georgia.

Potent Stuff: Memory, Imagination and Meaning in the Aesthetic Life of Amalia Amaki

Leslie King-Hammond

Africanism is inextricable from the definition of Americanness—from its origins on through its integrated or disintegrating twentieth-century self.

Toni Morrison[1]

These people, black visual artists—make things and make visions. Their job, their goal is to re-envision vision.

Michele Wallace[2]

I'm not interested in depicting anger or blacks as victims—though I know museums love that stuff. I prefer to show the positive side—to talk about normalcy.

Amalia Amaki[3]

It is not uncommon for scholars and historians who document the development of an artist's career to refer to this process as a journey. In the case of the aesthetic life and work of Amalia Amaki, it is more than just a journey. It is an odyssey that leads her through a series of discoveries, revealing her fascination with family, friends, heroes and heroines, cultural history, blues traditions, memory, imagination and meaning. Amaki creates bodies of work that draw on a vast range of media and are inspired by the complexity of her experiences as a woman and a person of

African descent and by her need to visually articulate the beauty of those realities. Memory, imagination and meaning are intricately woven into the odyssey of her narratives, which seek to define a sense of "normalcy" in the lives of her subjects. In her choice and use of materials—common, ordinary, functional, personal, every-day, mundane, normal *stuff,* combined with digitally manipulated photographs—her artistry becomes an evocative potent force of energy and revelation.

Amaki's odyssey as an artist in the United States comes with its own distinct history that includes all the inherent limitations imposed by a dominant society that still denies African Americans the opportunity of full participation in its democratic ideals. This history is also about the exclusion of the contributions of the black artist from the creation of a truly authentic American aesthetic legacy. These attitudes marginalize the artist of African descent to the roles of decoration, ornamentation and entertainment within the canons of mainstream art. In her research art historian Lisa Farrington summarizes the complex and conflicted plight of African American women artists:

> Prompted by an unwelcome inheritance of axiomatic portrayals that falsely defined them as lustful, loathsome, and inferior, many women artists of color have chosen to counteract these perversions by portraying themselves with dignity, honesty, and insight. Others have challenged the status quo by doggedly pursuing artistic careers despite the deeply rooted prejudices that excluded them from the realm of the artist. Inaccurate conceptions of African-American women, shrouded for centuries in an intricate web of sexual and racial fantasies,

have proven to be enduring impediments to their progress.[4]

This displacement was addressed by culture critic Michele Wallace in her seminal 1992 essay, which asked the poignant question, "Why Are There No Great Black Artists?" Within the ranks of white and black intellectuals, the black artist was often viewed as an illustrator or copyist, who did not create imagery of historical importance or originality. Wallace sensed a "contempt," a hostility that called for a "re-envisioning vision."[5] This is the rationale upon which Amaki has created her own theory or theology of normalcy and positivity to portray the image of the African American subject with artistic imagination, humanistic import and cultural meaning.

Wallace's critique is compelling and demands attention to fully comprehend the impact and legacy of a primarily white male–dominated art world:

> In the context of mass culture, the image of the black is larger than life. Historically, the body and the face of the black have posed no obstacle whatsoever to an unrelenting and generally contemptuous objectification. And yet, until recently, there has been no position within or outside American visual culture from which one could conceptualize the African American as a subject. The prominence of black directors in film finally threatens to change that picture. But the difficulty of the project for black film has to do precisely with the history of a mostly invisible black visibility.[6]

Art historian Lisa Gail Collins defines this problem as a "visual paradox at the center of African American thought. Simultaneously there is a

preoccupation with visual culture and a neglect of visual art and artists."[7] Artist Ellen Gallagher (b. 1965) articulates the problem of visualizing the black subject, observing, "Somehow in America black artists aren't allowed to use banal images of blackness. On the other hand, the idea of something black and inscrutable is also very disturbing."[8] Whether visible or invisible, inscrutable, grotesque, heroic or humane, the problem of representing and interpreting the black subject and, especially, the black female subject has confounded the art world and American society, both black and white, since Africans arrived on the shores of America in 1619.

Amalia Amaki's training as an artist and a scholar has richly prepared her for this challenge. How does an artist of color create for herself a definable, visible presence given the constraints of history, the currency of the present and the aspirations and challenges of the future? Amaki has earned two bachelor degrees in photography/ art history and journalism/psychology, a masters degree in modern European and American art, and a doctorate in twentieth-century American art. She was trained by photographers Ansel Adams (1902–1984) and Beaumont Newhall (1908–1993) and was mentored by the notoriously reclusive painter Georgia O'Keeffe (1887–1986). Amaki is an artist-scholar who comprehends the range of dynamics, both intellectual and technical, essential to visualizing the normalcy and positivity that reflect the humanistic core and aesthetic reality of black life in America.

In recent years there have been growing numbers of African American artists who have become increasingly aware of the visual paradox Collins describes. Amaki is not alone in her quest to create an authenticity of imagery that is unique and indicative of the need to visually express the historical legacy of African American women. Renée Stout (b. 1958), Betye Saar (b. 1926), Elizabeth Talford Scott (b. 1916), Joyce Scott (b. 1948), Faith Ringgold (b. 1930), Leonardo Drew (b. 1961), Ed Sorrells Adewale (b. 1936), Willie Cole (b. 1955), Aminah Brenda Lynn Robinson (b. 1940) and Deborah Willis (b. 1948) are but a few of the artists working to create a visual language that achieves this mandate. To make

visible the invisible, writer Toni Morrison skillfully articulates how the fundamental premise of an American Africanist voice is essential to this process of revelation, personhood and identity:

Through the simple expedient of demonizing and reifying the range of color on a palette, American Africanism makes it possible to say and not say, to inscribe and erase, to escape and engage, to act out and act on, to historicize and render timeless. It provides a way of contemplating chaos and civilization, desire and fear, and a mechanism for testing the problems and blessings of freedom.[9]

It is in those "blessings of freedom" that these artists have evolved an imagery that expresses the impressions, memories and imagination of their experiences. The artwork of Amalia Amaki evokes the power of cultural permanence crucial to the heritage of America from an Africanist perspective that has yet to be incorporated into mainstream art theory, thought and practice.

Empowering Creativity

Power must be viewed in part as an artifact of imagination and a facet of human creativity.
W. Arens and Ivan Karp[10]

To more effectively understand nature, form and process in the work of Amaki and the community of artists with whom she shares affinity, it is important to identify and recognize those elements and objects used by these artists to create images that convey the impact of memory, imagination and artistry crucial to the intent and meaning of their work. This is of paramount importance, given their position as artists and as African Americans who have suffered, in Michele Wallace's assessment, the *contempt* of benign neglect, selective amnesia and gross misrepresentations of their aesthetic genius and personal being. Within the human history of the African American experience, the struggle for the "power" to be self-determining has been central to artists' need to visualize Morrison's blessings of freedom in their artwork. Scholars W. Arens and Ivan Karp argue that the "concept of 'power' as it is used by all peoples, encodes

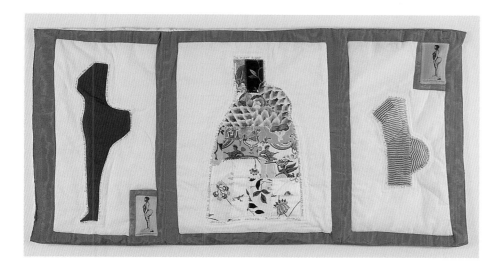

Figure 1 Deborah Willis, *The Hottentot Venus*, 1995, fabric and mixed media, 27 × 52 inches, Courtesy Bernice Steinbaum Gallery.

ideas about the nature of the world, social relations, and the effects of actions in and on the world and entities that inhabit it."[11]

It is therefore through the human agency of the artist—in this case, the artist of African descent—that deliberate choices were made to select easily accessible objects of humble and personal origin that would decidedly empower or activate the creative process and resolution of their imagery. Dominant cultures have always identified and prioritized icons of class, hierarchy and power. Among marginalized or disenfranchised groups the signs, symbols and effects of empowerment can often be hidden or camouflaged within plain view and deeply shrouded in secrecy. It is within the power and creative capacity of the artist as the human agent to transform the ordinary to the extraordinary—to take an object and reassign or amplify its original intent, use or meaning. Africanists Kris L. Hardin and Mary Jo Arnoldi, in their studies on African material culture, have observed that "each situation also implicates the use of objects in some way and when explored fully draws attention to the complex ways in which humans shape the material world as they are simultaneously shaped by that work. . . . Objects are one means then, by which humans shape their world, and their actions have both intended and unintended consequences."[12]

In the modernist tradition of collage, using mixed-media "cut-and-paste" techniques, Amaki has created narratives out of a wealth of personal, found, recycled, broken, obsolete, discarded and useless objects that tell stories, evoke memories, excite imagination and capture and recreate history in new and meaningful ways to artfully visualize the experiences of black life. Photography is an important vehicle of expression within Amaki's expansive series entitled *Three Cheers for the Red, White and Blue* (cats. 1–4, 6, 10–11, 13–17). Amaki interweaves cyanotype photographs of African American blues singers like Billie Holiday, Gertrude "Ma" Rainey, Ida Cox and Bessie Smith into compositions constructed from pieced commercial cloth that have images of the confederate and American flags or strips of cloth impregnated with burnt impressions from a household iron. These works are penetrating commentaries on the conditions of class, race and gender. Burnt-iron impressions and ironing boards have also been used by Willie Cole in his print series. Such domestic subject matter has also been used by Jacob Lawrence (1917–2000) and William Henry Johnson (1901–1970), who portrayed black working women ironing as symbols of power and domestic authority within the homes of both black and white families.

Amaki's work interrogates viewers with questions about survival, artistry, womanhood and the nature of what constitutes an American aesthetic. Similarly Deborah Willis, who is also a photographer-artist-scholar, uses mixed-media, pieced cloth and photographic transfers, in works such as *The Hottentot Venus* (fig. 1), to examine the tradition of "women's work" and the morbid fascination with the differences of the black female body. Amaki, Willis and Faith Ringgold defy the notion that the Western tradition of painting is the primary vehicle with the capacity to convey power and importance. Each has achieved, through the use of common materials and innovative photographic technology, a stylistic resolution fostering new aesthetic and artistic criteria.

Essence and Abstraction

All great, simple images reveal a psychic state.
Gaston Bachelard[13]

Amaki's inspiration also comes from the psychic remembrances of her childhood and home.

Philosopher Gaston Bachelard, in his seminal publication *The Poetics of Space,* has contemplated the subtle and nuanced elements found within the interiority of intimate space. Bachelard describes how the simple image of home elicits a psychic state or response that fills the memory with visions of poignant meaning. Often these memories come as fragments, vignettes or parts of an experience that are not always remembered in their exact or original occurrence. Visual artists have had to explore and invent means to recreate these visions of personal, cultural, spiritual or historical importance from materials and objects that were the most accessible—*stuff,* found within the interiority of their own personal spaces or regional locales. The term *stuff* has had particular meaning in the African American community since the 1800s, when its origin can be traced; stuff is "almost anything: sex, drugs, loose talk, money, etc.,"[14] including personal possessions that often have little or no monetary worth but carry great sentimental or personal meaning. Poet Clarence Major defines such African American slang as a "classic example of a secret tongue"[15] used to convey or protect private information within inner circles of the black community. Major further elaborates on the operations of this private language:

> **African American slang is not colloquialism; it is not dialect, not argot, not jargon or cant. Black slang is composed of or involves the use of redundancies, onomatopoeia, mispronunciations, and clipped forms. In this way, the collective verbal force of black speakers throughout many black communities in America carries on the tradition of renewing the American language—while resisting and using it.[16]**

Amaki is cognizant of this verbal practice, believing that "sight and sound exist in time and space," while "writing is an abstraction of sound."[17] Visual artists of African descent have had to find means to create imagery using the strategies similar to those of black language. Through the push-pull dynamic of resistance and engagement in the manipulation of artistic and technical processes, the black artist has created new aesthetic styles, visual language and secret meanings.

The essence of these innovations can be seen in the abstractions of Amaki's work that incorporates boxes, buttons and images of blues women. Among her other accomplishments Amaki is a sophisticated collector of a wide range of Americana with an emphasis on African American heritage, and she incorporates these artifacts into her compositions. In a series of candy boxes, the photographic images of famous women blues singers are placed on the top of heart-shaped boxes as in *Holiday Sweets* (cat. 49). Billie Holiday's photograph is surrounded with white mother-of-pearl and plastic buttons. A red ribbon is placed as a wrapping or a covering across her "sweets"— her breasts—and functions as a double signifier of bodily protection and sexual temptation or taboo. The abuses of the black body are rooted deeply and inextricably in the history and legacy of American slavery, the disenfranchisement of women's bodies and the negation of female intellect.

Amaki uses buttons to adorn and empower and to provide psychic healing for the profound disrespect women of African descent have endured, especially blues singers, who were an important part of Amaki's Southern upbringing. It is not incidental that buttons play such a powerful mediating role in Amaki's aesthetic. She vividly recalls, "My mother kept buttons around. People who grew up in the Depression saved everything. When we outgrew something, Mother cut off the buttons and the zippers and used the fabric for quilts. She had buttons we could handle and those we couldn't touch. That's why I'm attached to the pearl and bone ones. Those were special to her."[18] Buttons were precious in ways within African American culture that were largely missed by dominant cultural assessments. In slavery to have buttons on your clothes was a special sign of prestige, and buttons were often collected as personal family jewels. Buttons have often been found in the gravesites of African and African American slaves and have been attributed to the special element of prestige and status that was conveyed upon the deceased. Historians find buttons to be fascinating, if not obscure, cultural icons. Diana Epstein has studied this aspect of material culture and observes that "buttons are irresistible small relics, documents of art, craft,

history, and legend. It is necessary to set aside the association of buttons as trifles, to revise their image as everyday fasteners, and to restore to them the importance, splendor, and exclusiveness that made them luxury items through the eighteenth century."[19] Amaki's buttons are resplendent; these gems and semiprecious jewels adorn the sacred objects she creates to pay homage to the prestige of her subjects. They also honor the memory and legacy of her mother with extraordinary imagination, innovative artistry and remarkable craftsmanship.

The use of cloth is also crucial to the aesthetic reality of Amalia Amaki's vision. Children of Depression-era parents are left with an indelible imprint of how to respect the most ordinary and humble possessions and objects. Cloth is a life-essential material that historically has played a crucial role, not only defining the culture, but becoming a primary vehicle to express technical prowess, artistic genius as well as other worldly powers. For example among the Bunu Yoruba people of central Nigeria, cloth is used as a medicine to heal. Africanist scholar Elisha P. Renne has observed that "white cloth conveys a sense of unity and interconnectedness among personal, social, and natural domains. Some types of illness, conceptualized as disruption in the connection between these spheres, may be remedied through the use of white cloth."[20] Amaki's work and use of white buttons and cloth can be viewed as a metaphoric device to heal the "disruption" and the damage that was inflicted upon blues women. Amaki's use of these particular materials heals and elevates these women whom she reveres as "renegades. . . . It's not every teenager that could decide like Billie Holiday that she was going to control her economic destiny."[21] Amaki's visual creations are as radical in concept as were the behavior, lives and achievements of the women she chooses to *re*-envision.

The potent presence of *stuff* in the works of artists Renée Stout, Aminah Brenda Lynn Robinson and Elizabeth Talford Scott attests to the ancestral power of African retentions in the utilization of materials, moral intent, spiritual beliefs and commitment to family and community. There are in fact conceptual and visual links to BaKongo traditions, which came to the New World during the slave trade in the form of *minkisi,* which were made for purposes of communal healing.[22] Sylvia Williams, former Director of the National Museum of African Art, notes that "one should not be surprised to find that here and there fragile fragments of custom and belief have survived; survived, perhaps in response to new changes and crises. The visual reality, however, was transformed."[23]

Within this transformative, cathartic New World reality, these artists responded to the immediacy of their experiences with readily available

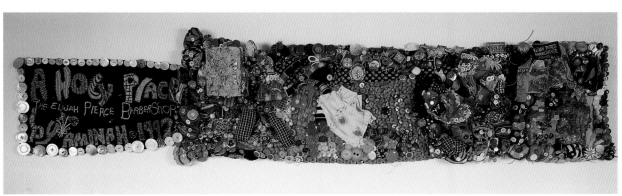

Figure 2 Renée Stout, *Fetish #1*, 1987, monkey hair, nails, beads, cowrie shells and coins, 12 × 3½ × 3½ inches, Dallas Museum of Art, gift of Roslyn and Brooks Fitch, Gary Houston, Pamela Ice, Sharon and Lazette Johnson, Maureen McKenna, Aaronetta and Joseph Pierce, Matilda and Hugh Robinson and Rosalyn Story in honor of Virginia Wardlaw.

Figure 3 Aminah Brenda Lynn Robinson, *A Holy Place*, 1984–1993, mixed media, 17 × 67½ inches, Columbus Museum of Art, Ohio, gift of the artist in memory of her son, Sydney Edward Robinson (1967–1994), 1993.005. © Aminah Brenda Lynn Robinson/Licensed by VAGA, New York, NY.

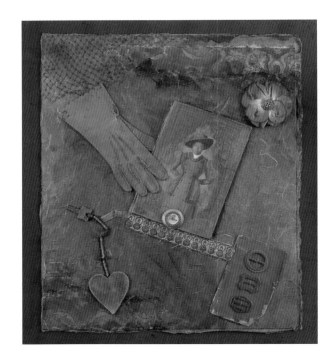

Figure 4 Betye Saar, *Miss Ruby Brown,* **2001, mixed-media collage on paper, mounted on paperboard, 24⅜ × 20¼ × ½ inches, Courtesy Michael Rosenfeld Gallery, LLC, New York, NY.**

materials and created works that reflected their lives. During the 1990s Renée Stout created a profound series of *minkisi*-like works incorporating a mélange of media, collage and bricolage, inspired by her first encounters with BaKongo practitioners in museums (fig. 2).[24] This experience was similar to Amaki's studied observations of African aesthetic practices. Aminah Brenda Lynn Robinson re-envisions and transforms the same use of materials to create panoramic button, beaded, quilted RagGonNons, which are visual and verbal puns drawn from the fragments of African technical practice and African American slang (fig. 3). Robinson draws from the vast pool of these cultural legacies to define the RagGonNon as a "rag on and on."[25] The essence of her abstractions takes on new and different statements regarding the ordinary object and the collective potency of the material stuff she has transformed into iconic family jewels.

The idea of family jewels and heirlooms in the Africanist American sensibility can be seen in Amaki's candy boxes, which create sweets from buttons that are affixed in shaped boxes or "served" on trays, as in *Truffles (Delight)* (cat. 56), *Candy Box* (cat. 23) and *Nuts and Chews* (cat. 51). In similar work Amaki employs the symbol of a fan—a staple in the Southern black church, used to cool oneself during the long, hot Sunday

services in the summer. Amaki embellishes the actual fan with multiple rows of buttons surrounding the shape like a radiating halo. She places photographs within the composition, as in *Dream Fan* (cat. 55) and *Lovers* (cat. 35), which heightens the feeling of nostalgia and sentimental memories. A similar approach can be seen in the work of Betye Saar, who reverses the maximal application of buttons as executed by Robinson and Amaki to a minimal placement of buttons as in her aunt's portrait, *Miss Ruby Brown* (fig. 4)—an elegant statement of dignity, personhood and beauty.

Family, community and its connection to the legacy of survival from slavery have been issues of significant and justifiable hypersensitivity to African Americans, given the particularly harsh circumstances in which families were constantly torn apart, sold off or forced to live under dire conditions even long after the abolition of slavery. Amaki has strong roots in her family and community and shares this legacy with the remarkable mother and daughter artists Elizabeth Talford Scott and Joyce Scott. Amaki, like the Scotts, shares a strong Southern heritage, a love of family and community and a deep sensitivity to materials of humble origin. Elizabeth Scott was born in South Carolina and learned to quilt from her mother and many sisters. In the later years of her life, the traditional quilts she made began to transform, evolving into new mediated ways of crafting narratives about her memories; she used systems of knots, rocks, buttons, beads, ribbons, shells and metallic fabrics to create works that were often designed as visual stories and, as C. Daniel Dawson describes, "family medicine,"[26] as in *Flower Garden* (fig. 5).

Amaki and Joyce Scott share a love of music, materials, lifestyles and an exceptional facility to intellectually and conceptually extract and manipulate the breadth of global art traditions to create, as Amaki states, an "art that is a gateway for the viewer to express new ways of seeing."[27] In Scott's *P-Melon* (fig. 6) she uses blown glass beads, paint and thread to question the issues of identity; as Scott explains, the subject is "trapped within her own sexuality, we're all trapped in gender, race, and class if you believe you have

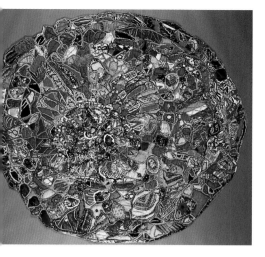

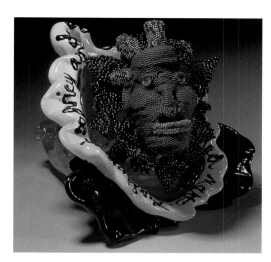

Figure 5 Elizabeth Talford Scott, *Flower Garden,* 1994, knotted fiber and threads, 72 × 72 inches, Courtesy the artist.

Figure 6 Joyce Scott, *P. Melon,* 1995, blown glass, beads, paint and thread, 11 × 14 × 8 inches, Courtesy the artist.

no freedom of choice and are under the weight of other people's suggestions about what you are."[28] Amaki belongs to a sacred community of fearless artists who see their future and their historical legacy as part of not just America, but the larger universe. It is now up to the mainstreams of the art world to rise to the challenge of these transformative *re*-visionists who speak volumes about the role of women and people of African descent in the new horizons of the twenty-first century.

Notes

1. Toni Morrison, *Playing in the Dark: Whiteness and the Literary Imagination* (Cambridge: Harvard University Press, 1992), 65.

2. Michele Wallace, "Why Are There No Great Black Artists? The Problem of Visuality in African-American Culture," *Black Culture,* Dia Center for the Arts (Seattle: Bay Press, 1992), rpt. in Michele Wallace, *Dark Designs and Visual Culture* (Durham: Duke University Press, 2004), 191.

3. Amalia Amaki, quoted by Catherine Fox, "Collages are not button-down art: Amalia Amaki savors the familial intimacy of common treasures," *The Atlanta Journal-Constitution,* March 20, 1994, N2.

4. Lisa E. Farrington, *Creating Their Own Image: The History of African American Women Artists* (New York: Oxford University Press, 2005), 8.

5. Wallace 191.

6. Ibid. 186.

7. Lisa Gail Collins, *The Art of History: African American Women Artists Engage the Past* (New Brunswick: Rutgers University Press, 2002), 1.

8. Edward Levine, "60 Ways of Looking at a Black Woman," *The New York Times,* Art and Leisure, 31.

9. Morrison 7.

10. W. Arens and Ivan Karp, eds., *Creativity of Power: Cosmology and Action in African Societies* (Washington: Smithsonian Institution Press, 1989), xii.

11. Ibid.

12. Mary Jo Arnoldi, Christraud M. Geary and Kris L. Hardin, eds., *African Material Culture* (Bloomington: Indiana University Press, 1996), 1.

13. Gaston Bachelard, *The Poetics of Space: The Classic Look at How We Experience Intimate Places,* 1969 (Boston: Beacon Press, 1994), 72.

14. Clarence Major, ed., *Juba to Jive: A Dictionary of African American Slang* (New York: Penguin Books, 1970), 455.

15. Ibid. xxviii.

16. Ibid. xxx.

17. Amalia Amaki, panel discussion on "Telling Tales: Narrative Threads in Contemporary African American Art," Delaware Center for the Contemporary Arts, December 3, 2004.

18. Amaki, quoted by Fox.

19. Diana Epstein, *Buttons* (New York: Walker and Company, 1968), 9.

20. Elisha P. Renne, *Cloth That Does Not Die* (Seattle: University of Washington Press, 1995), 38.

21. Andrea D. Barnwell, "Amalia Amaki's Blues Women," *Women in the Arts* (Holiday 2003): 24.

22. See Wyatt MacGaffey's comprehensive essay, "The Eyes of Understanding: Kongo Minkisi," in *Astonishment and Power: Kongo Minkisi and the Art of Renée Stout* (Washington: Smithsonian Institution Press, 1993), 21–106.

23. Ibid. 14.

24. Ibid. For a full discussion of the relationship, see Michael D. Harris, "Resonance, Transformation, and Rhyme: The Art of Renée Stout," in *Astonishment and Power,* 107–156.

25. For a more complete discussion of the RagGonNon, see Leslie King-Hammond, "Aesthetic Realities /Artistic Vision: Aminah Brenda Lynn Robinson," in *Symphonic Poem: The Art of Aminah Brenda Lynn Robinson* (Columbus, Ohio: Columbus Museum of Art; New York: Harry N. Abrams, 2002), 49.

26. C. Daniel Dawson, *Family Medicine: The Art of Elizabeth Talford Scott* (Washington: Smithsonian Institution, 1997).

27. Amaki, panel discussion.

28. Joyce Scott, quoted in *Joyce J. Scott: Kickin' It with the Old Masters* (Baltimore: Baltimore Museum of Art, 2000), 43.

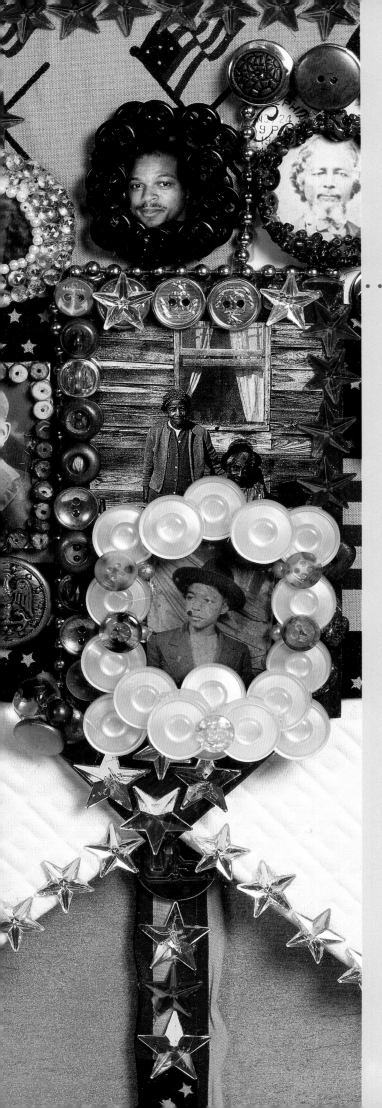

Amalia Amaki's Curio Cabinet

Andrea D. Barnwell

Throughout her career, Amalia Amaki has explored her ongoing interest in how photography, film and manipulated images alter and impact the history of visual culture.[1] It is, therefore, not surprising that surrealists, especially Man Ray, inform her work. An examination of a cross section of Amaki's art reveals that souvenirs are vital components within her exploration. Although she has incorporated handheld fans and postcards into more than one hundred works, discussions of Amaki's art focus primarily on her innovative use of buttons, beads, cyanotypes, flags and photographs of anonymous subjects. The overarching significance of handheld fans and postcards—souvenirs that are equally important signatures of her work—has not been adequately considered.

For more than three decades Amaki has created art that supports her aim to highlight and comment on the normalcy of African Americans.[2] Discussing the influences that initially prompted Amaki to consider souvenirs as points of departure, this examination focuses on two specific bodies of her art—a group of buffalo soldier fans and a series of mixed-media photographs based on vintage postcards of two black children performing. This discussion examines how souvenirs became vehicles through which Amaki investigates overlapping and seemingly disparate subjects, explores popular perceptions and challenges national, social and artistic histories.

Throughout this discussion, "souvenir" is used as a categorical term that intentionally suggests items created for trade and invokes memory and commemoration. This discussion is informed by Susan Stewart's premise that souvenirs act as sites where the exterior collides with the inner self and where personal narratives intersect with historical accounts. It is also guided by the idea that souvenirs must be removed from their original contexts in order to serve as traces of them.[3] The handheld fans that Amaki includes in her work serve as traces of spirituality. The vintage postcards that she incorporates are markers of unfamiliar yet equally as compelling turn-of-the-century contexts. Together these souvenirs are vehicles through which Amaki moves beyond trinkets and decorative objects to disrupt the boundaries between craft and fine art.

Handheld fans—staples in black churches in the South—are recurring souvenirs in Amaki's work. They conjure a variety of images: funerals, the funeral homes that advertise on the backs of fans, overcrowded sanctuaries that seemingly combust due to the heat generated by emotion, elder women in big hats and the registered nurses wearing all-white uniforms who are on hand to cool and revive members of the congregation who are overcome by the spirit and subsequently faint. Fans, available in various sizes and shapes, are souvenirs that evoke black churches in general as well as the Wheat Street Baptist Church where Amaki's family worshiped.

A native of Atlanta, Amaki recalls that Wheat Street Baptist Church was one of the few churches in the city that had air conditioning— a cool air circulating system used in conjunction with a large, round drumlike fan. While this air conditioning did not compare to early twenty-first-century systems, Amaki explains that the Wheat Street sanctuary was markedly cooler than many other churches. Despite the fact that the church maintained a comfortable temperature, fans were placed in the pews each Sunday. Amaki has always been amused by the idea that fanning enables the user to express emotion, style and character. Growing up she observed the differing ways in which people handled fans. An elder woman wearing a big hat, for example, might fan herself with slow, broad, deliberate strokes, as opposed to a young man who might hold the handle closer and enact a cool vertical wave. His way of fanning might vary from that of a young woman making quick, short strokes. As in many churches, members of the congregation fanned themselves during the service and raised their fans to demonstrate their endorsement of the minister's sermon.

In Amaki's community the function and life of fans persisted long after the service ended. It was commonplace to talk about the sermon after church while fanning oneself with the fan that had been distributed in church. It was typical to use the same fan all week and return to church with it the next Sunday. Therefore, beginning at a very young age, Amaki was a captive audience and a member-participant in fanning —a performance-based ritual that was often more about articulating one's spirituality than cooling off.

For Amaki fans are not only accessories but, rather, powerful souvenirs that act as the mark of spirituality, conviction, the power of prayer and an unwavering relationship with God. Though spirit and spirituality defy definitions and rely on blind faith, the need to articulate their power remains. In her introduction to *My*

Soul Is a Witness: African-American Women's Spirituality, Gloria Wade Gayles explains:

Like the wind, it [spirit] cannot be seen, and yet, like the wind, it is surely there, and we bear witness to its presence, its power. We cannot hold it in our hands and put it on a scale, but we feel the weight, the force, of its influence in our lives. We cannot hear it, but we feel ourselves speaking and singing and testifying because it moves, inspires, and directs us to do so.[4]

Amaki reveals that for her spirituality is a way of life, a framework and a means of knowing. A symbol of how spiritual people conduct themselves, fans helped concretize the visual picture of spirituality. For this reason Amaki's eventual decision to incorporate souvenir fans into her work was the result of a natural progression.

In the late 1970s Amaki traveled to Spain and Mexico. Although these trips were primarily vacations, they afforded her the chance to see how fans were carried, used and worn in other parts of the world. In 1976, for example, she took a three-week trip exploring Madrid, Barcelona, Pamplona and Seville with a Spanish friend. The women who danced with fans of various shapes and sizes were particularly fascinating. The way in which Spanish dancers handled their fans was clearly informed by their specific cultures, yet their performances harkened back to Amaki's worship experiences, intriguing her. While black church fans remained of specific interest, the appeal and treatment of fans in Spain compelled her to start collecting them. Beginning in 1978 while studying photography and art history at the University of New Mexico, where she earned a bachelor of arts degree, Amaki noticed fans on a regular basis during Albuquerque's many festivals and celebrations. Taking advantage of being in close proximity to Mexico and traveling to Mexico City, Guadalajara and Juarez, she observed that fans were carried and worn as part of everyday attire.

In 1989 Amaki acted on her sustained and widespread interest in handheld fans and started working on a series of ten mixed-media works with fans as their foundations. Each work was inspired by film noir titles such as *Vigil in the Night, All Mine to Give* and *Shadow of a Doubt*, and each included photographs of anonymous African American subjects. They were also informed by Amaki's ongoing fascination with Man Ray and the relationships that he established in his photographs and surrealist films. She approached this body of fan-based work as an opportunity to respond to his art and further explore the correlations that he proposed through his work. While Amaki transformed fans from pliable, two-dimensional forms to delicate works with imaginative surface textures, she also combined and explored her long-standing interests in surrealism, appropriated images, film, popular culture and spirituality. Securing them in cases and in locked shadow boxes, she created fan-based works that had spiritual and artistic depth. Working on two or three fans simultaneously, Amaki completed the series in 1990. Thoroughly engaged by their shapes, compelled by the idea that fans functioned as more than mere tropes and excited by the multiple connotations that they evoke, Amaki was certain that she would revisit this series and incorporate fans into her work for years to come.

In 1996 Amaki began working on her second series of fans—a group of thirty photo-based works aptly titled *Fan Series* that incorporated buttons, beads, flags and photographs (fig. 1). She continued investigating themes such as race, nation, sacrifice and belonging. Likewise, she pursued the technical ideas she had explored in the first fans. Resuming this series, Amaki investigated powerful, relevant topics that, due to design, oversight, neglect, institutionalized racism or accident, have not been adequately addressed. Since then fans have remained a consistent presence within her work.

It is useful to note that Amaki was developing her series of quilts titled *Three Cheers for the Red, White and Blue* at the same time that she was developing *Fan Series*. Although the quilts do not incorporate fans, the conceptual and aesthetic links between the two series underscore how Amaki was developing and creating works in a variety of media that address blues

women, history, patriotism and popular representations of black people. *Three Cheers for the Red, White and Blue #1* (cat. 1), a tribute to Billie Holiday on three banner-like panels, incorporates repeated images of the jazz singer's signature promotional photograph. The faint red, white and blue Xs down the center of the piece, which cover Holiday's face, clearly suggest the racial prejudice and injustices that she endured despite the fact that she is credited with making jazz the bedrock of American culture. Holiday, Bessie Smith, Alberta Hunter and Gertrude "Ma" Rainey became the protagonists of several quilts. Amaki's aim was to depict them as powerful women rather than defeated victims. Amaki was aware that at that time biographies of African American women blues singers and their lyrics were unapologetically linked to love, longing, drug addiction, extramarital affairs, crime, domestic violence and overt sexuality.[5] Through this series Amaki asserted that blues women are the innovators and principal agents of an internationally regarded form of American music. Quilts and flags are common examples of Americana. Employing

satire, ironic references to the American flag and manipulated images of the women that she has dubbed "renegades," the artist challenges and disrupts deeply imbedded perceptions such as patriotism and the American way.

Amaki's blues quilts are collectively linked to her series of buffalo soldier fans because of the provocative ways in which they call perceived norms into question. A subset of *Fan Series,* buffalo soldier fans foreground the African American soldiers assigned to various posts on the Western frontier beginning in 1865. After the Army Reorganization Act of 1866, two cavalry regiments and four infantry regiments were created for African American soldiers.[6] Stationed from the one-hundredth meridian to the Pacific Coast and from Canada to Mexico, these segregated regiments were scattered in posts throughout the American West. The cavalry's primary responsibility was to suppress Indian resistance and make the frontier safe for white settlers in the late nineteenth century. Infantrymen, support groups to cavalrymen, devoted their attention to a variety of skilled and unskilled jobs including guarding military forts, erecting buildings, installing and maintaining telegraph lines and building military roads.[7]

In *Buffalo Soldier Fan #1* (cat. 5), *Buffalo Soldier Fan #2* (cat. 7) and *Buffalo Soldier Fan #6* (cat. 19) Amaki reinforces the honor and distinction with which African American soldiers served. Encrusted with images, postal stamps, flags, postcards and brass buttons with eagle emblems, the souvenirs, which serve as the foundation for these assemblages, are barely recognizable. Amaki pays tribute to the buffalo soldiers whose contributions irrevocably altered the history and size of the United States. Her inclusion of images of anonymous people who are not identifiably servicemen as well as more familiar subjects such as Bill Pickett suggests that buffalo soldiers are metaphors for African American involvement, commitment, talent, ingenuity and sacrifice on the Western frontier and beyond.[8]

In her buffalo soldier fans, as in her blues quilts, Amaki subtly challenges commonplace ideas such as American pride, honor and glory through

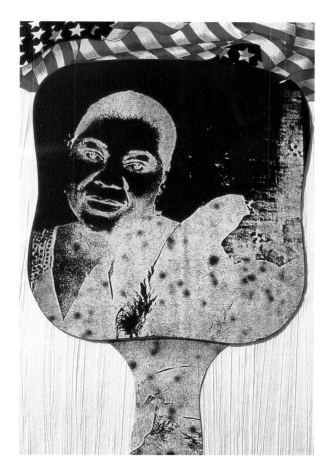

Figure 1 Amalia Amaki, *Fan Series, Ghost Fan*, 1996, reworked to become *Bessie Fan* (cat. 18).

her use of the American flag. While the stars and stripes in these pieces clearly represent the American flag, the maroon, white and blue fabric suggests that aspects of this legacy are under-discussed, truly off-color and perhaps not as they appear at first glance. In other words while red, white and blue flags were waved as the ultimate symbols of freedom, they also cloaked injustices that blacks endured in the military, specifically, and in America, in general. Likewise, the not-quite-right colors in Amaki's work also allude to the Native American struggle to hold on to the Great Plains. The mass sequestering of Native Americans to reservations and the ongoing discrimination against African Americans are among the ironies and desperations to which her art alludes. En-cased and presented in locked boxes, Amaki's buffalo soldier fans allude to sacred traditions such as draping the coffins of fallen soldiers with American flags and presenting flags to families of soldiers who have died at war. These compelling works are tributes to honor and life lost.

Employing fans as the foundation of these spe-cific works irrevocably links spirituality, belonging and nostalgia. Although Amaki engages a wealth of art historical, social, political, economic and cultural ideas in her work, fans are important symbols through which she articulates her funda-mental belief system. Influenced by all of these factors, she addresses the substance, hopes, fears, pressures, histories and ironies that affect the experiences of African Americans. Fans are not mere motifs in Amaki's work; they connect cen-tral ideas to a community of spiritual people that communally worship, seek to make sense of (or at least peace with) the world's inconsistencies and inequities and, most importantly, rely on contin-ued guidance and mercy. Even after completing thirty works in *Fan Series,* Amaki continues to incorporate fans in her art.[9] In addition to articu-lating the triumphs, tragedies, honor and ironies of several well-known African Americans, fans remain a vantage point from which she chal-lenges commonly held beliefs and perceptions.

Amaki has always been compelled by the simpli-city and formal qualities of postcards. The idea that someone could send a private message that any-one could access, while only the recipient would

appreciate the complete significance, continues to intrigue her. For Amaki these souvenirs achieve the "equivalent of having a private conversation in public. No one is offended; no one feels left out."[10] An avid enthusiast of postcards—especially those from the 1920s, 1930s and 1940s—Amaki has amassed an extensive collection. Many include whimsical images or casual salutations such as "Dear Little Friend" or "A Token of Great Regard." She first included them in her work in 1978.

I'd Rather Two-Step (cat. 21), a richly textured mixed-media photograph is based on a suite of vintage picture postcards published around 1900.[11] In the large diptych of sepia photographs, child performers wearing coordinated costumes orchestrate elaborate dance moves, strike dra-matic poses, effortlessly perform for the camera and exude charisma. While their interaction is compelling, the collaged surface of the picture plane, which is encrusted with individually adhered pearls, small photographs, strands of faux gems and countless buttons, is equally as engaging. The intensely worked surface affiliates the children with unparalleled attention to detail and tailor-made care. By using innovation, con-tinuing her ongoing exploration of manipulating images, expanding the souvenirs beyond their original 3 × 5 format and creating richly textured surfaces, Amaki responds to this rich source mate-rial, creates new associations for the subjects and brings them into her own lexicon.

In the left side of the diptych, the young boy orchestrates an elaborate pose while his dance partner arches backward and makes direct eye contact with the viewer. Above them, layers of individually applied smooth, pearl buttons are built up to create a heavily encrusted picture plane. Four smaller photographs of the children dancing hover around the girl's head each out-lined with a circular frame of buttons. The shape of a fan—one of Amaki's signature emblems—is superimposed on the boy's chin and torso. The juxtaposition of a photograph of a black child shrouded in a circular frame of buttons and the young Native American girl on the fan prompts questions about what their relationship to one another—as well as with the dancers—might be. By linking subjects that do not have an apparent

association with one another, Amaki calls into question perceptions of heritage, lineage and intermingling backgrounds. Multiple images of the black baby and the principal subjects are duplicated across the mixed-media work. Arranged in this format, they clearly invoke 35mm film negatives and motion pictures.

The collaged strip of photographs melds into the right side of the diptych where the dancing young girl performs alone. With her eyes closed, she strikes a dramatic pose and seems to revel in the act of being shrouded in a sea of countless buttons. From the arch of white and pearl buttons that frames her face to her button-encrusted shoes, the bejeweled fasteners heighten her theatrical gesture and conjure countless musings: decoration, adornment, "button, button, who's got the button" and other children's games, hand-me-downs, recycled fasteners from previously worn garments and "there's no place like home." From her fingertips she releases a series of miniature images of herself striking the identical pose. Resembling a deck of trick cards, they

too are outlined with buttons. Her attire, complete with a sash, fashionable jewelry and soft-sole shoes, coupled with the personality that she projects encourage curiosity about who she might be.

The series of vintage postcards upon which *I'd Rather Two-Step* is based includes the same two children who appear in at least twelve poses (figs. 2–3).[12] Their charisma and ability to exude the personalities of seasoned entertainers captivated Amaki the moment she saw the postcards at a trade show in 1991. The postcards featuring the girl handling a fan—a symbol with which Amaki's art had already been associated—were especially alluring. This series, which is based on actual photographs, differed dramatically from the majority of the postcards in her collection, which are drawn or painted. In contrast to handheld fans, with which Amaki had a personal relationship, this suite of turn-of-the-century postcards was unfamiliar to the artist. For all of these reasons, Amaki knew right away that these uncommon

Figure 2 Le Cake-Walk postcard, ca. 1900, 142/10.

Figure 3 Le Cake-Walk postcard, ca. 1900, 142/4.

source materials would ultimately become the subject of an extensive body of work.

Intentionally seeking out this series of postcards, Amaki located examples where senders had written on both sides of the postcards. In other instances the children's clothing and shoes had been hand-tinted (figs. 4–5). In several examples the senders wrote general handwritten messages to the addressees (figs. 6–8). The children's ability to strut and theatricalize, impersonate adults and further exaggerate the cakewalk appeals to most who view them. They have elicited reactions and speculation: "I'm pretty sure they're from Martinique." "I believe they're from Senegal." "They look related, but I doubt if they're brother and sister." The desire to create identities and contexts for the children was a strong impulse for Amaki. She has created countless works that incorporate photographs of anonymous subjects. However, no other images have prompted her to revisit them over a period of ten years or to create more than thirty mixed-media photographs. Several

examples from this series are Amaki's most compelling pieces to date.

The original success, context and subjects of these postcards are currently unknown. The caption at the bottom of each postcard provides brief contextual information: "LE CAKE-WALK, Dansé au Nouveau Cirque, LES ENFANTS NÈGRES." The identification number and the initials S. I. P.—an abbreviation for Salon I., Paris—in the lower left- and right-hand corners respectively do not shed any additional light on who the children might be.[13] Since viewing stereographs of tourist sites and foreign peoples became a popular form of entertainment as early as 1854 in France, it is also possible that these postcards were exchanged and viewed for entertainment purposes.[14] Considering that the postcards were published around 1900, during the golden era of the postcard craze, and since postcards with the postmark are sought-after collectors' items, it is likely that they served as historical documents and mementos for audiences that saw a theatrical production of Le Cake-Walk at the Nouveau Cirque. Publishers would

Figure 4 Le Cake-Walk postcard with hand-tinting, ca. 1900, 142/9.

Figure 5 Le Cake-Walk postcard with hand-tinting, ca. 1900, 142/2.

Figure 6 Le Cake-Walk postcard with handwriting, ca. 1900, 142/5.

Figure 7 Le Cake-Walk postcard with handwriting, ca. 1900, 142/1.

Figure 8 Le Cake-Walk postcard with handwriting, ca. 1900, 142/8.

have wanted them to serve as souvenirs and marketing materials that were mailed and widely distributed.

Amaki's principal interests are not examining how black dance has historically been presented in postcards, the popular and critical reception in Paris to performances at the Nouveau Cirque at the turn of the century or the profound influence of all-black shows that were touring the United States at that time. However, it bears noting that the publication of postcards of "Les Enfants Nègres" in 1900 coincided with the decade when the cakewalk became an international phenomenon. The cakewalk—a dance described as a smooth walking step with the body held erect—originated as a parody whereby slaves mocked owners who danced a minuet and then paraded in a grand march.[15] As the dance became more satirical, a backward sway was added, and the movement became a dancing strut.[16] Reveling in the idea that they had become a spoof, slave owners devised cakewalking contests and staged performances to entertain their guests.[17] Around

1890 as black dancers, singers, comedians, composers and directors began playing significant roles in minstrel shows, the cakewalk became a mainstay of all-black theatrical productions.[18]

I'd Rather Two-Step was the first of many works in a series that was inspired by the vintage photographs. Amaki, compelled by the young performers' magnetism, created other contexts for them and reinvented them again and again. *Kids Dancing in a Red Knowing* (cat. 66), *Les Enfants* (cat. 25) and *I'd Rather Two-Step Than Waltz* (cat. 50), which also include fans, buttons, photographs of anonymous African Americans and Native Americans, details of a well-known photograph of Madame C. J. Walker, superimposed over the children's faces in a masklike fashion, and other collaged items, demonstrate the innovative ways in which Amaki reinvents the postcards and manipulates them beyond their original presentation.

Amaki's works that incorporate handheld fans, vintage postcards and other souvenirs are united

LE CAKE-WALK
sé au Nouveau Cirque. *LES ENFANTS NÈGRES.* S.I.P.

LE CAKE-WALK
Dansé au Nouveau Cirque. *LES ENFANTS NÈGRES.* S.I.P.

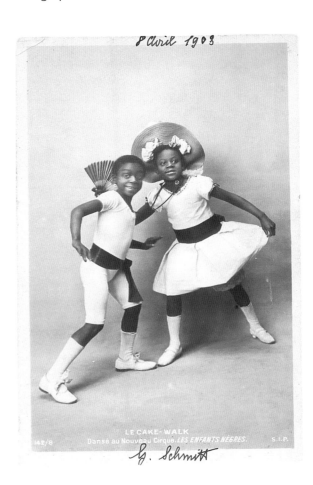

LE CAKE-WALK
Dansé au Nouveau Cirque. *LES ENFANTS NÈGRES.* S.I.P.

Amalia Amaki's Curio Cabinet

by her ongoing fascination with manipulating images, her desire to create new contexts and her ability to convey meaning in unconventional ways. Souvenirs typically connote items created for trade, tourism and transcultural encounters. Although the handheld fans and postcards that Amaki incorporates into her work mark specific events, they are not static relics, trinkets, mementos or curiosities. Working in concert with buttons and photographs of anonymous subjects, they are the vehicles through which she creates alternate and perhaps unconventional meanings. Amaki's ability to transform them from commodities that mark an event or a time period into works of art is based on her innovative combination of art training, an informed vision and a bounty of personal encounters. Amaki is certain that these souvenirs will recur within her work. Fans that incorporate Alberta Hunter (her mother's closest friend) and Bessie Smith are among the works currently in progress. Likewise, Amaki has not completed her investigation of the suite of vintage postcards. Ultimately, her souvenir-based art is intensely worked and complex. These works seem to mirror her upbringing in a close-knit family that was rooted by values, moral wisdom, ethics, intergenerational dialogue, a profound support of individual potential and a belief in community. They enable her to explore her artistic vision, incorporate the fundamental frameworks that continually guide her path and move outside and beyond the curio cabinet.

Notes

1. This essay is in part based on interviews and conversations I have had with Amalia Amaki. I am grateful to Anne Collins Smith for reading several versions of this essay. Kirsten P. Buick, Arnie Epps and Bill Gaskins also lent invaluable suggestions and support.

2. See Catherine Fox, "Collages are not button-down art: Amalia Amaki savors the familial intimacy of common treasures," *The Atlanta Journal-Constitution*, March 20, 1994, N2.

3. Susan Stewart, *On Longing: Narratives of the Miniature, the Gigantic, the Souvenir, and the Collection* (Baltimore: Johns Hopkins University Press, 1984). See also Ruth B. Phillips, *Trading Identities: The Souvenir in Native North American Art from the Northeast, 1700–1900* (Seattle: University of Washington Press, 1998), 4–9; and Dean MacCannell, *The Tourist: A New Theory of the Leisure Class* (New York: Schocken Books, 1976).

4. Gloria Wade Gayles, *My Soul Is a Witness: African-American Women's Spirituality* (Boston: Beacon Press, 1995), 2.

5. See Angela Y. Davis, *Blues Legacies and Black Feminism: Gertrude "Ma" Rainey, Bessie Smith, and Billie Holiday* (New York: Vintage, 1999).

6. The Army Reorganization Act of 1866 provided for the ninth and tenth cavalry regiments and the thirty-eighth, thirty-ninth, fortieth and forty-first infantry regiments to be for black enlisted men. The Army Reorganization Act of 1869 combined the four infantry regiments into two.

7. See Monroe Lee Billington and Roger D. Hardaway, *African Americans on the Western Frontier* (Niwot: University of Colorado Press, 1998); and T. G. Steward, *Buffalo Soldier: The Colored Regulars in the United States Army* (New York: Humanity Books, 2003). Several reasons have been offered for how the term "buffalo soldiers" originated. One popular explanation posits that Indians gave black soldiers the name because their hair color resembled buffaloes. Others suggest that the Indians, out of respect for the soldiers' fighting prowess, likened them to noble buffaloes.

8. Bill Pickett was the cowboy from Oklahoma who invented the rodeo event of bulldogging and performed it across the United States and in several foreign countries.

9. Amaki also created two large-scale fans: *Number One Fan #1* (1995), which is in the collection of the Atlanta Hartsfield-Jackson International Airport, and *Number One Fan #2* (cat. 8), which is featured in this exhibition.

10. Amalia Amaki, interview by Andrea Barnwell, August 12, 2003, Atlanta, Georgia. See also Andrea Barnwell, "Amalia Amaki's Blues Women," *Women in the Arts* (Holiday 2003), 24.

11. J. L. Mashburn, author of *Black Americana Postcard Price Guide: A Century of History Preserved on Postcards*, dates the cards from 1910 to 1915. The records from Amaki's purchase explain that they were originally sold as early as 1900.

12. Amaki also discovered postcards in this series of a man impersonating a woman who poses next to a young boy wearing a fake mustache and dressed as an adult in an oversized pinstriped suit.

13. J. L. Mashburn, e-mail to author, December 12, 2004.

14. See William C. Darrah, *The World of Stereographs* (Gettysburg: Darrah, 1977).

15. Jacqui Malone, *Steppin' on the Blues: The Visible Rhythms of African American Dance* (Urbana: University of Illinois Press, 1996), 18.

16. Lynne Fauley Emery, *Black Dance from 1619 to Today* (Princeton: Dance Horizons, 1972), 208.

17. See Tom Fletcher, *100 Years of the Negro in Show Business!* (New York: Burdge, 1954); and Emery 91.

18. Large all-black road shows such as *The Creole Show* (1889), *South Before the War* (1891) and *The Octoroons* (1896) each featured elaborate scenes with cakewalks and effectively catapulted the energetic line dance into an international phenomenon. By the end of the nineteenth century the cakewalk's popularity "equaled that of the Charleston in the twenties and the lindy [hop] in the thirties" (Malone 71–72).

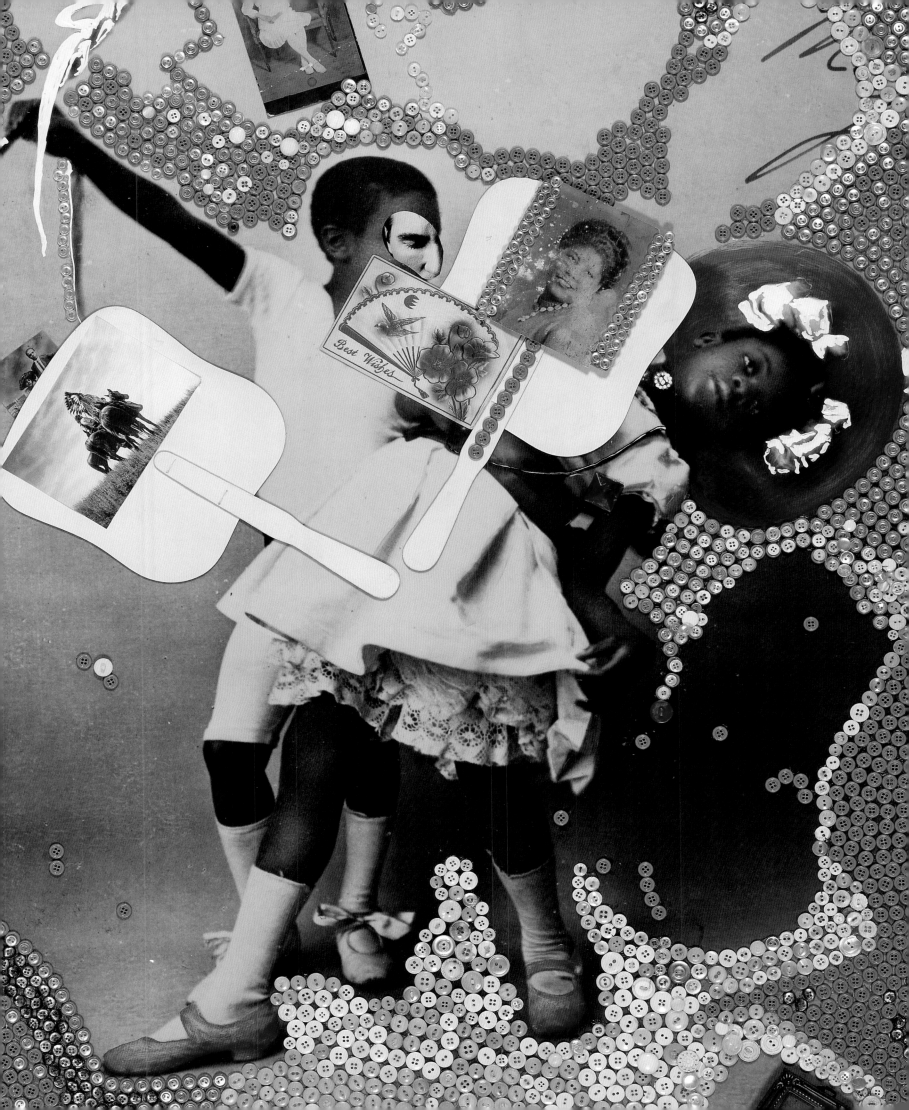

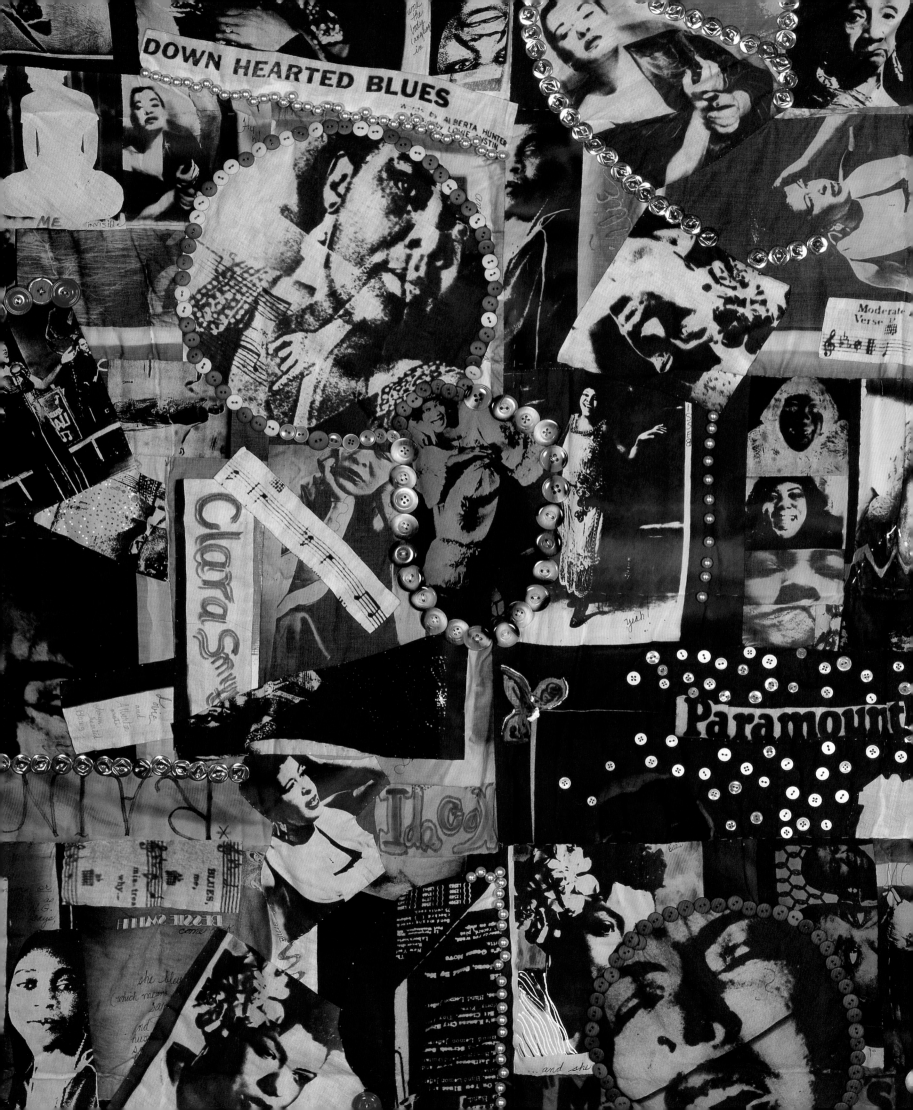

Catalogue
of the Exhibition

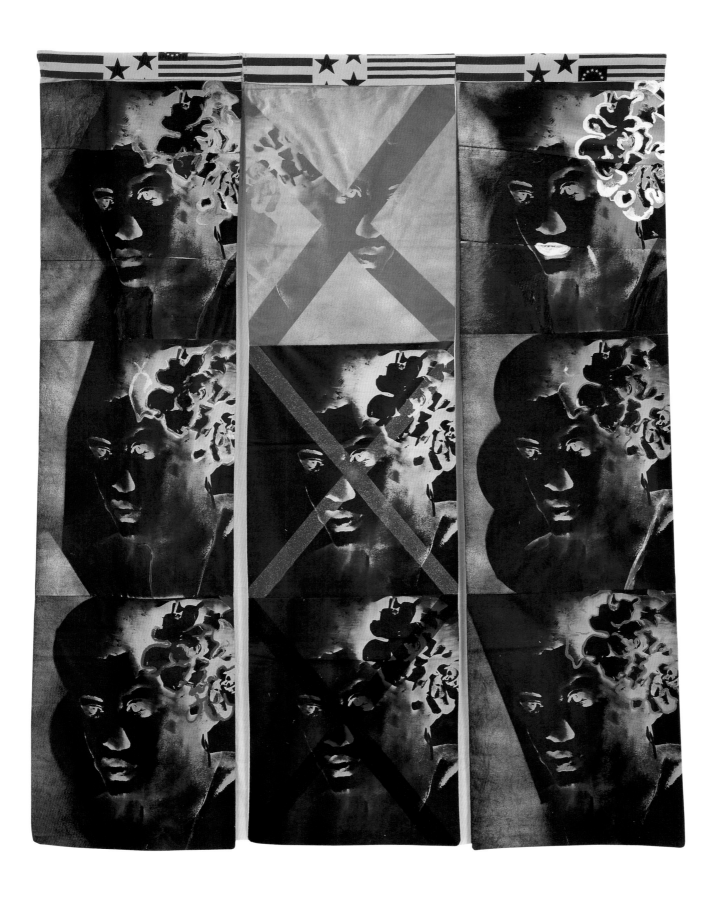

1 **Three Cheers for the Red, White and Blue #1, 1993**
60 × 54 inches

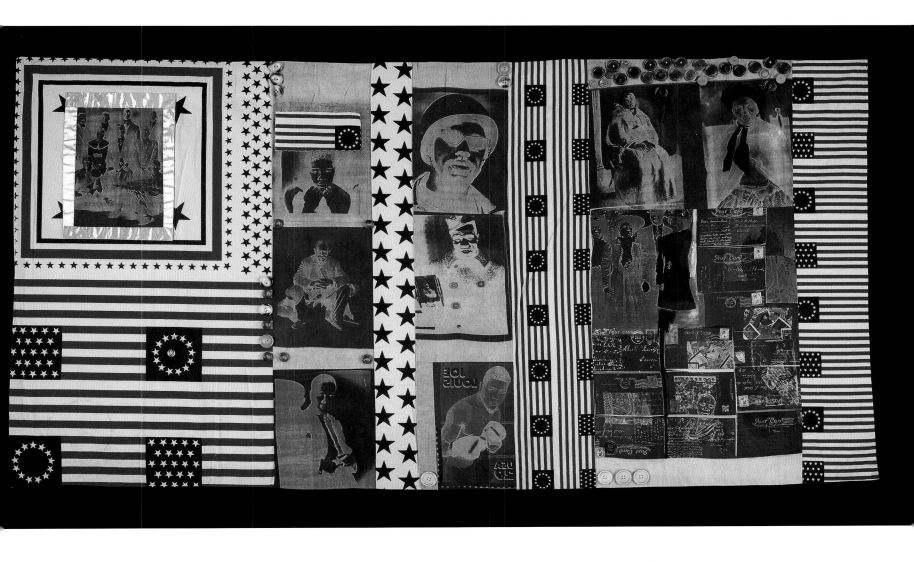

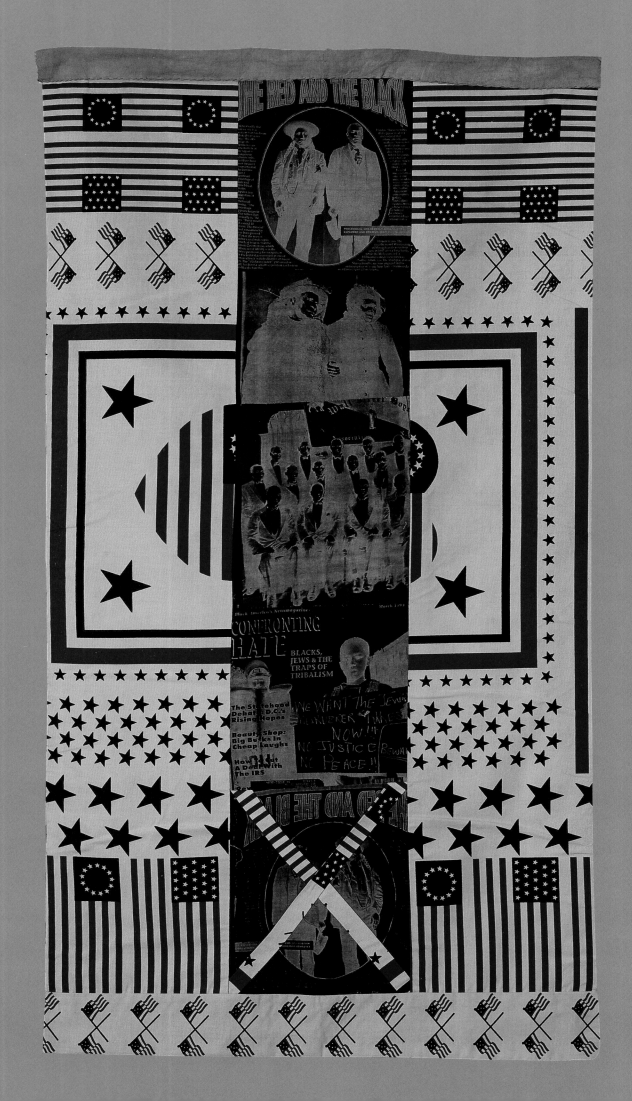

3 **Three Cheers for the Red, White
and Blue #3, 1993
47 × 27½ inches**

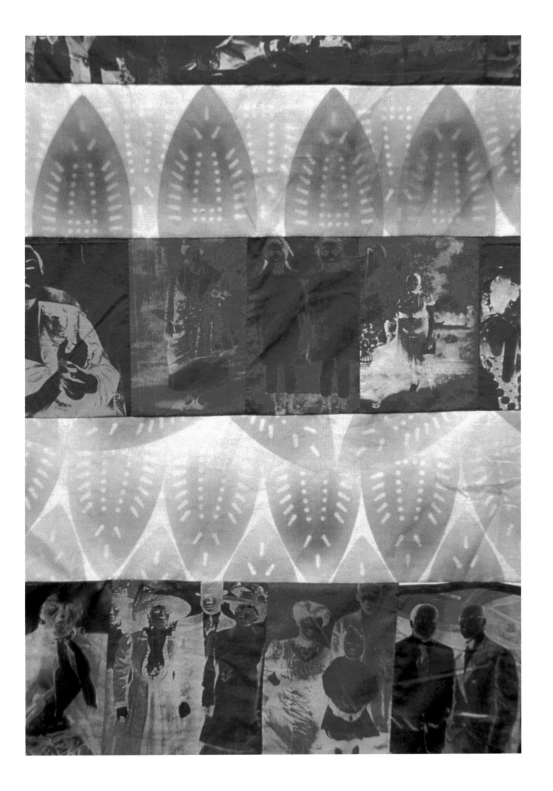

4 **Three Cheers for the Red, White
and Blue #15, 1993
43 × 37½ inches**

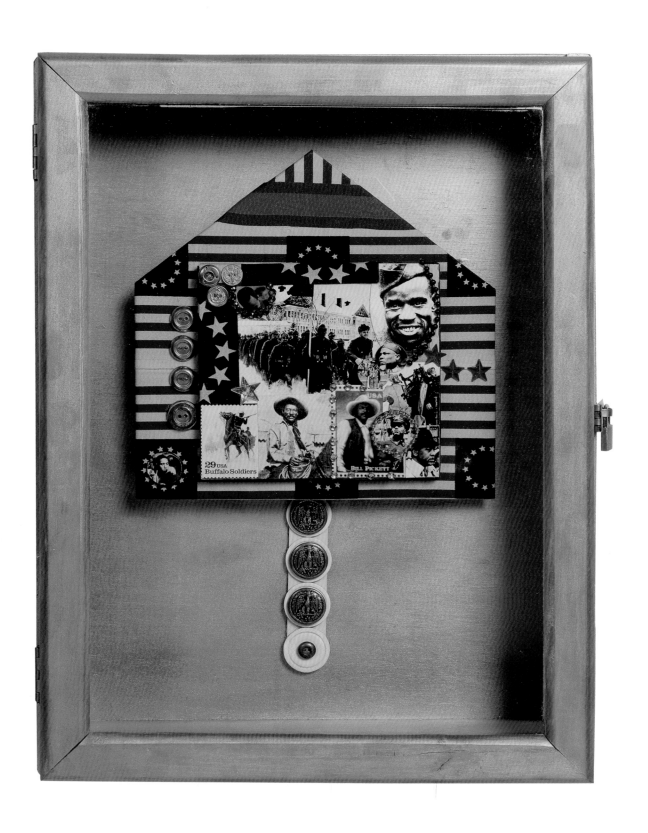

5 *Buffalo Soldier Fan #1, 1994*
20 × 16 × 4 inches

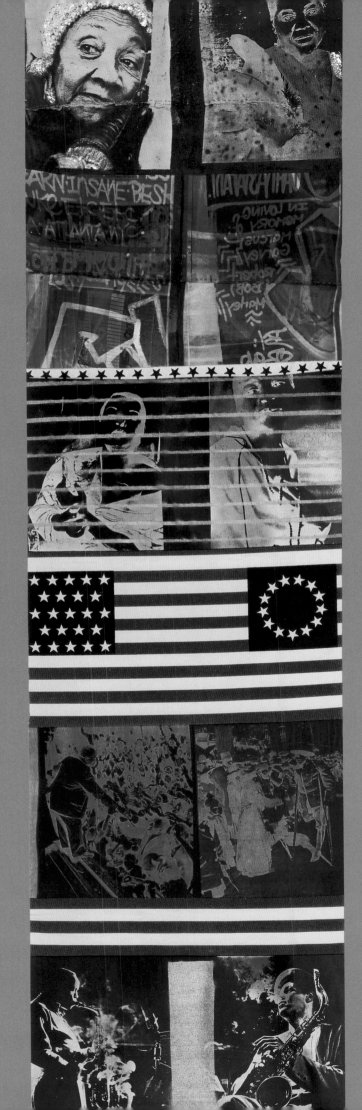

6 ***Three Cheers for the Red, White
and Blue #4, 1994***
58½ × 15½ inches

7 *Buffalo Soldier Fan #2,* 1995
20 × 16 × 4 inches

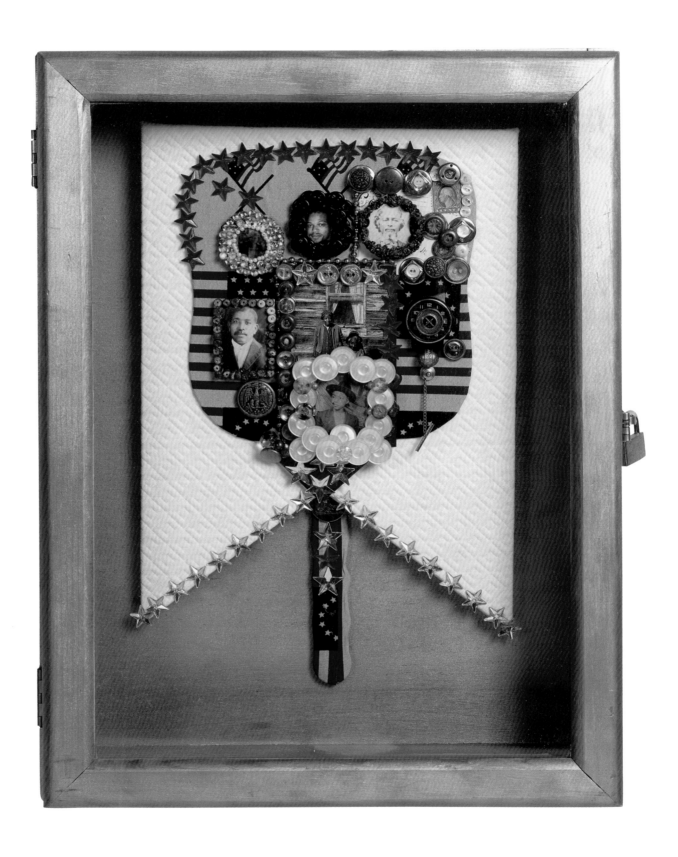

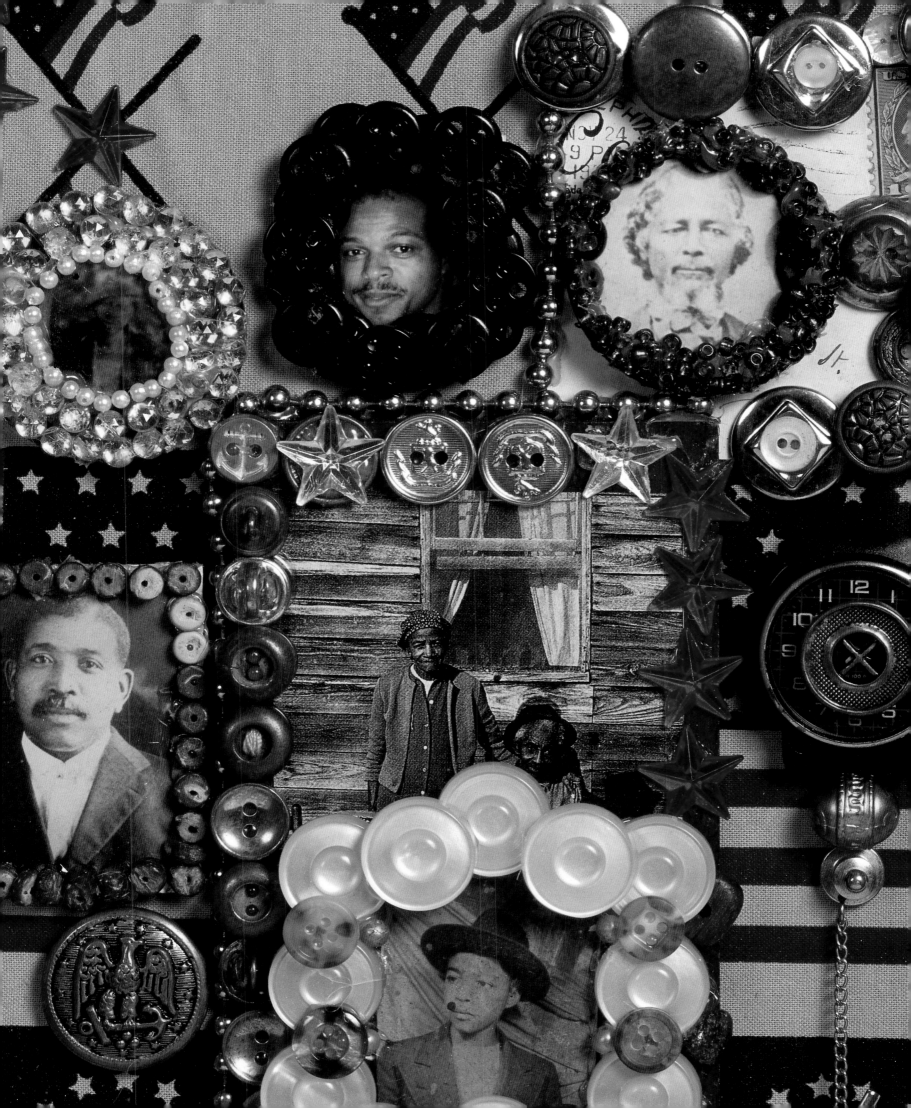

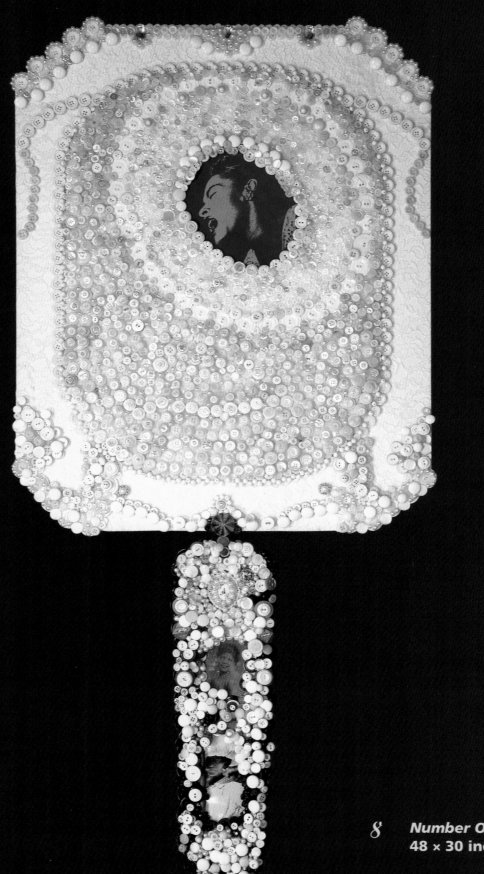

8 *Number One Fan #2*, 1995
48 × 30 inches

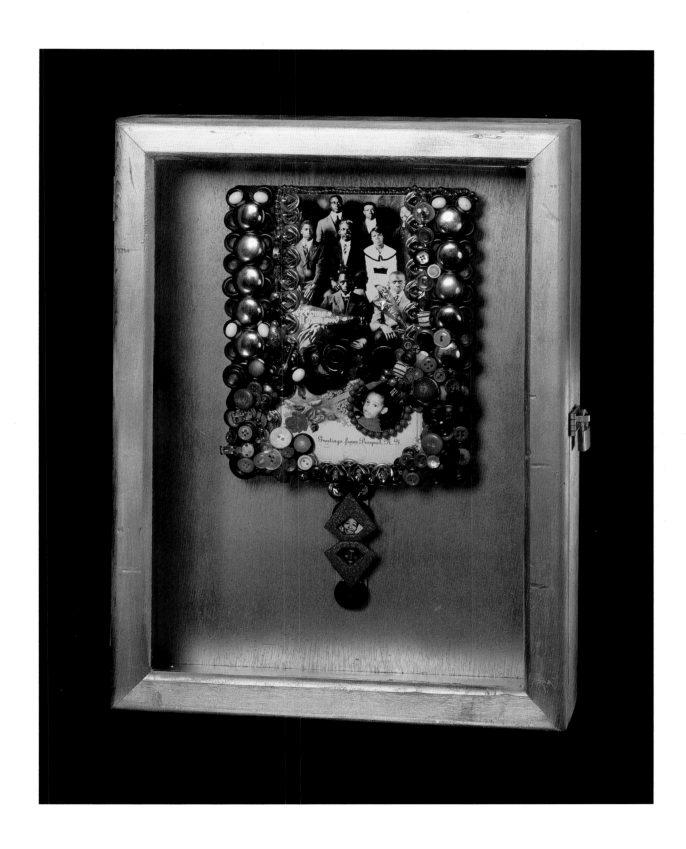

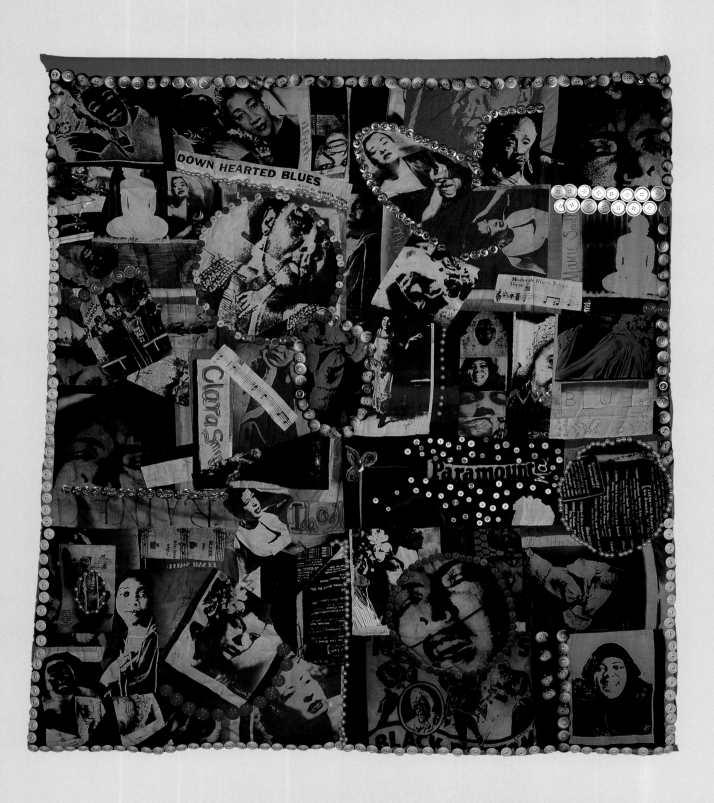

10 **Three Cheers for the Red, White and Blue #7 (I Guess That's Why They Call It the Blues), 1995**
54 × 48½ inches

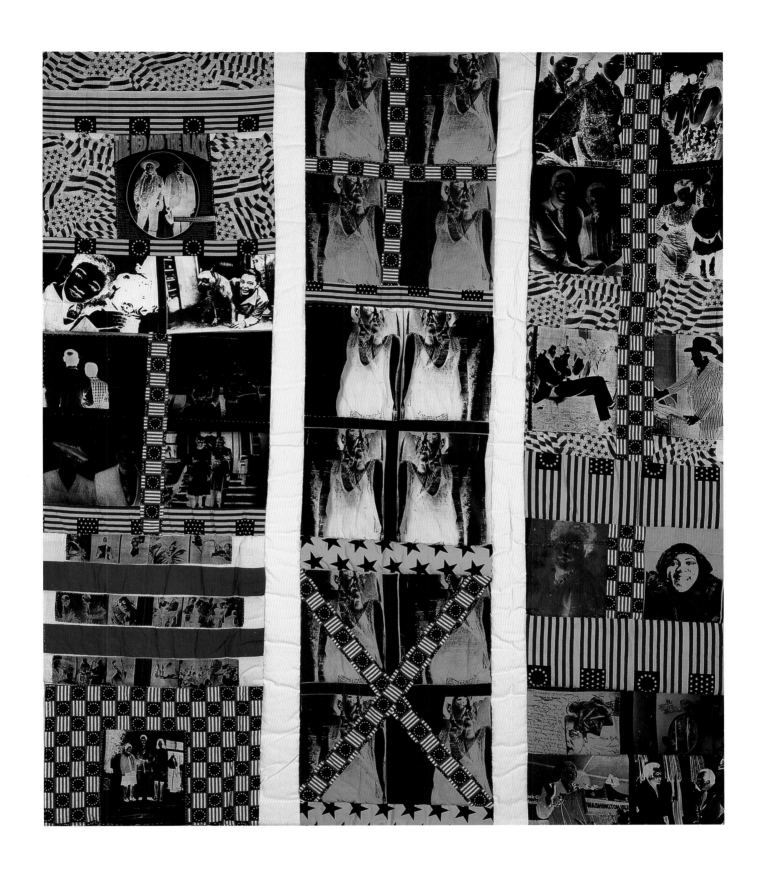

11 ***Three Cheers for the Red, White
and Blue #8,* 1995–1996
65 × 58 inches**

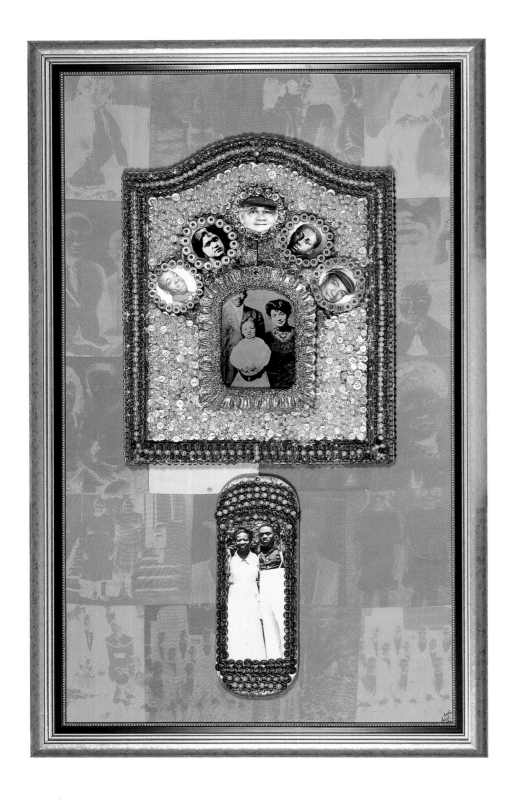

12 *Family Jewels,* 1996
40 × 24 inches

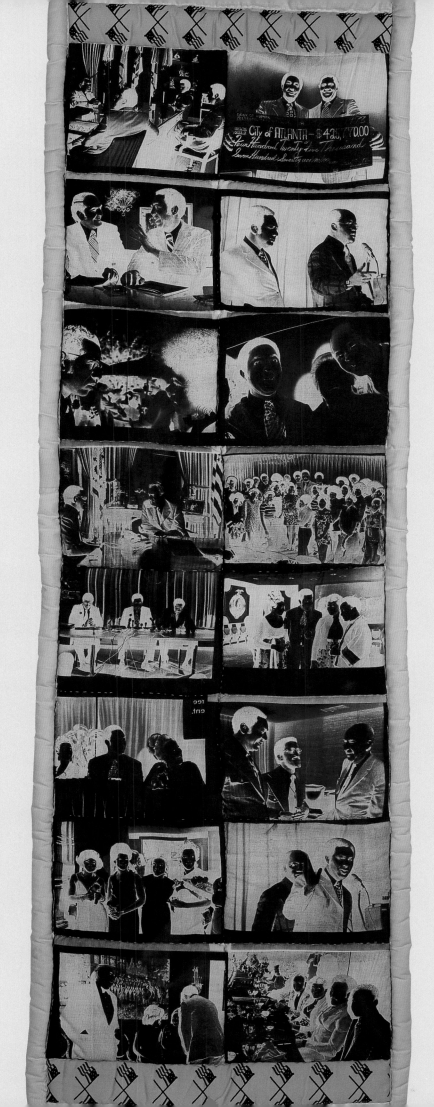

13 **Three Cheers for the Red, White and Blue #6, 1996**
66 × 22 inches

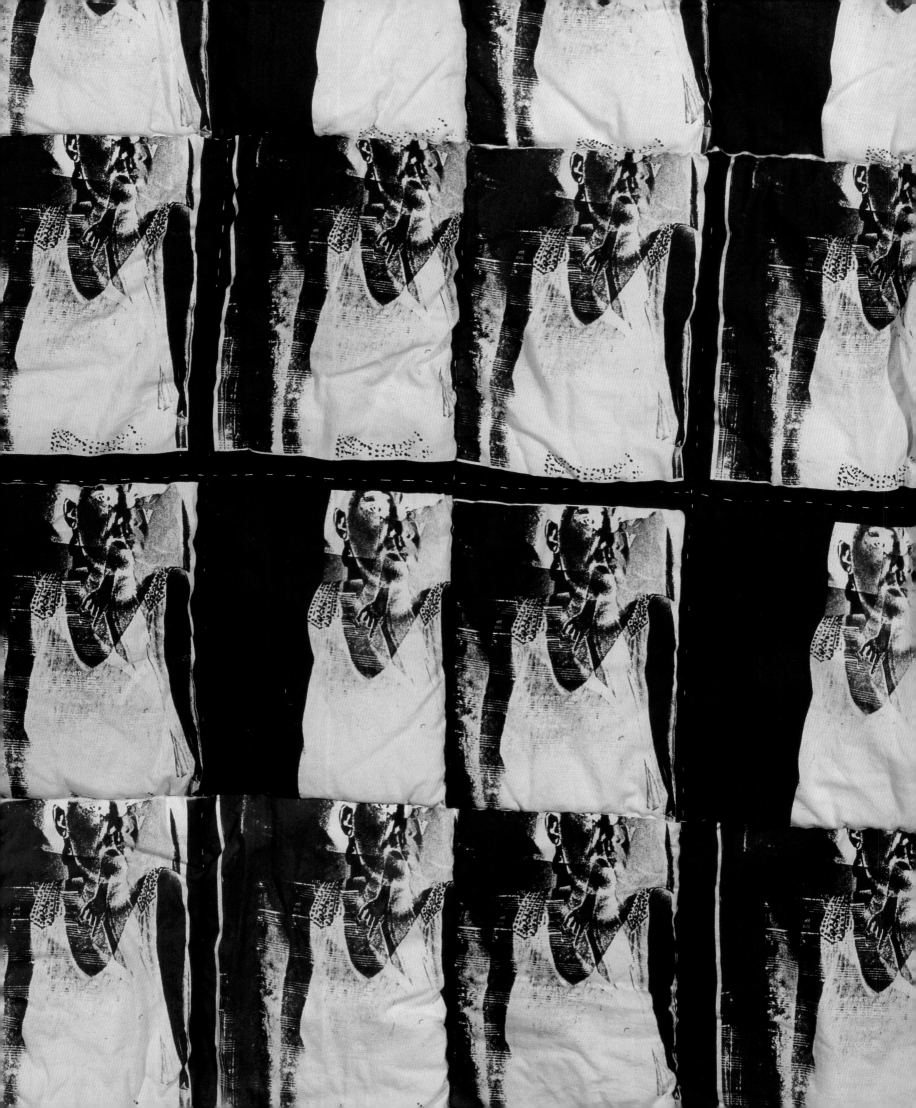

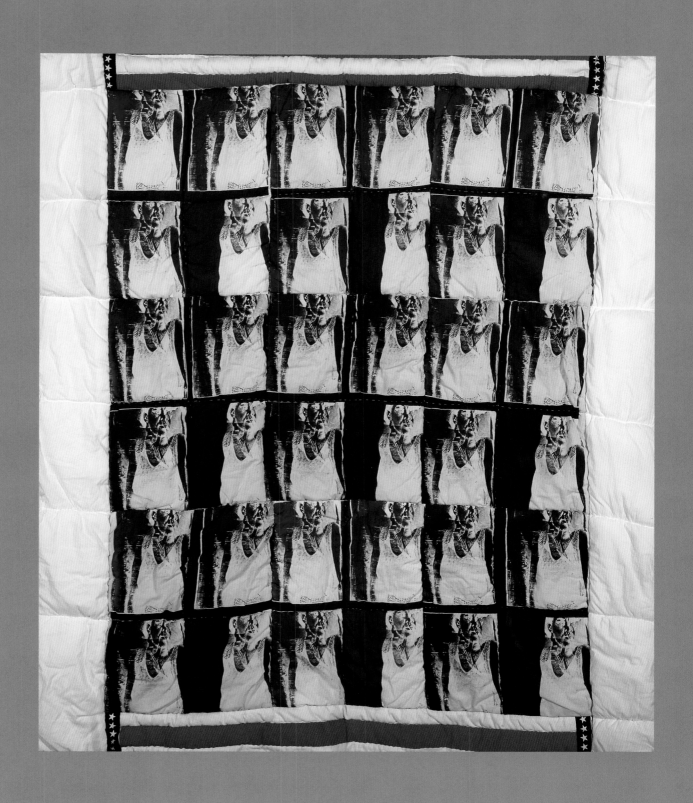

14 ***Three Cheers for the Red, White and Blue #9***
 (Bessie Remembered), **1996**
 64 × 56 inches

15 *Three Cheers for the Red, White and Blue #16*, **1996**
41½ × 37 inches

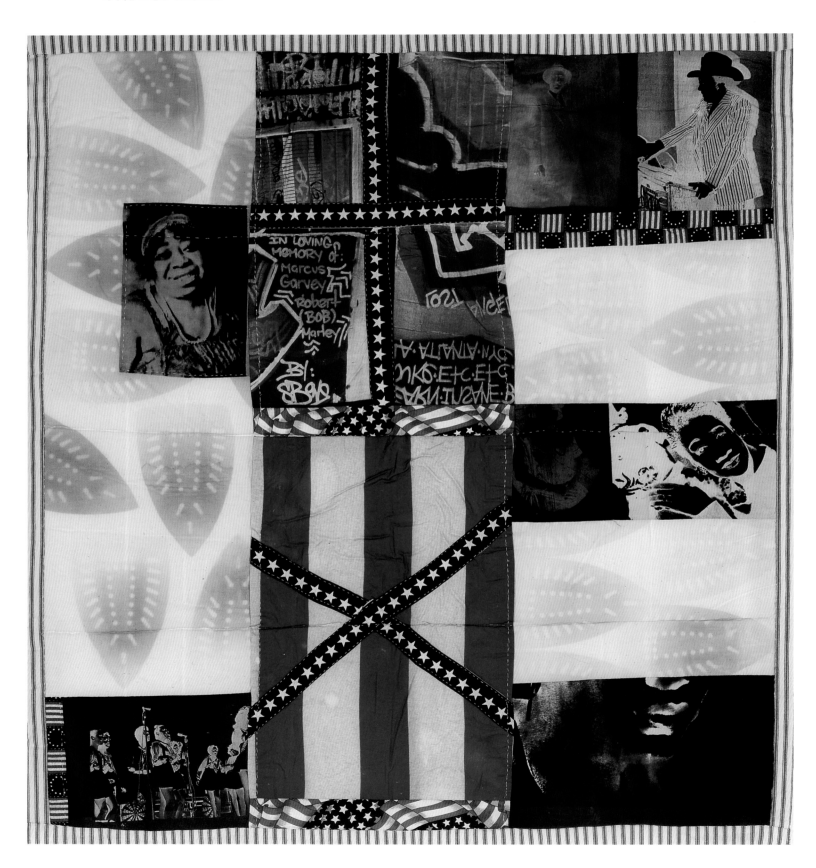

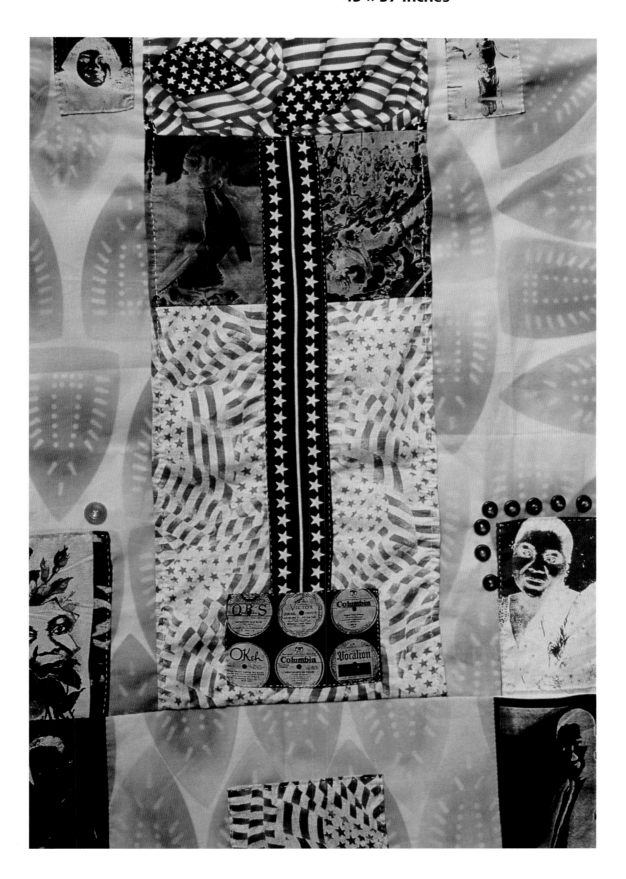

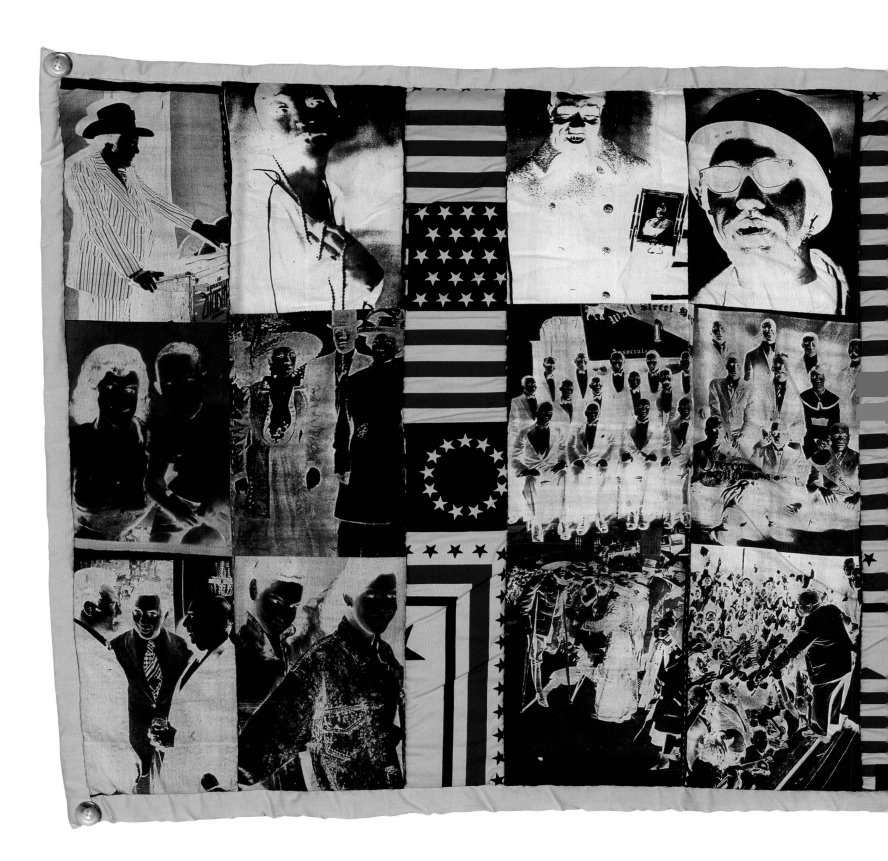

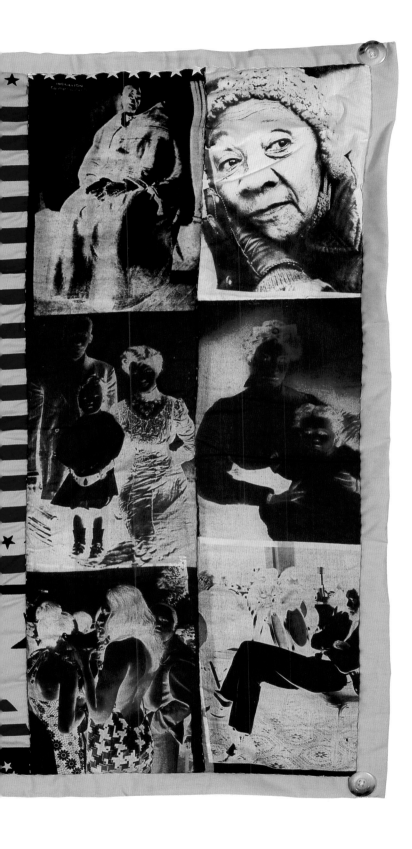

17 *Three Cheers for the Red, White and Blue #18*, 1996
36 × 72 inches

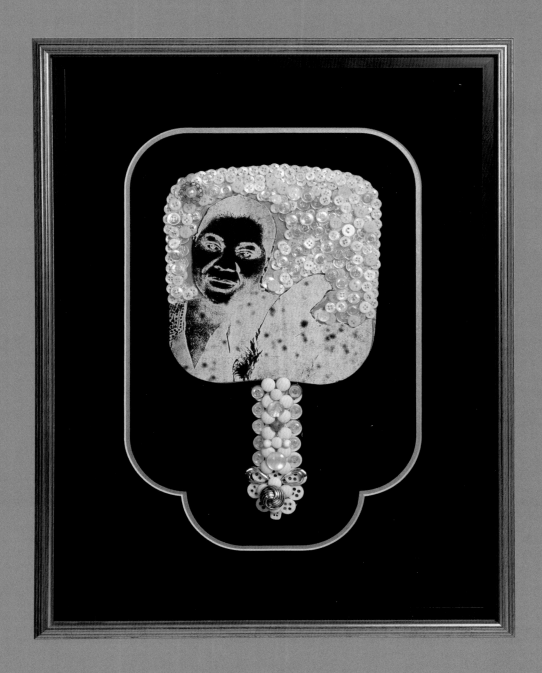

18 *Bessie Fan,* 1997
20 × 16 inches

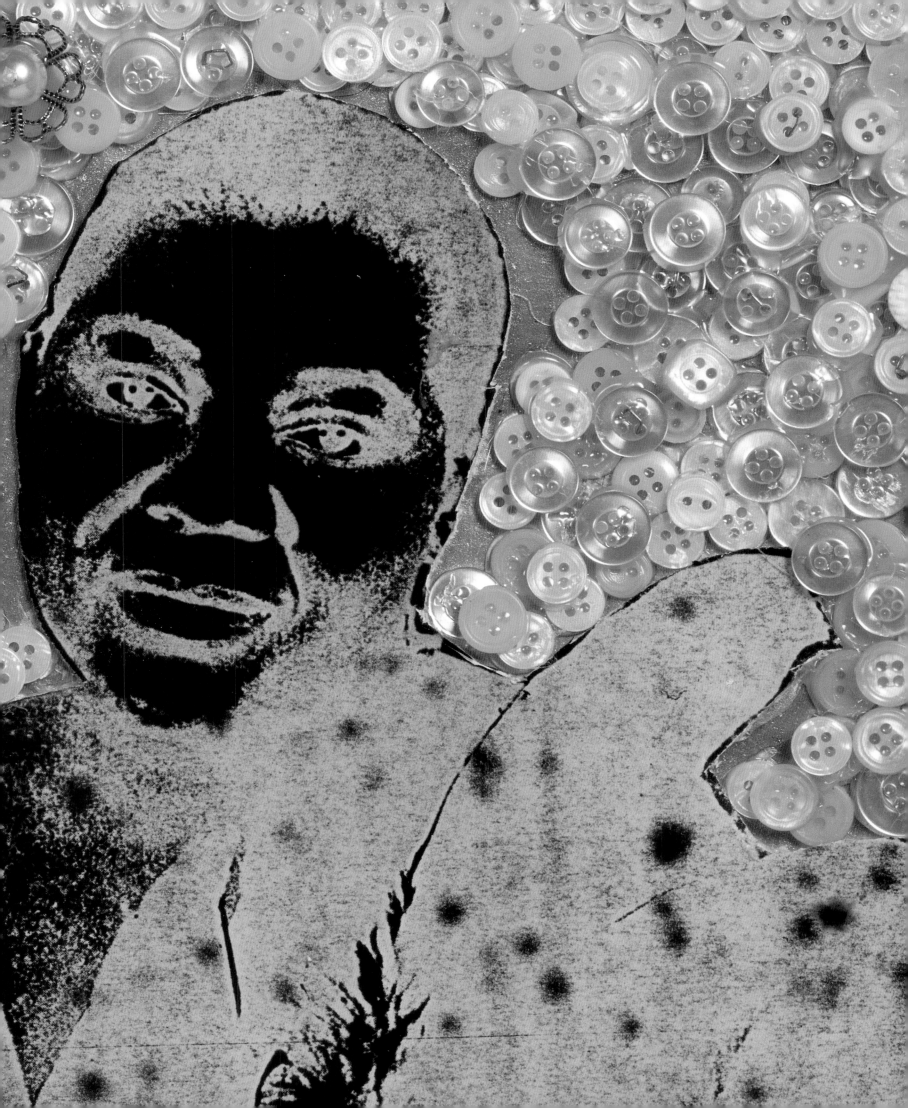

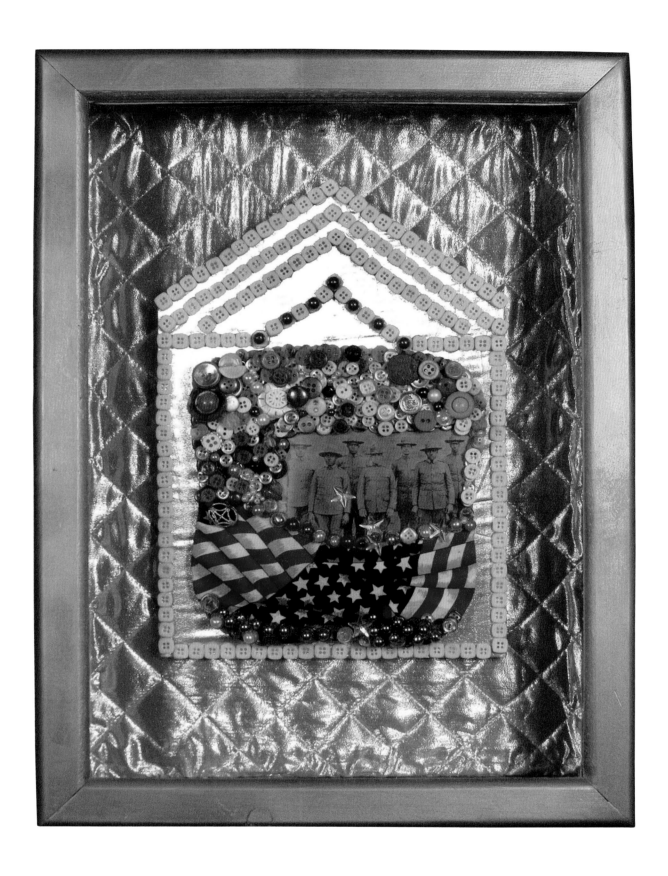

19 *Buffalo Soldier Fan #6, 1997*
20 × 16 × 4 inches

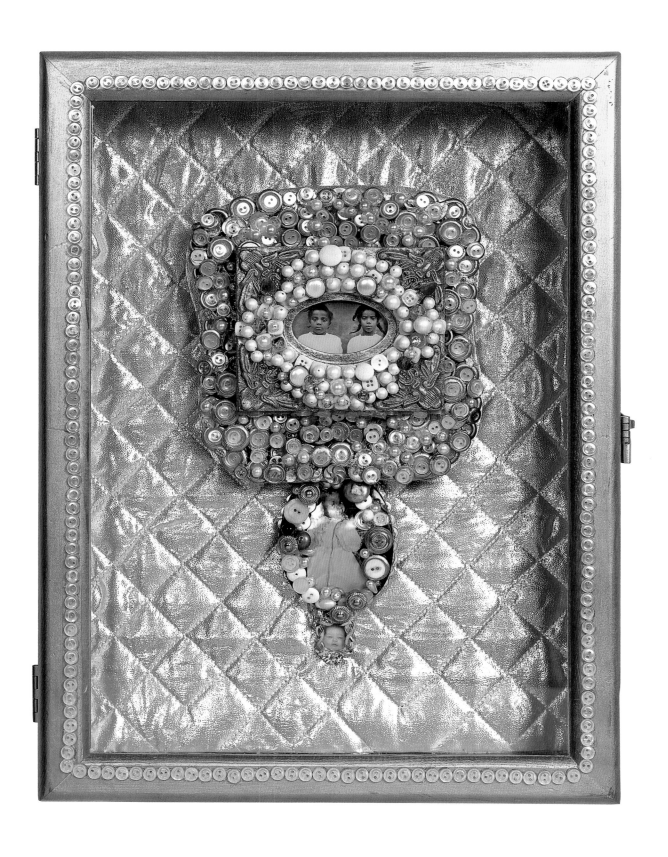

20 *Desert Babies #3: Sal and Moochie,* 1997
20 × 15 × 3½ inches

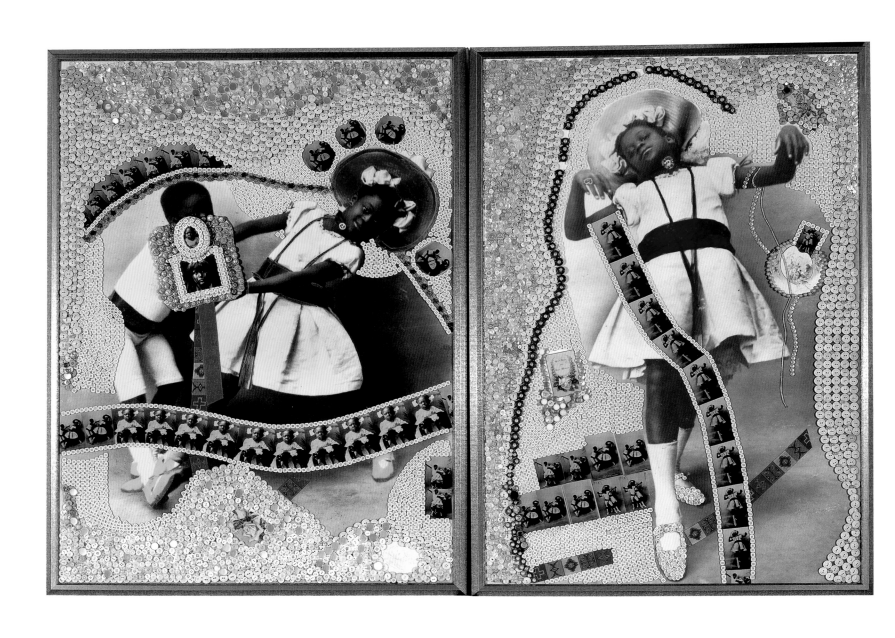

21 ***I'd Rather Two-Step,*** **1997**
50 × 70 inches

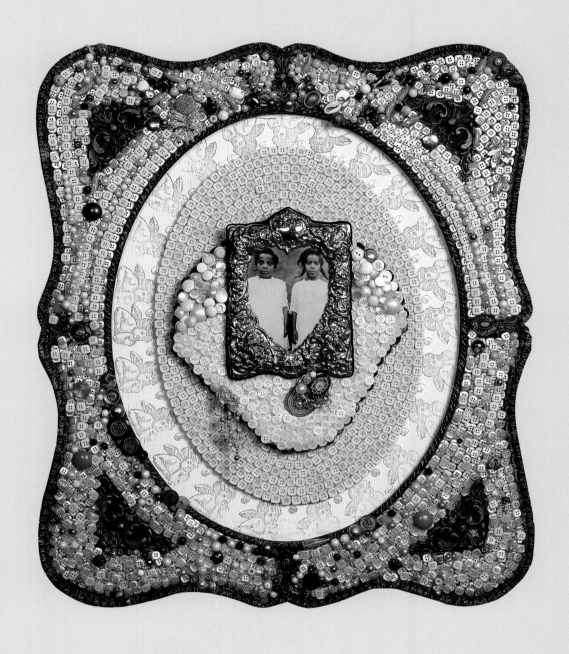

22 *Sisters (Duet),* 1998
26 × 22 × 2 inches

23 *Candy Box,* **1999**
2 × 9 × 10 inches

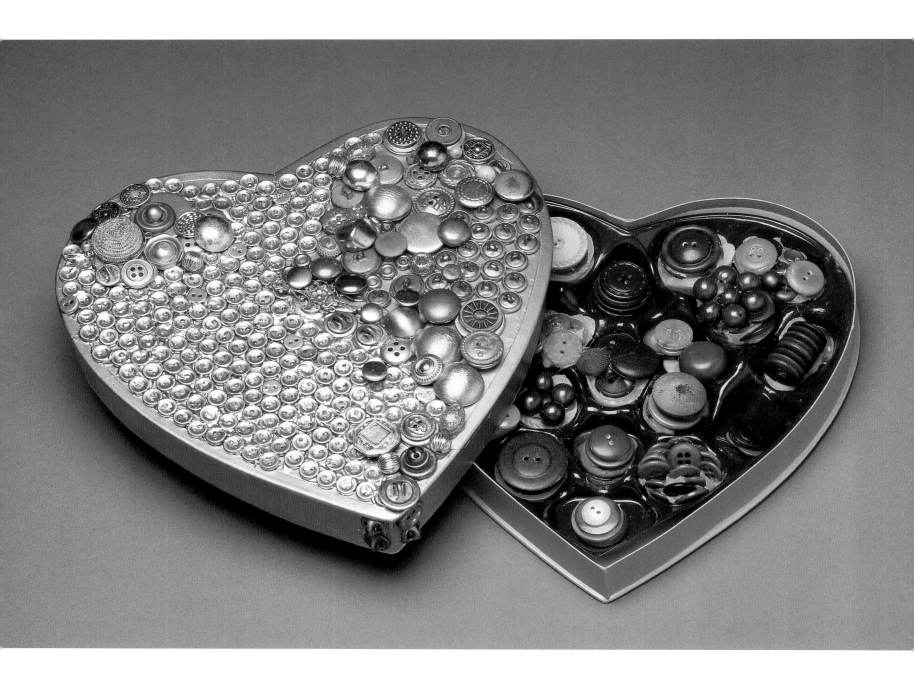

24 *Duet (Anniversary Fan),* **1999**
26 × 22 × 4 inches

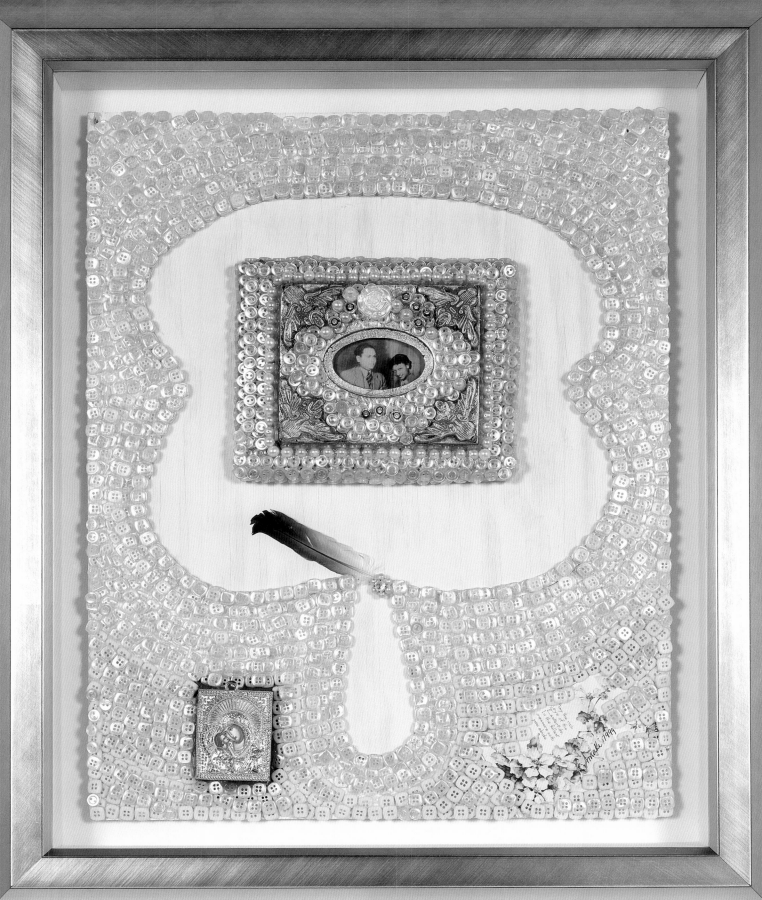

25 *Les Enfants,* 1999
52¼ × 105 inches

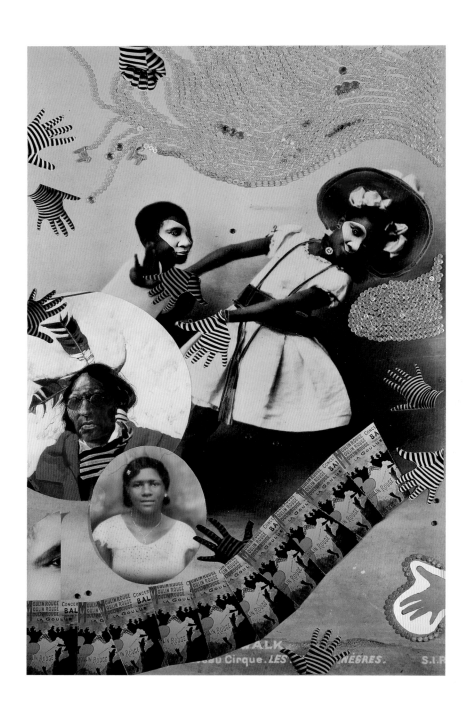

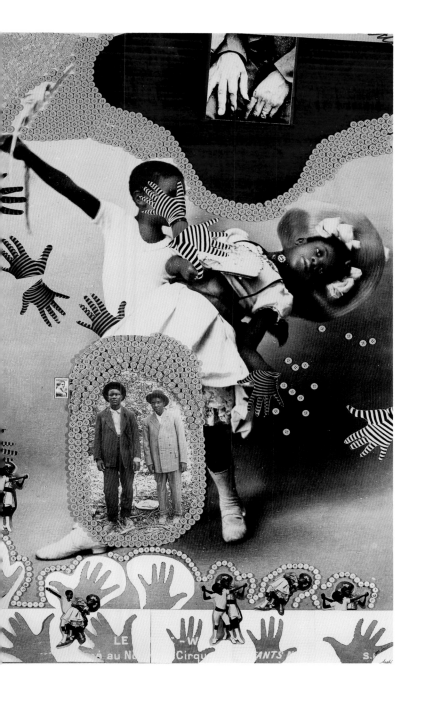
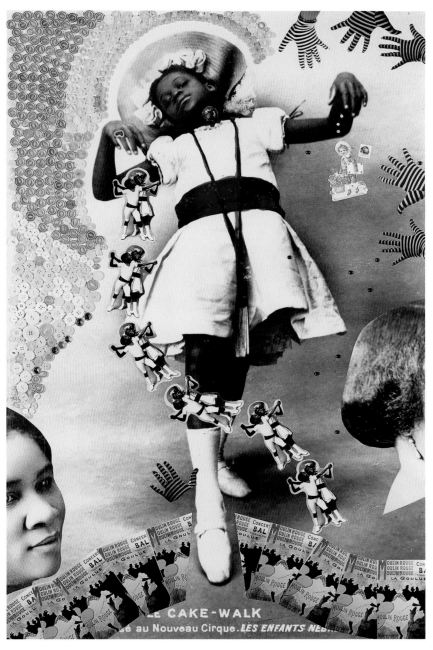

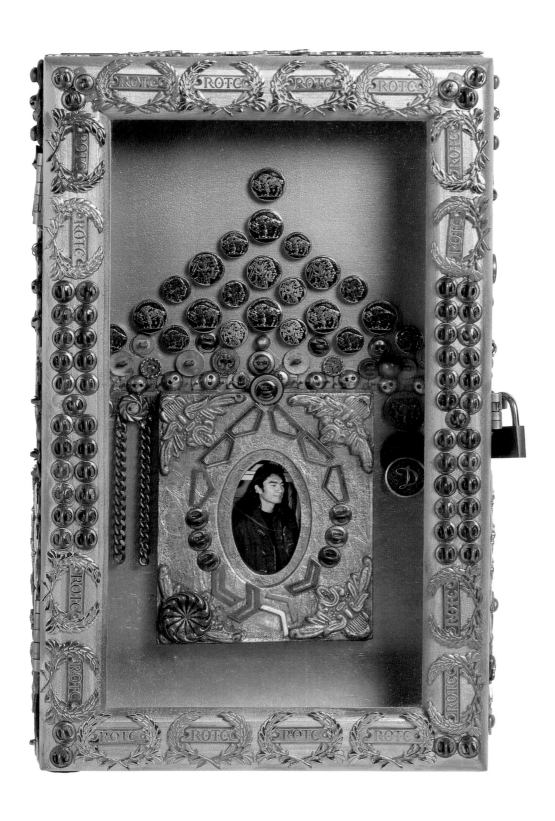

26 *Mixed Media, Southwest Memory #2*, **1999**
15 × 9 × 4 inches

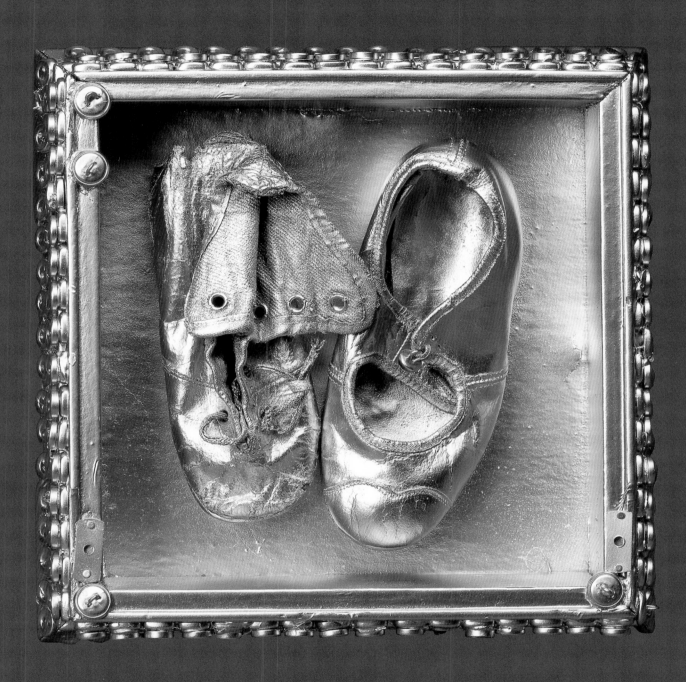

27 *Relics,* **1999**
8 × 8 × 2½ inches

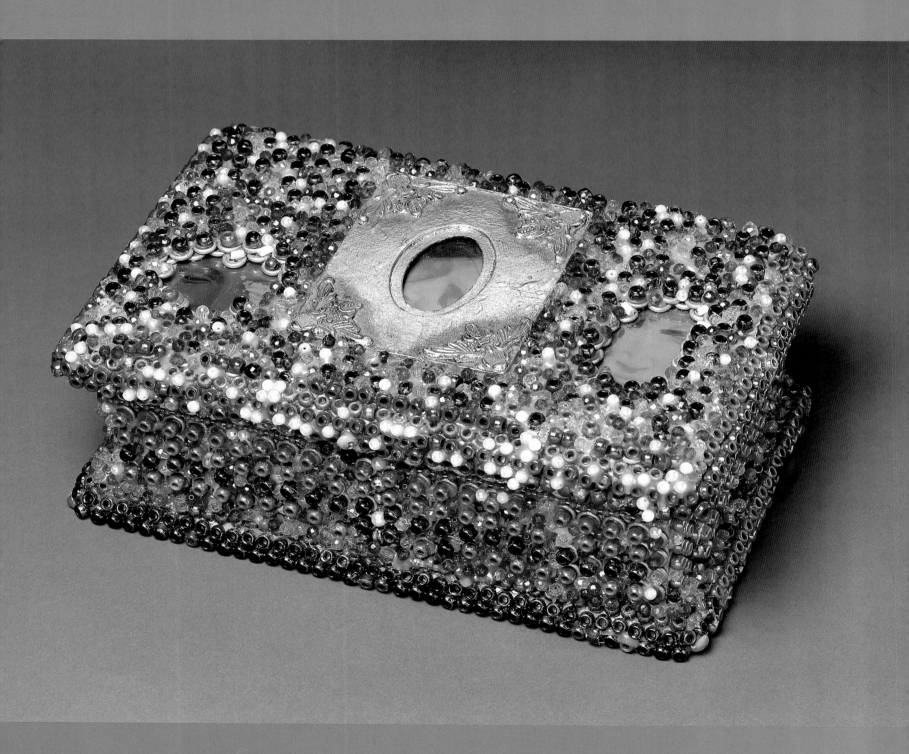

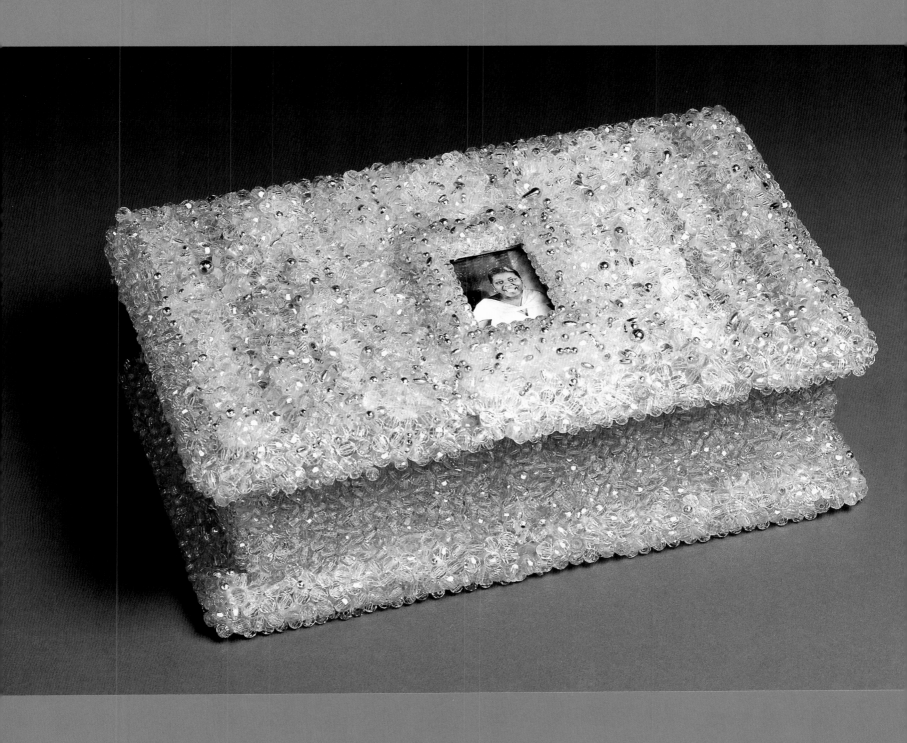

29 *Treasure Box #3,* **1999**
6 × 14 × 9 inches

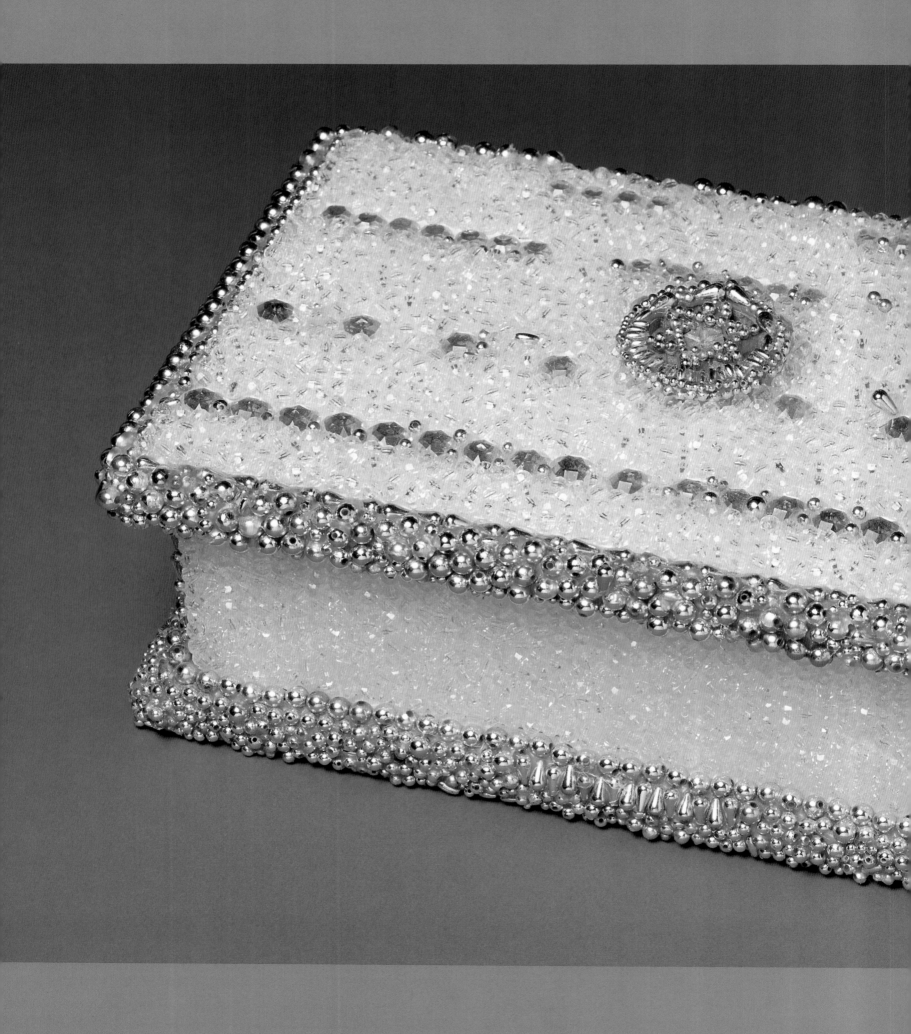

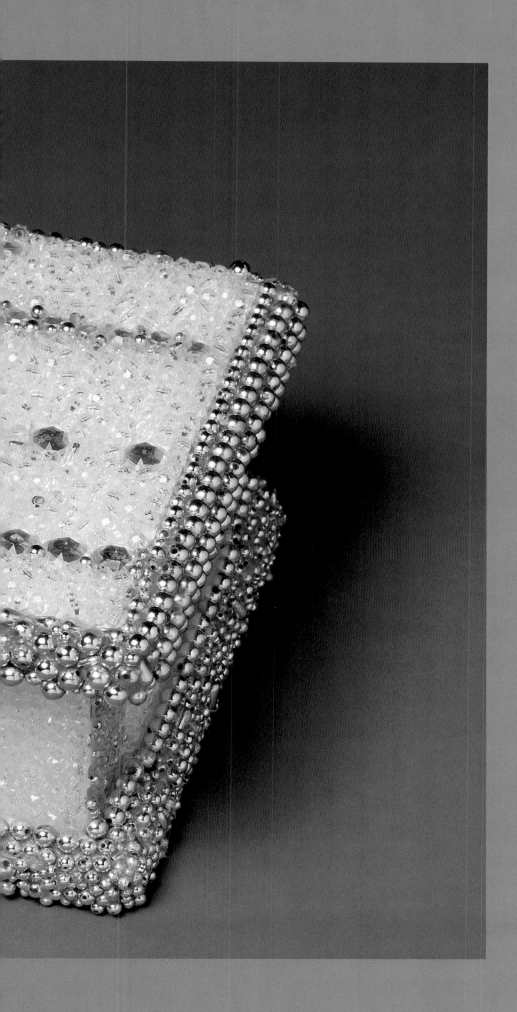

30 *Tzedakah Box,* 1999
6 × 14 × 9 inches

31 **Candy Box II, 2000**
1½ × 10 × 11 inches

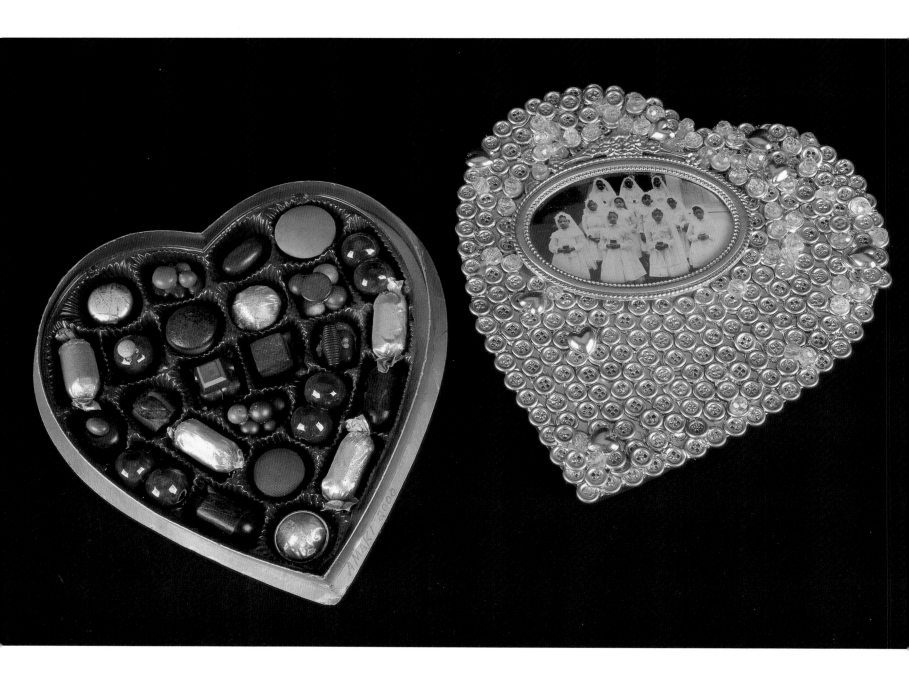

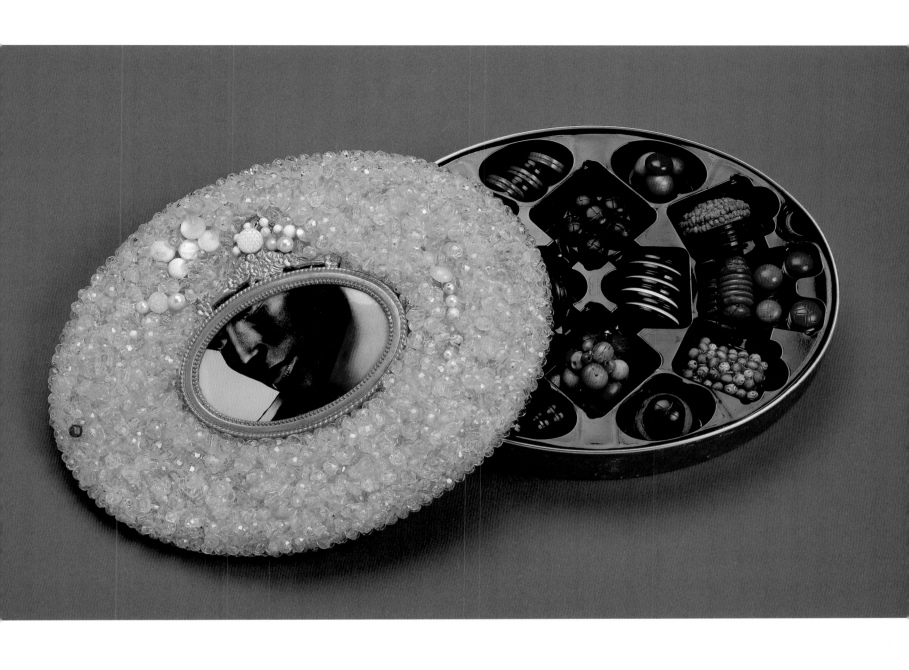

32 **Dark Chocolate, ca. 2000**
2½ × 12 × 10 inches

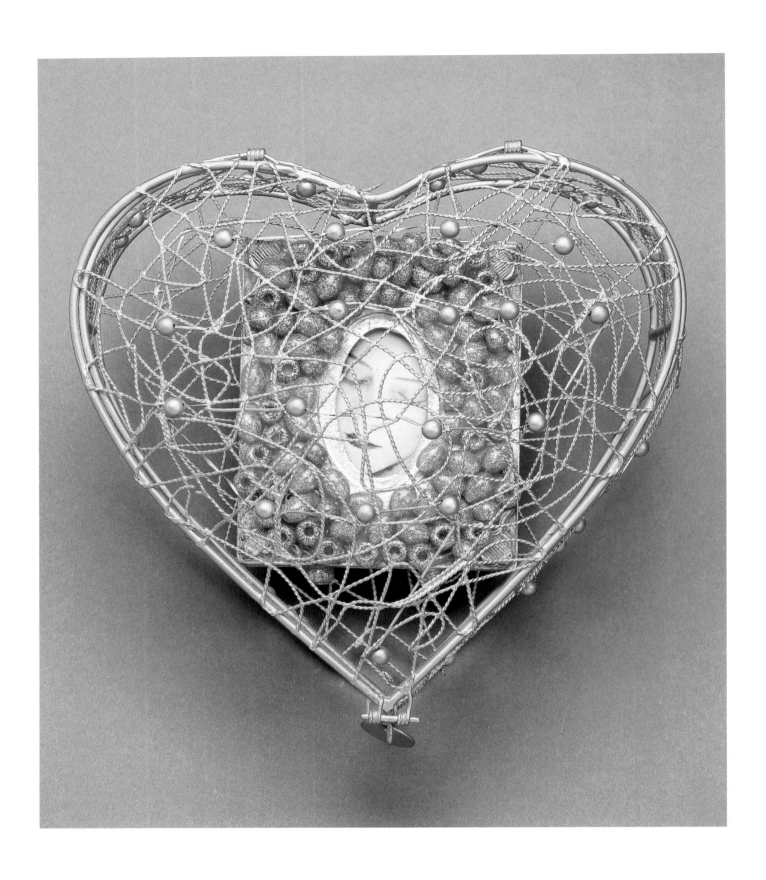

33 **Dreamer in a Cage #1, 2000**
11 × 10 × 3 inches

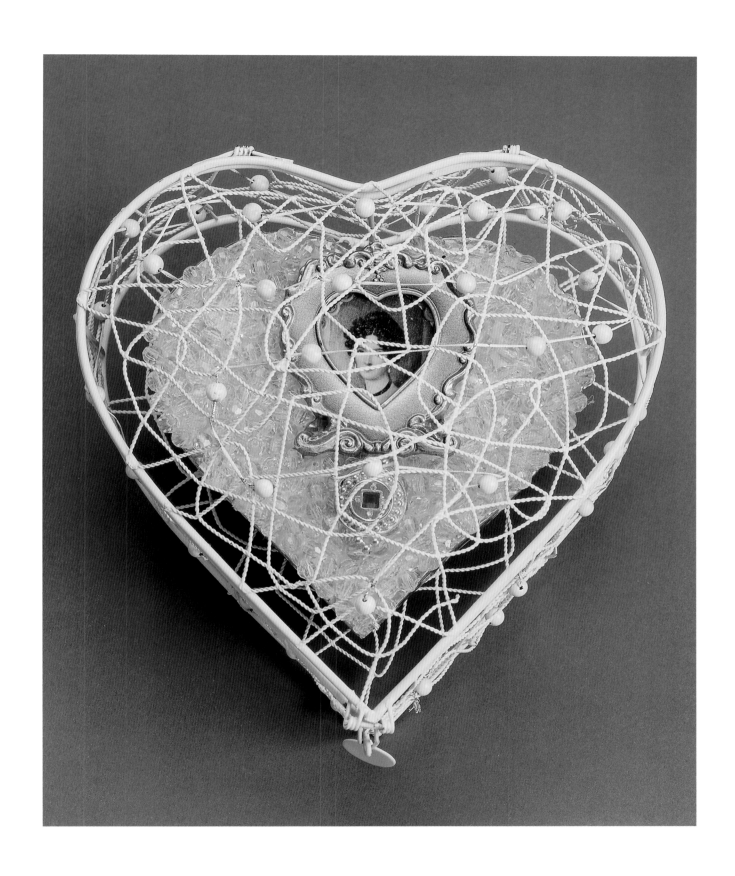

34 **Dreamer in a Cage #2, 2000**
11 × 10 × 3 inches

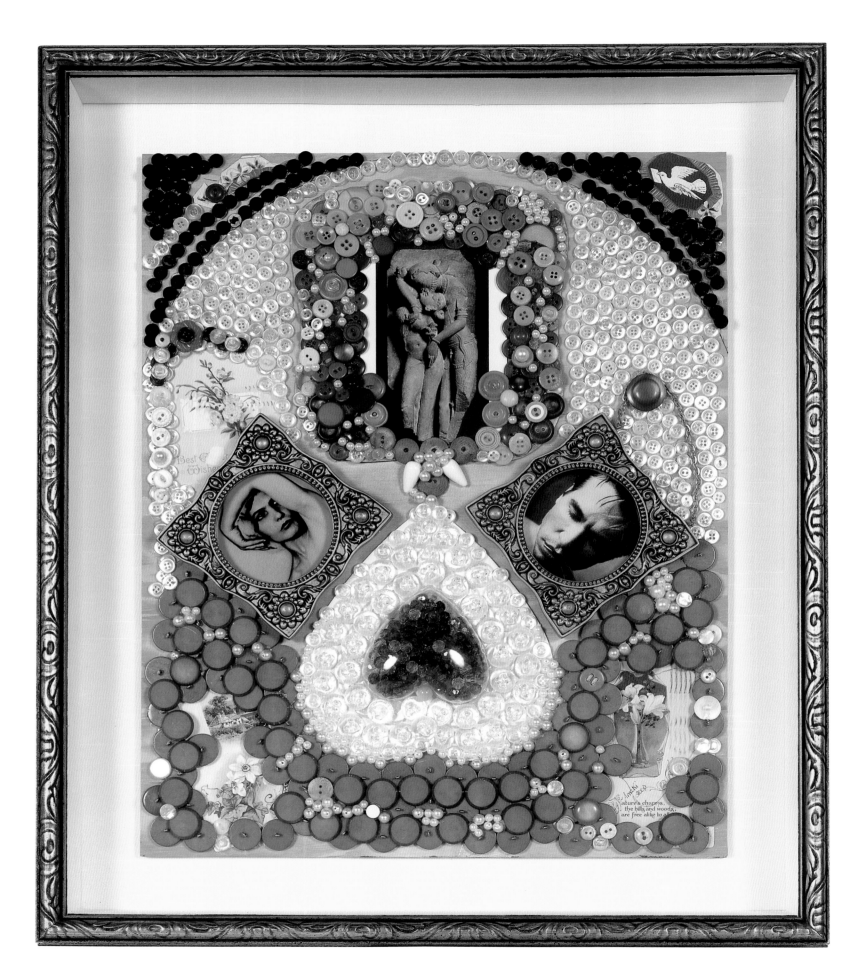

35 *Lovers, 2000*
26 × 22 × 4 inches

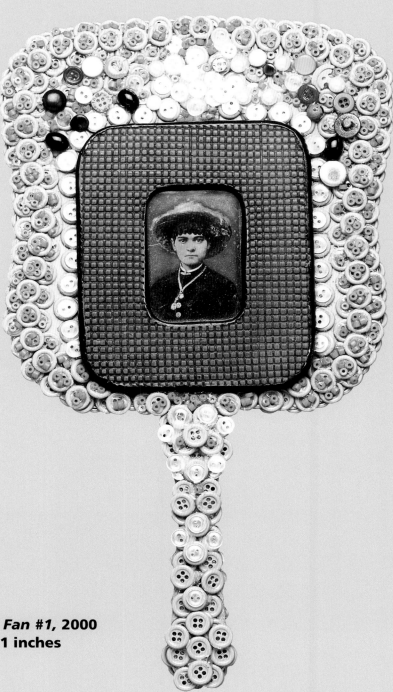

36 *Red Cap Fan #1, 2000*
14 × 8 × 1 inches

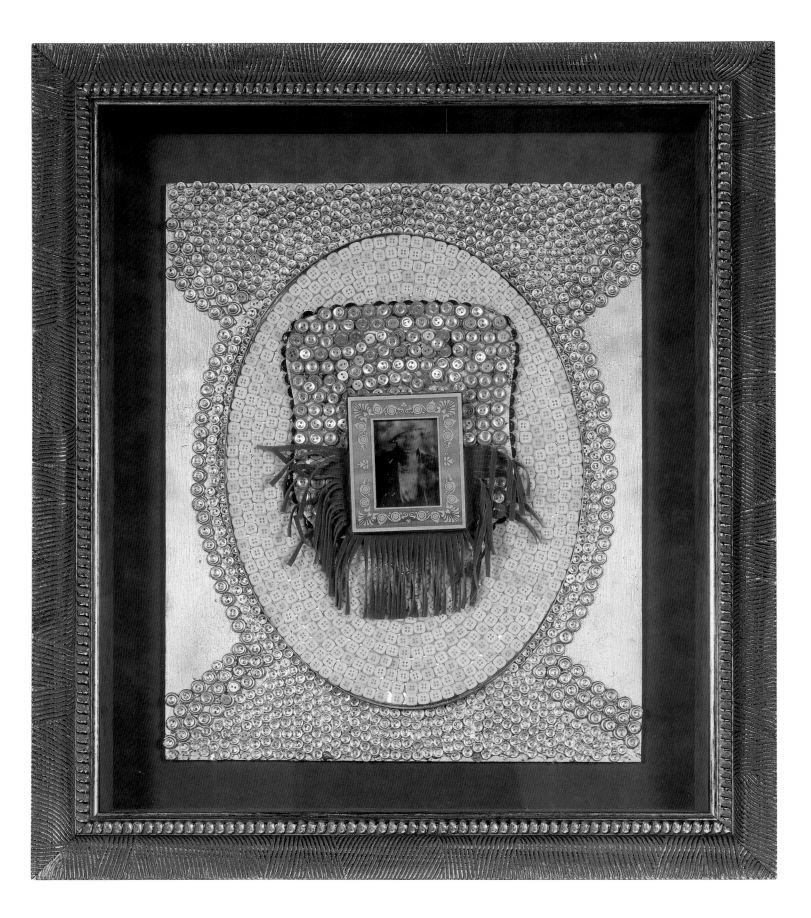

37 ***Southwest Souvenir Gaze, 2000***
28 × 24 × 4 inches

38 *Three Crosses, 2000*
14 × 14 × 3 inches

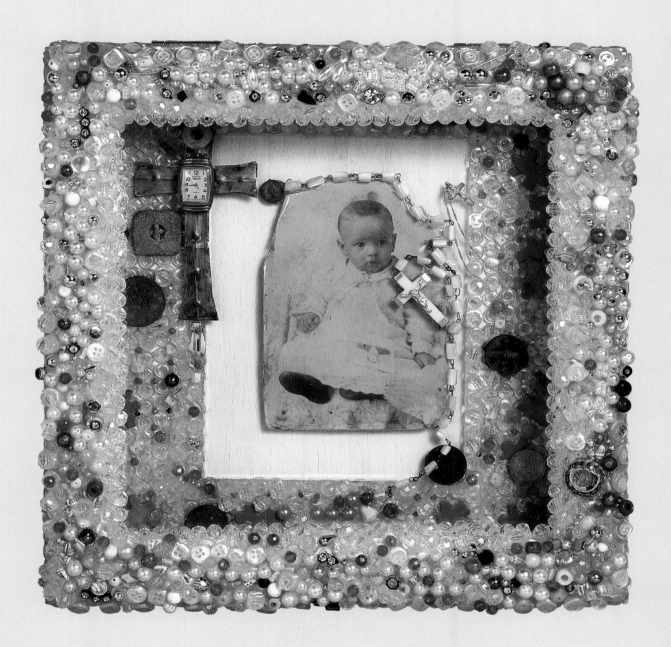

39 **Too Sweet, 2000**
3 × 9 × 12 inches

40 **Twosome, 2000**
26 × 22 × 4 inches

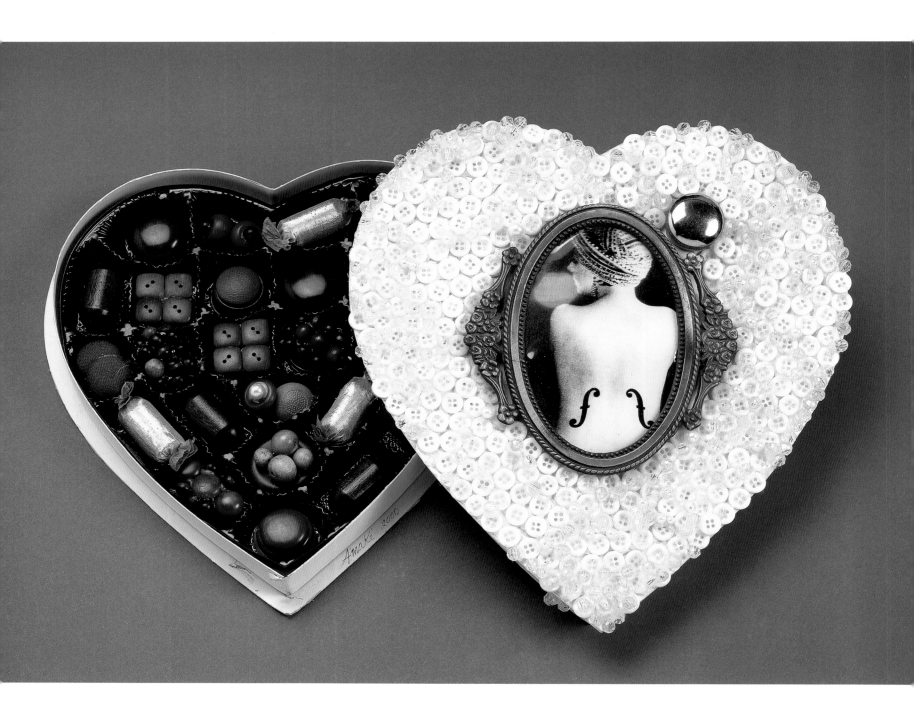

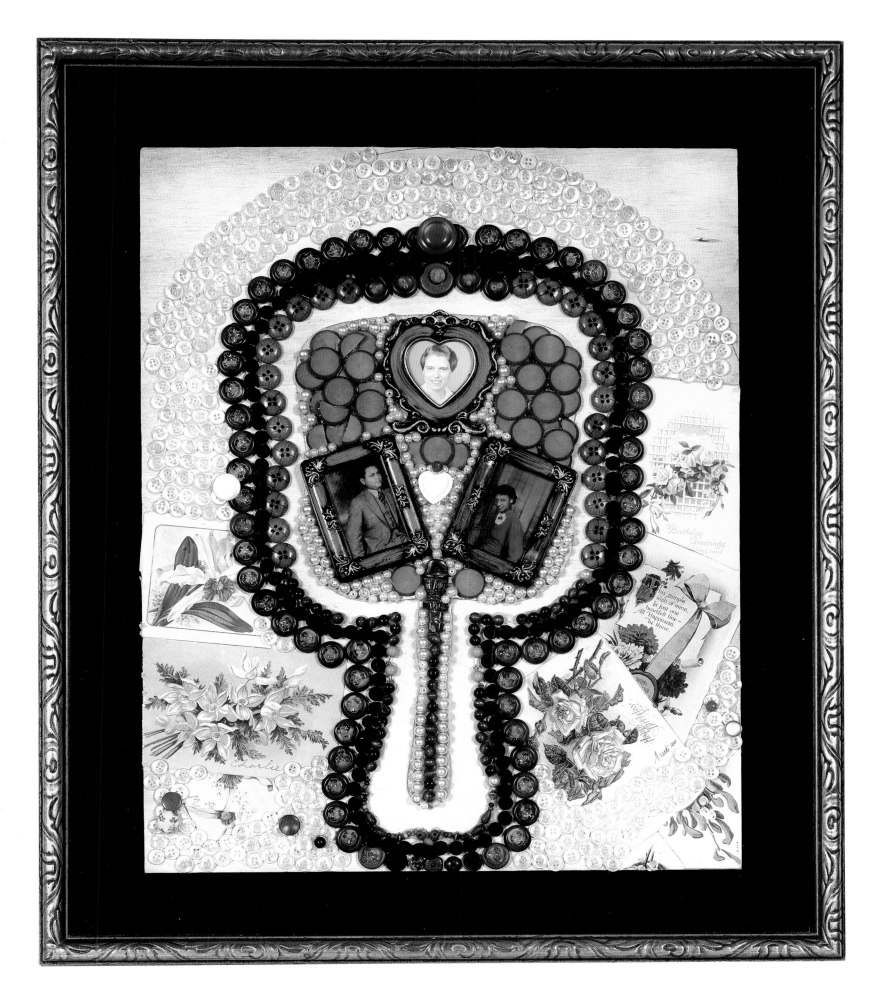

41 **Bon Bon, 2001**
2 × 3 × 3 inches

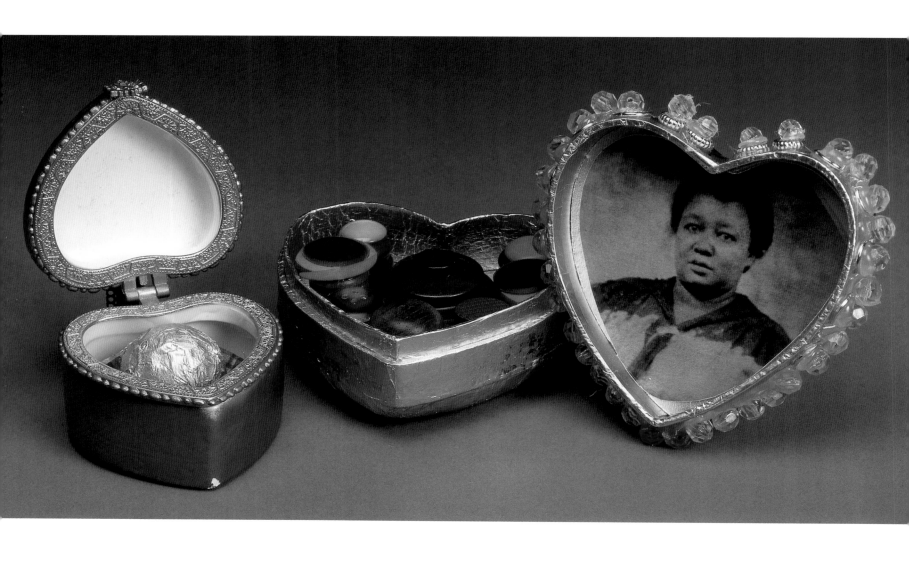

42 **Gold Leaf, 2001**
3 × 4½ × 4½ inches

43 *Caramel Apple,* 2001
9½ × 7 × 6 **inches**

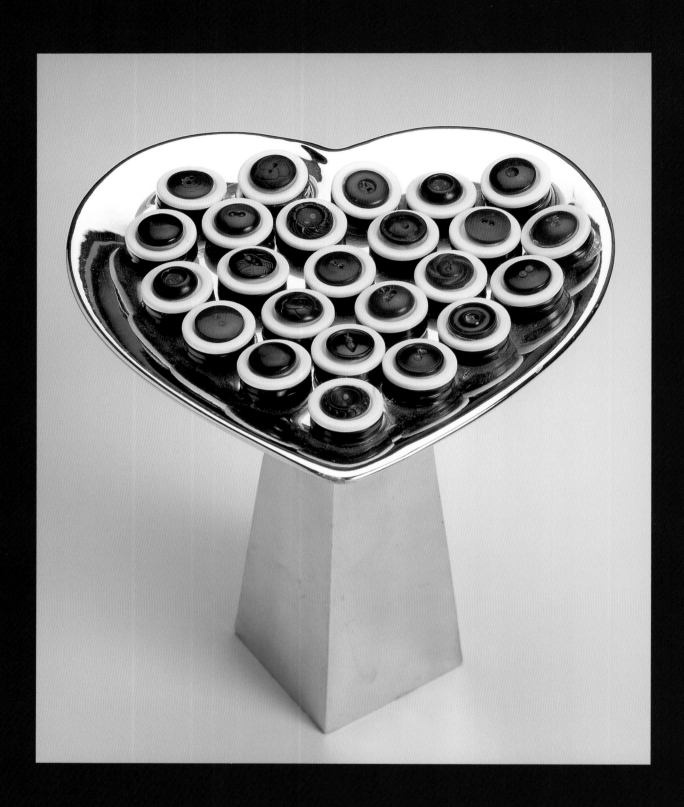

44 *Chocolate Centers*, **2001**
10 × 12 × 10 inches

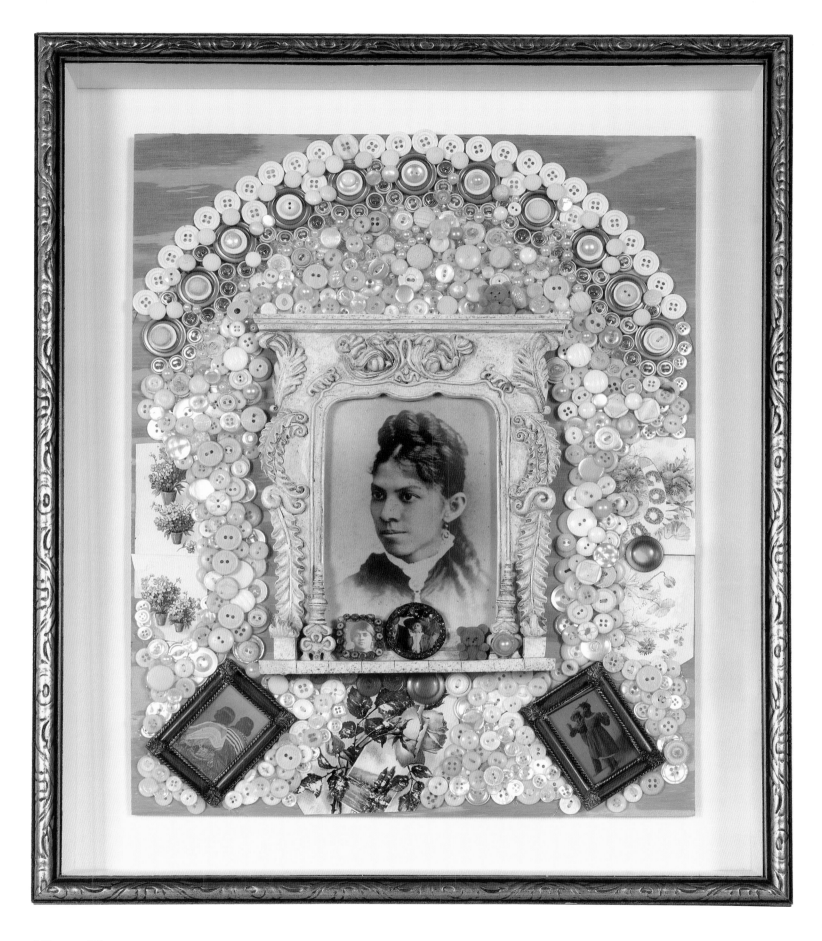

45 *Dollhouse, 2001*
26 × 22 × 4 inches

46 *Face It, 2001*
20 × 52 inches

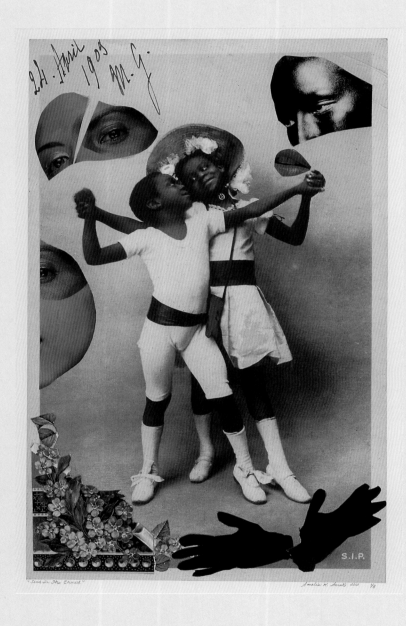

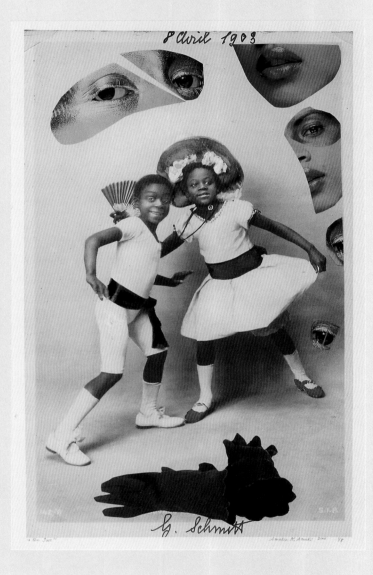

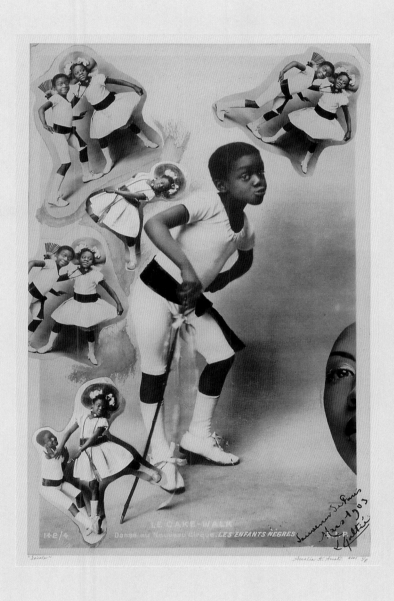

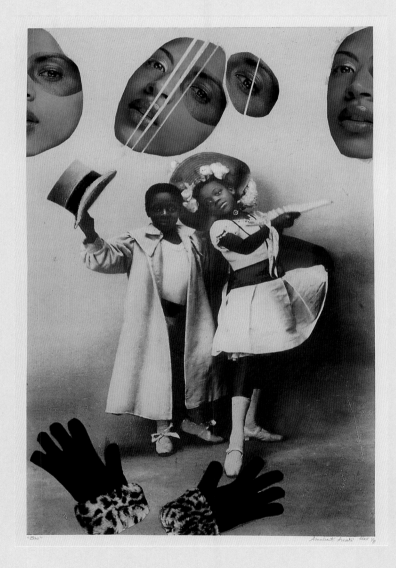

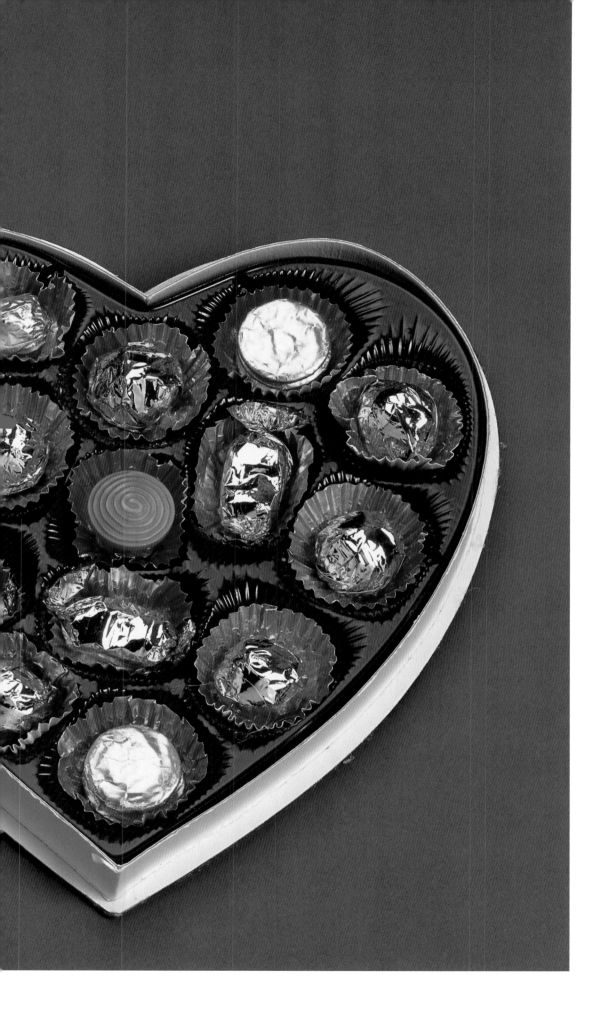

47 *Golden Nuggets, 2001*
2 × 10 × 10 inches

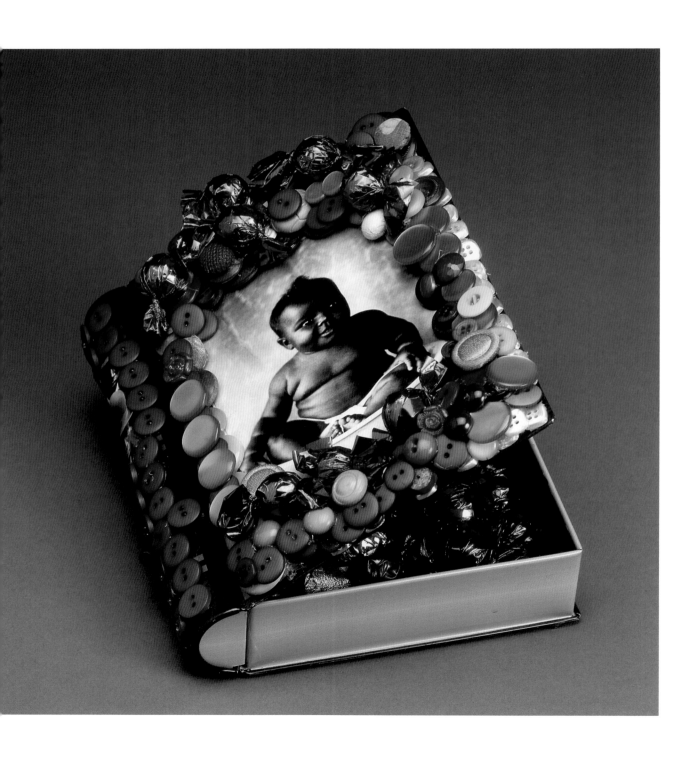

49 *Holiday Sweets,* **2001**
3 × 10 × 13 inches

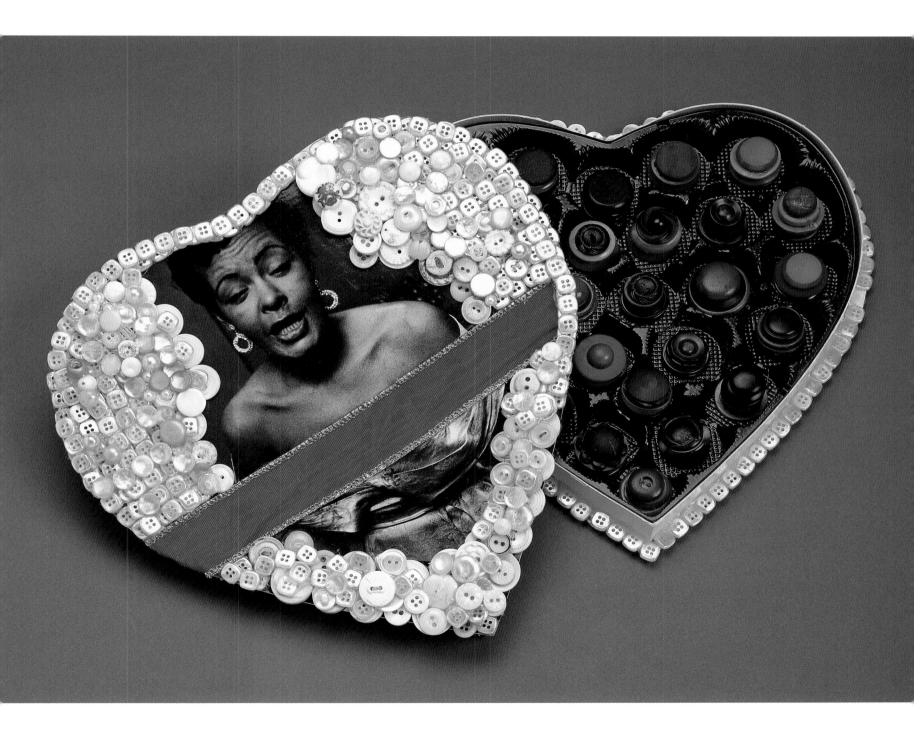

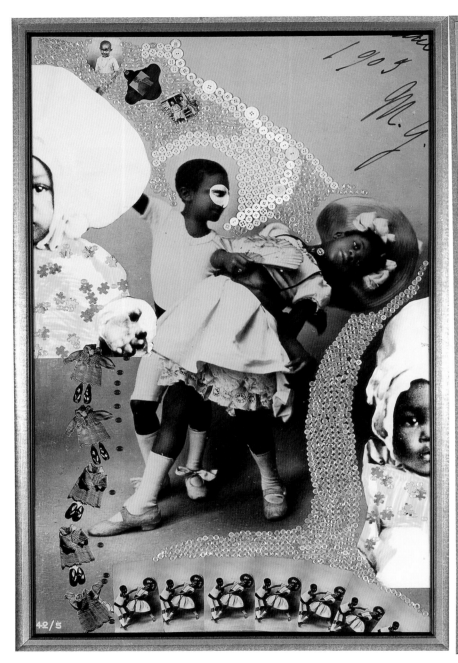

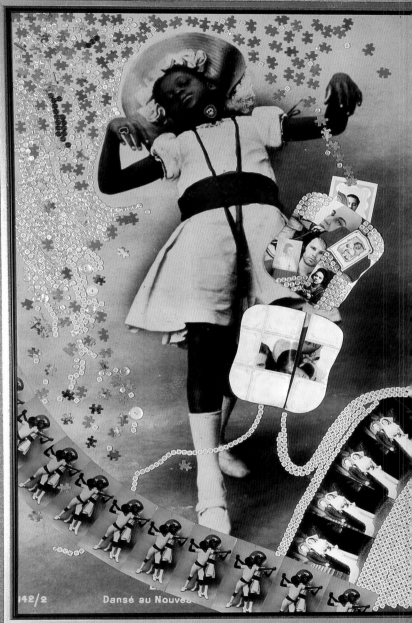

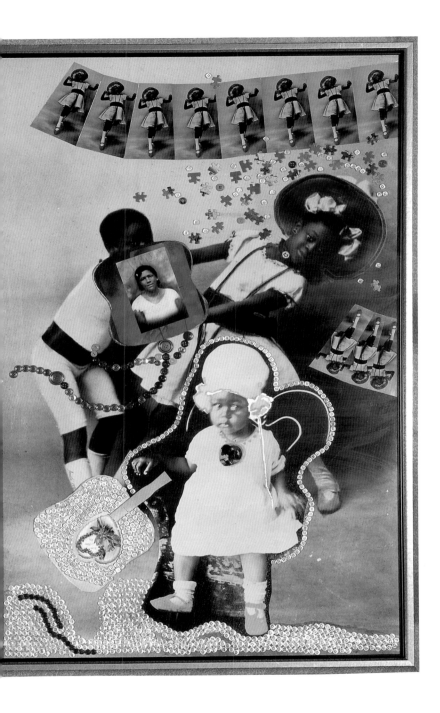

50 *I'd Rather Two-Step Than Waltz,* **2001**
51 × 102 inches

51 *Nuts and Chews,* 2001
3 × 9 × 9 inches

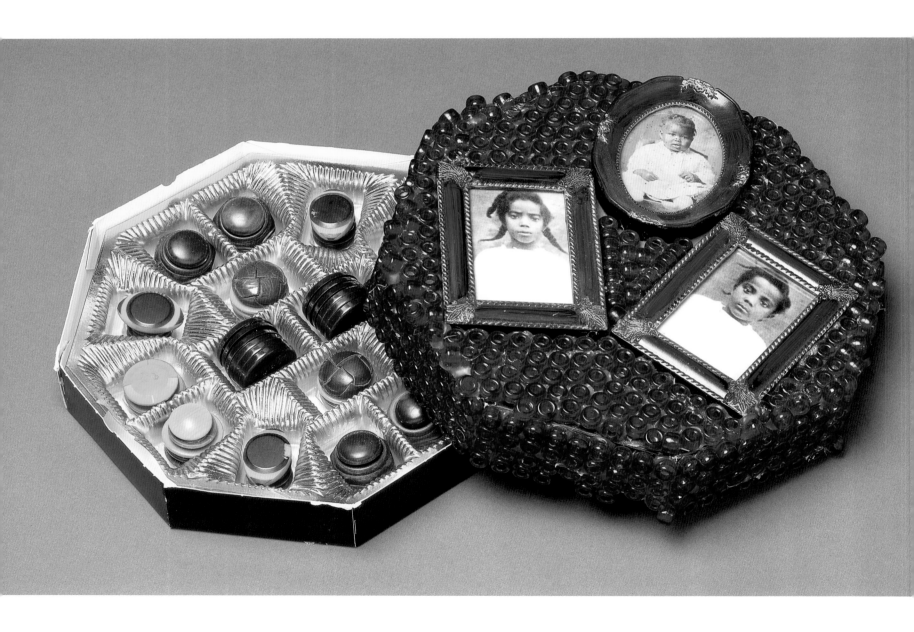

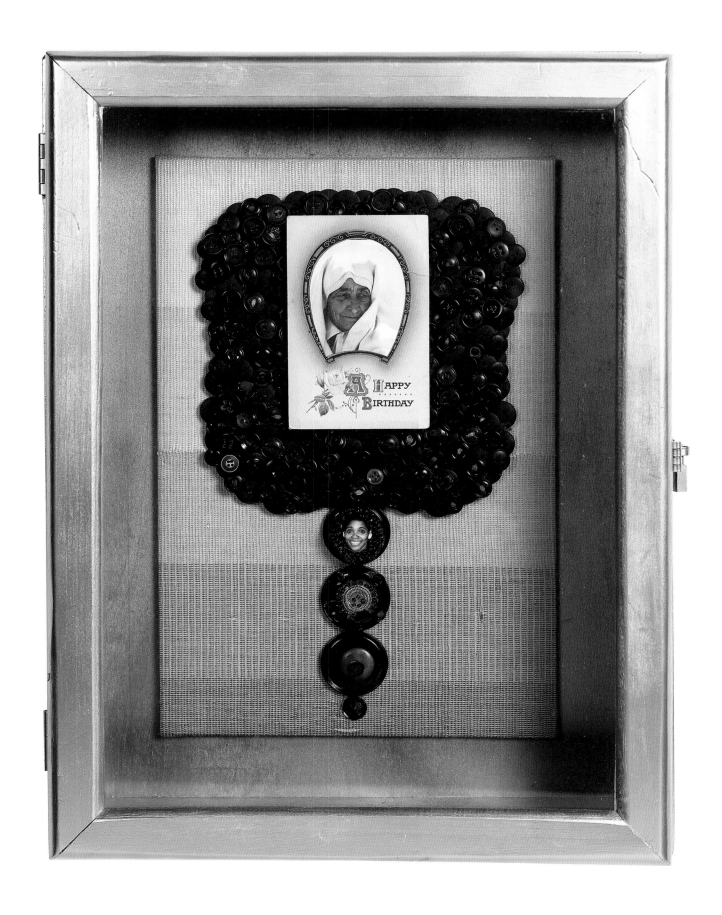

52 *OK, Georgia, 2001*
20 × 15 × 4 inches

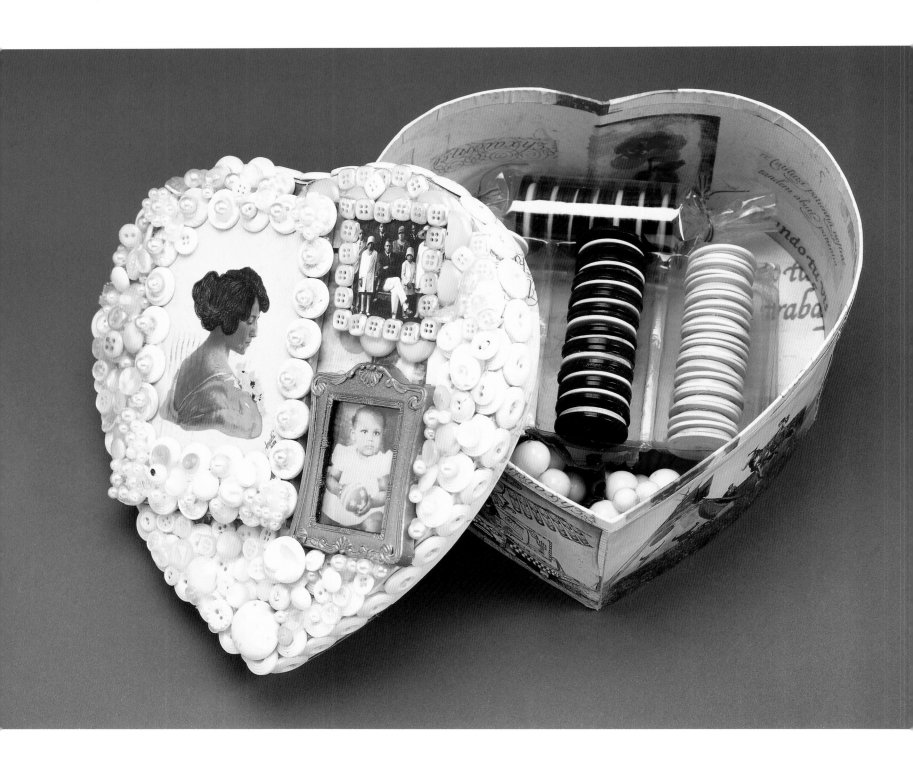

53 **Original Treats, 2001**
10 × 12 × 12 inches

54 *Special Treats, 2001*
14 × 12 × 12 inches

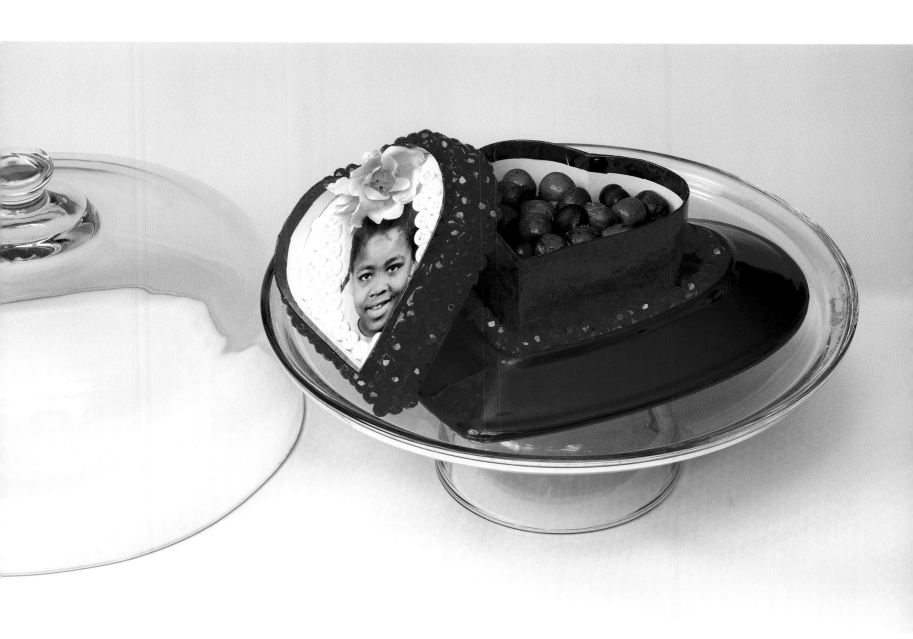

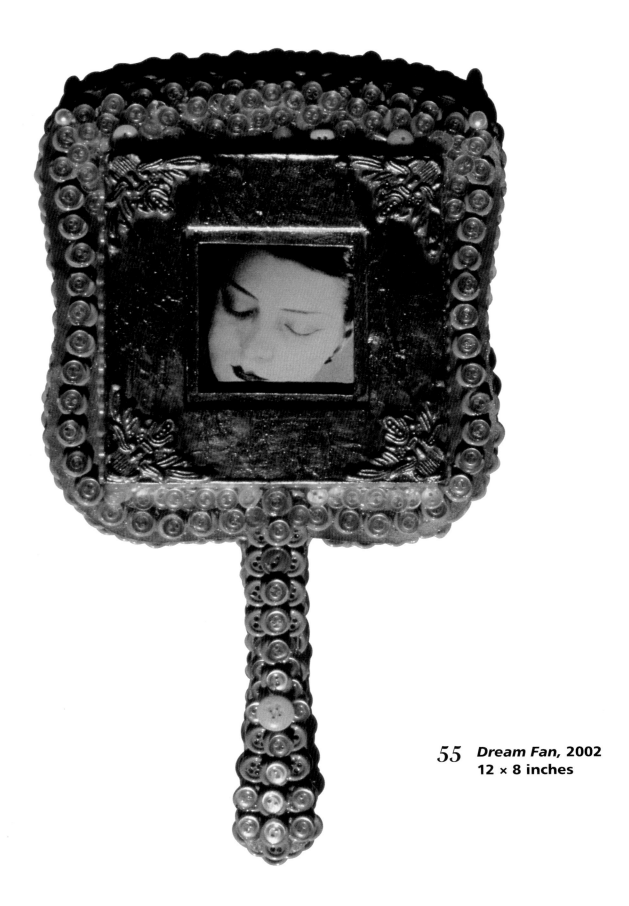

55 *Dream Fan, 2002*
12 × 8 inches

56 *Truffles (Delight)*, 2001
9 × 12 × 8 inches

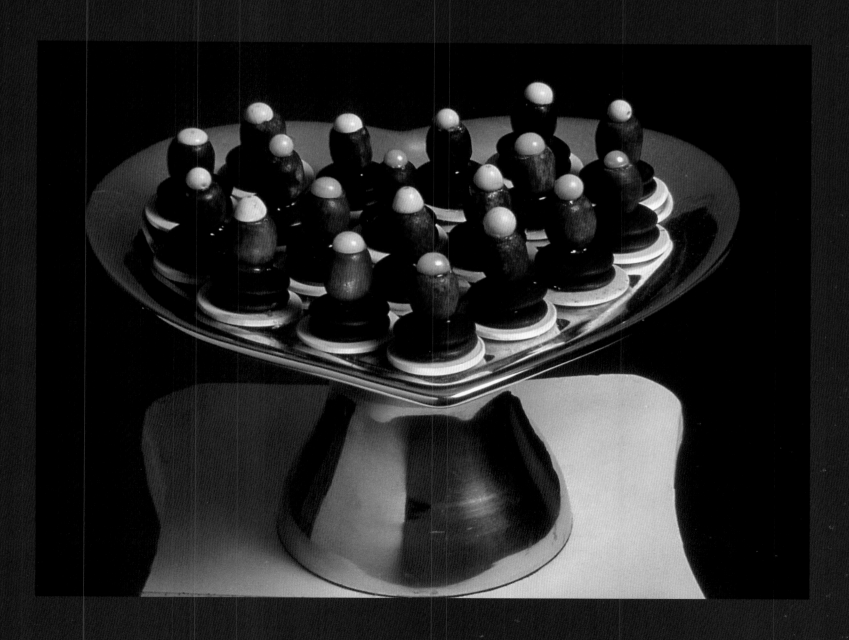

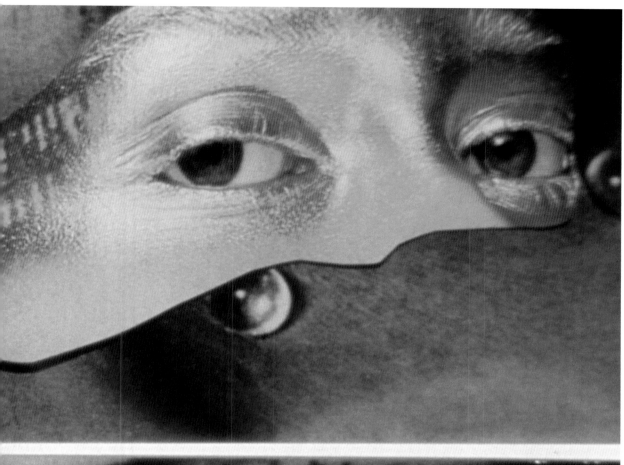

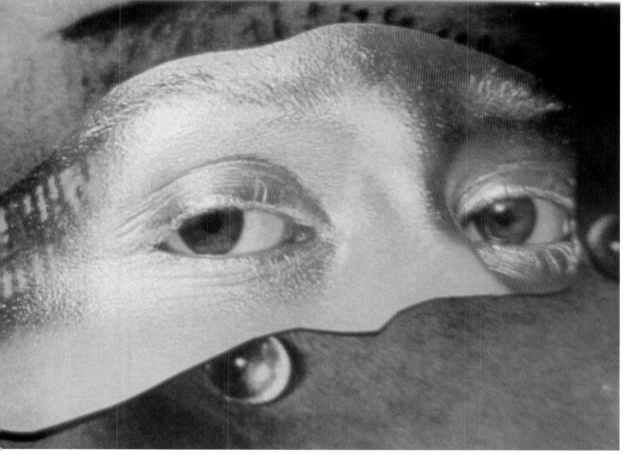

57 **Blink, 2002**
60 × 80 inches

58 *If Wearing Feathers Does Not Make You Indian, Does Drinking Coffee Make You Black?*, 2002
60 × 80 inches

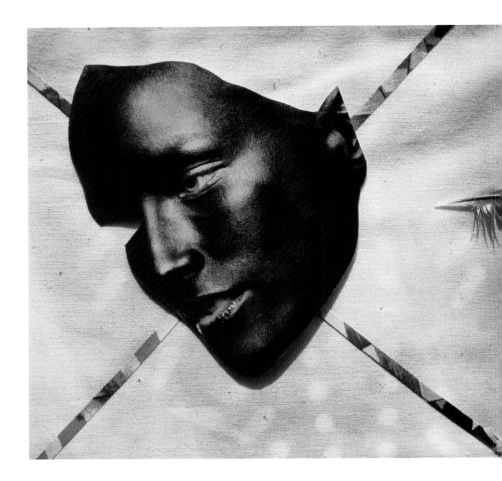

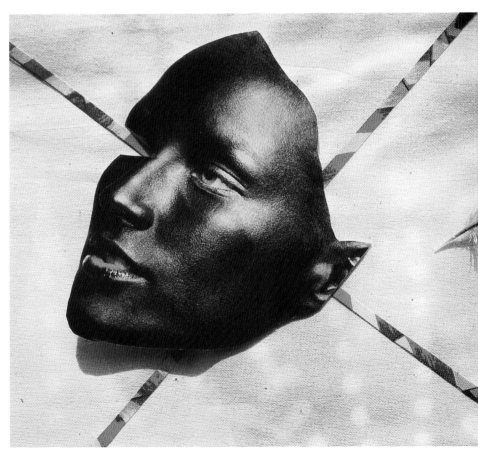

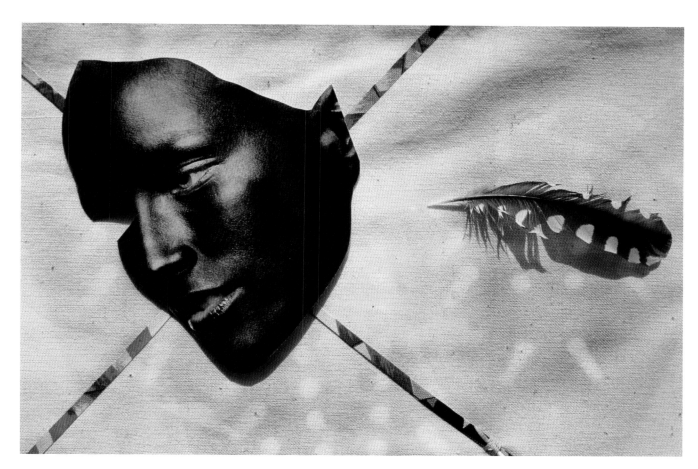

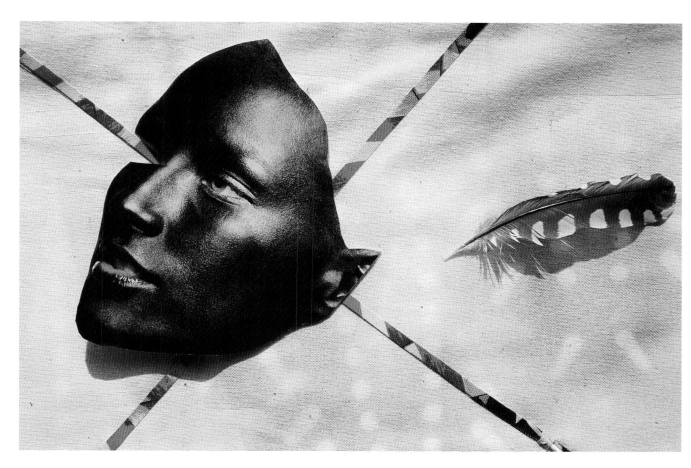

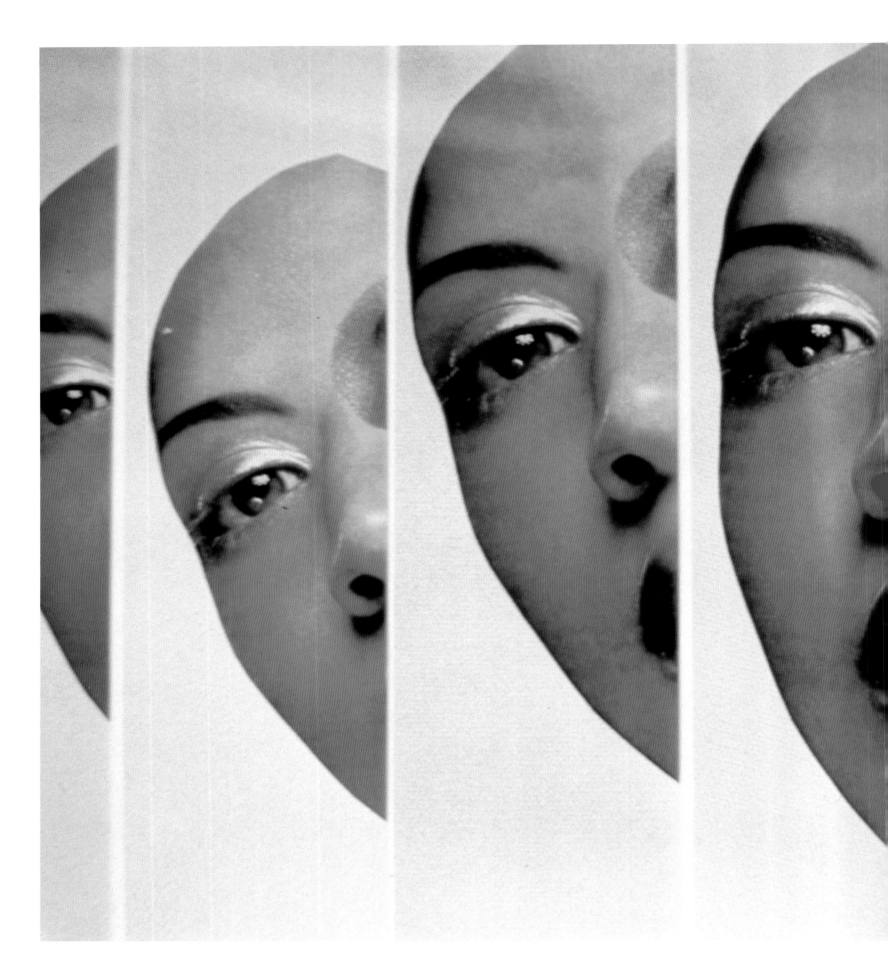

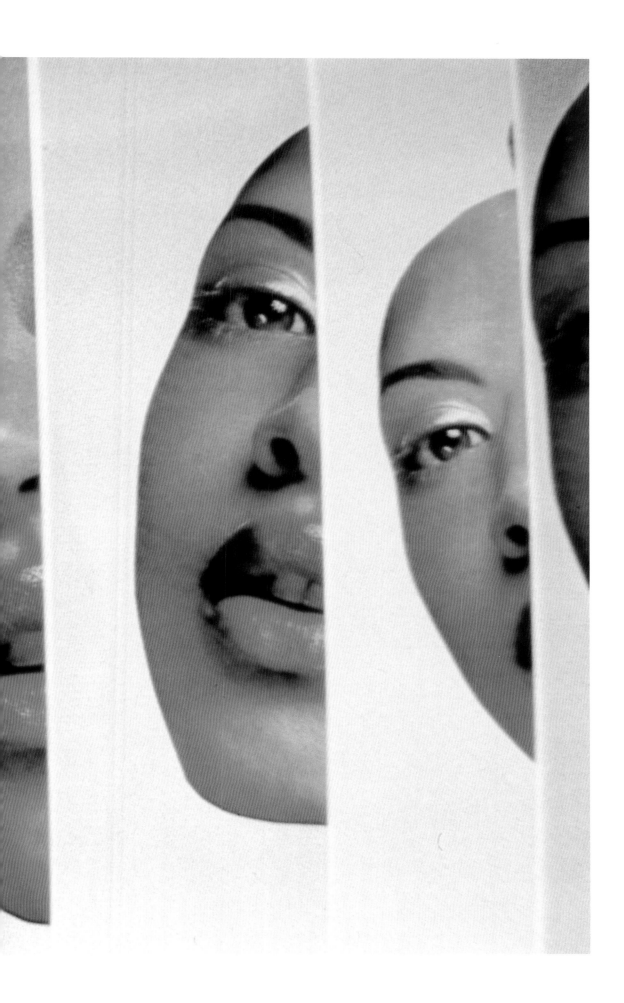

59 *Looker*, 2002
30 × 40 inches

60 *Red* (detail), 2002
36 × 198 inches

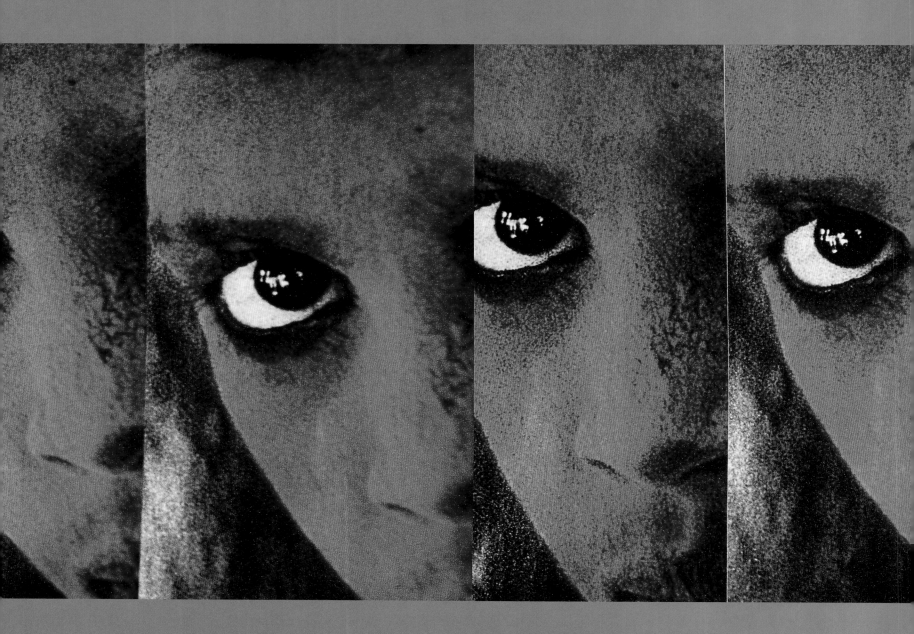

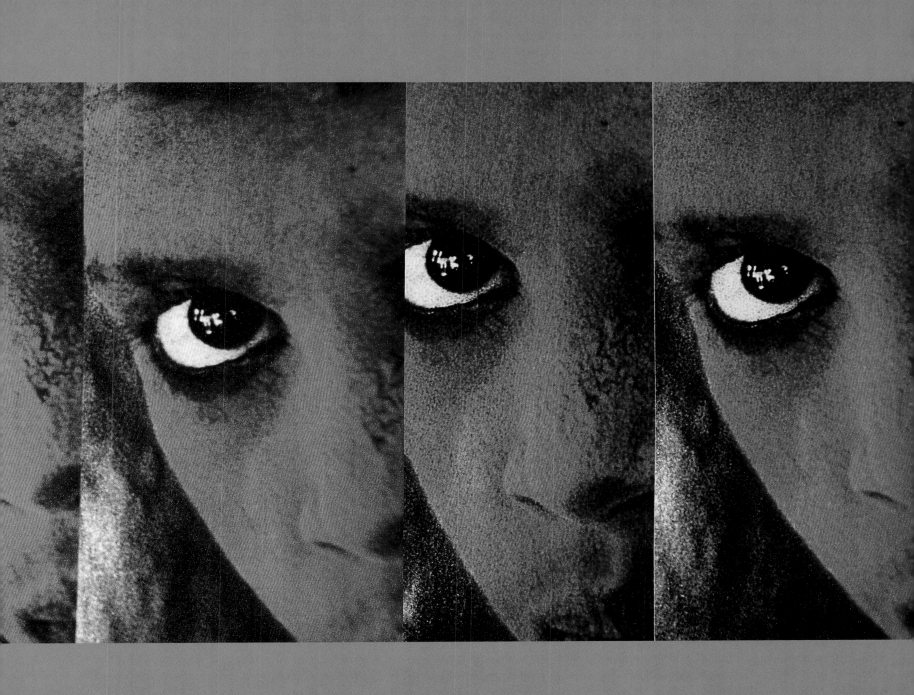

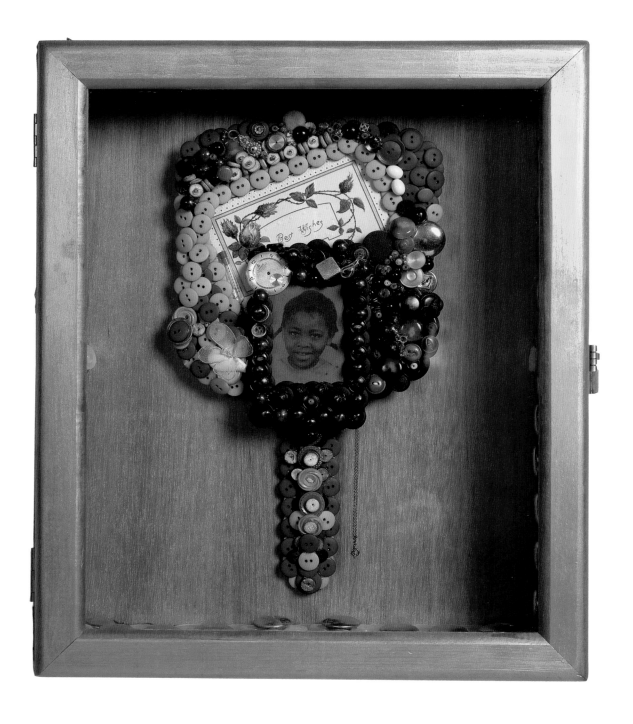

62 *Eagle*, 2003
40 × 30 inches

63 *Heart Purse,* 2003
 6 × 6 × 2½ **inches**

64 *Purse,* 2003
 6 × 6 × 6 **inches**

65 *Purse,* 2003
 6 × 6 × 2½ **inches**

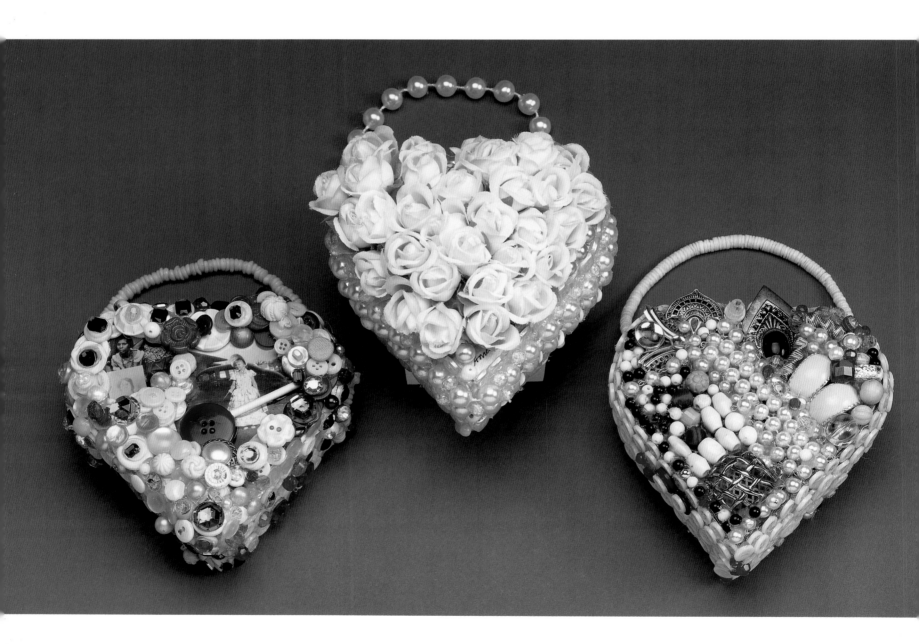

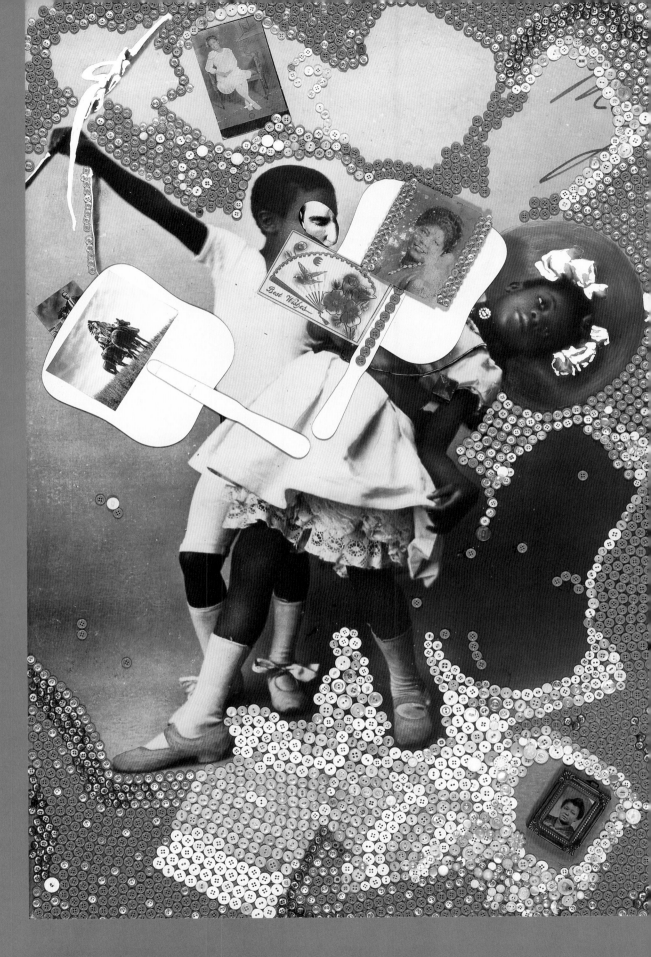

66 *Kids Dancing in a Red Knowing,* 2003
52 × 34½ inches

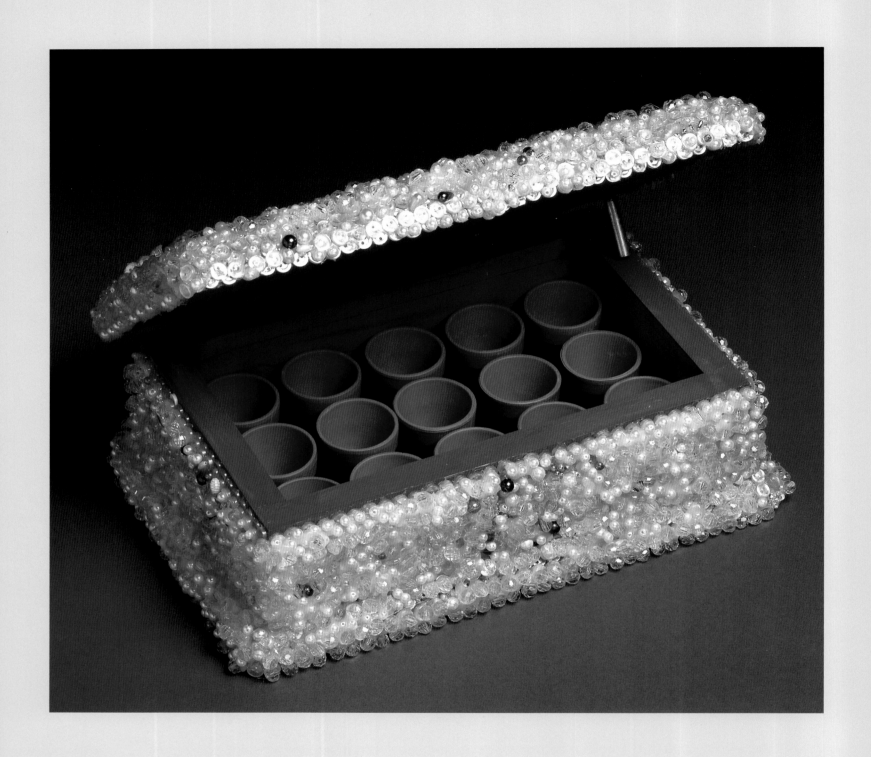

67 *Treasure Box #2, 2003*
6 × 14 × 9 inches

68 *Coconut Cake,* **2004**
13 × 14 inches

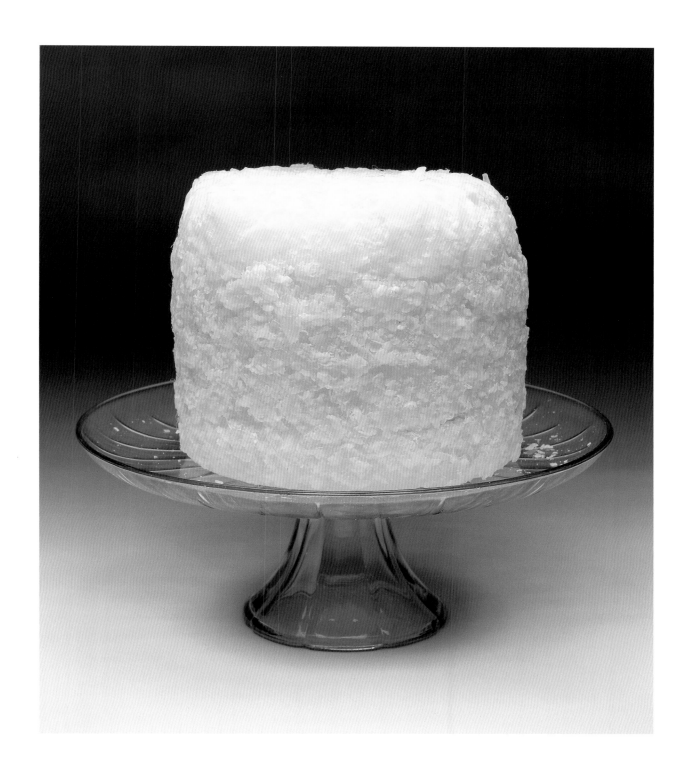

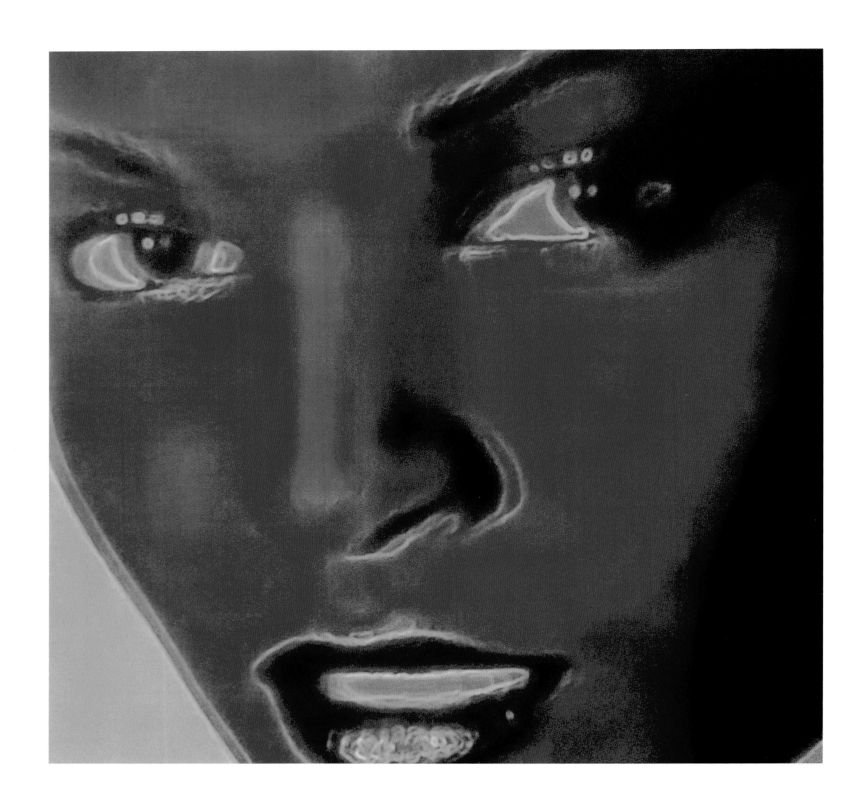

69 *Blue Lady,* 2004
28 × 30 inches

70 ***When Time Stands Still, 2004***
11½ × 12 × 3 inches

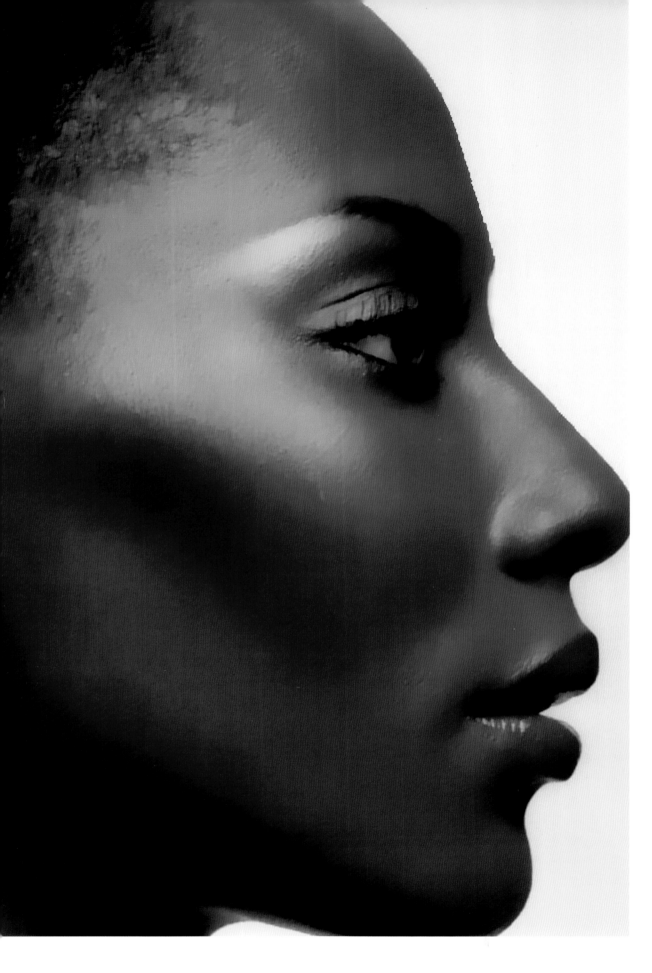

71 *Brown Lady,* 2004
29 × 19 inches

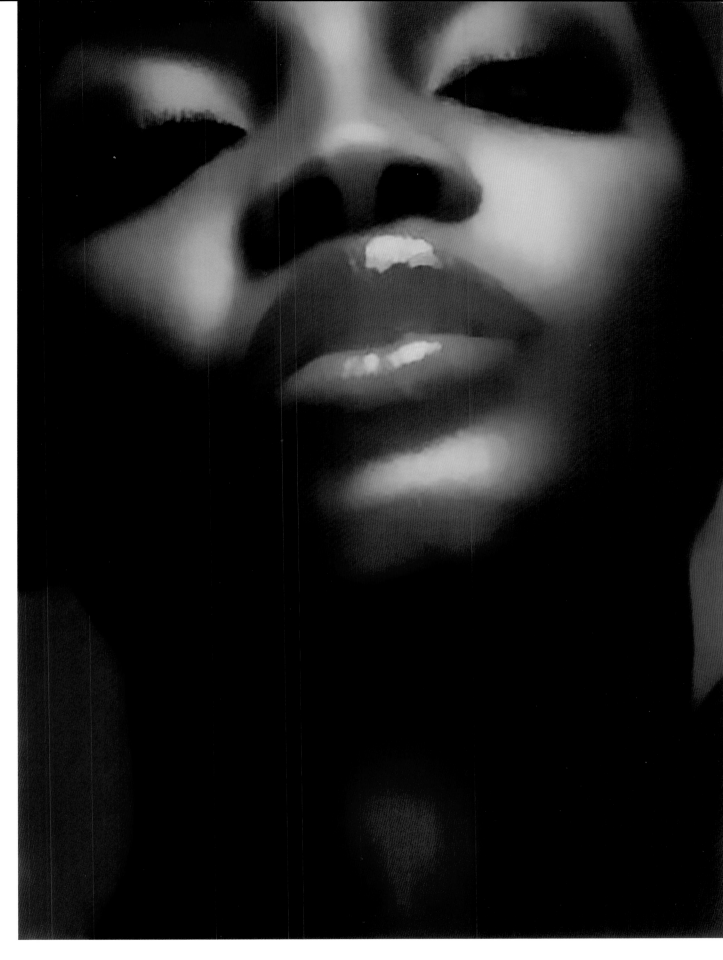

72 *Purple Lady,* 2004
29 × 21 inches

Checklist of the Exhibition

Three Cheers for the Red, White and Blue #1,
1993
Cyanotype on burned cotton, 60 × 54 inches
Museum of Fine Arts, Houston
Cat. 1, page 44

Three Cheers for the Red, White and Blue #2,
1993
Cyanotype on cotton, flag fabric, gold lamé and
buttons, 36 × 72 inches
Preston McKevers-Floyd
Cat. 2, page 45

Three Cheers for the Red, White and Blue #3,
1993
Cyanotype on cotton, 47 × 27½ inches
Mario and Susan Petrerino
Cat. 3, page 46

Three Cheers for the Red, White and Blue #15,
1993
Cyanotype on burned cotton, 43 × 37½ inches
Charlotte Allegra Clark
Cat. 4, pages 10, 47

Buffalo Soldier Fan #1, **1994**
Mixed media, 20 × 16 × 4 inches
Paul R. Jones
Cat. 5, page 48

Three Cheers for the Red, White and Blue #4,
1994
Cyanotype on cotton and paint, 58½ × 15½ inches
Courtesy the artist
Cat. 6, page 49

Buffalo Soldier Fan #2, **1995**
Mixed media, 20 × 16 × 4 inches
Paul R. Jones
Cat. 7, pages 32, 50–51

Number One Fan #2, **1995**
Mixed media, 48 × 30 inches
Minnesota Museum of American Art
Cat. 8, page 52

Overcome Evil with Good, **1995**
Mixed media, 20 × 16 × 4 inches
Benno and Babette Rothschild
Cat. 9, page 53

Three Cheers for the Red, White and Blue #7
(I Guess That's Why They Call It the Blues),
1995
Cyanotype on cotton with buttons and beads,
54 × 48½ inches
Ed and Joan Wolf
Cat. 10, pages 42, 54

Three Cheers for the Red, White and Blue #8,
1995–1996
Cyanotype on cotton, 65 × 58 inches
Courtesy the artist and Sandler Hudson Gallery
Cat. 11, page 55

Family Jewels, **1996**
Mixed media, 40 × 24 inches
Hammonds House Galleries
Cat. 12, page 56

Three Cheers for the Red, White and Blue #6, 1996
Cyanotype on cotton and fabric, 66 × 22 inches
Paul R. Jones
Cat. 13, page 57

Three Cheers for the Red, White and Blue #9 (Bessie Remembered), 1996
Cyanotype on cotton, 64 × 56 inches
Courtesy the artist
Cat. 14, pages 6, 58–59

Three Cheers for the Red, White and Blue #16, 1996
Cyanotype and iron-burned fabric, 41½ × 37 inches
Ruth West
Cat. 15, page 60

Three Cheers for the Red, White and Blue #17, 1996
Cyanotype on fabric, 43 × 37 inches
Paul R. Jones
Cat. 16, page 61

Three Cheers for the Red, White and Blue #18, 1996
Cyanotype and iron-burned fabric, 36 × 72 inches
David and Robin Jones
Cat. 17, pages 62–63

Bessie Fan, 1997
Mixed media, 20 × 16 inches
Ed and Joan Wolf
Cat. 18, pages 64–65

Buffalo Soldier Fan #6, 1997
Mixed media, 20 × 16 × 4 inches
Louis Tanner Moore
Cat. 19, page 66

Desert Babies #3: Sal and Moochie, 1997
Mixed media, 20 × 15 × 3½ inches
Paul R. Jones
Cat. 20, page 67

I'd Rather Two-Step, 1997
Mixed media, 50 × 70 inches
Ann and Ben Johnson
Cat. 21, page 68

Sisters (Duet), 1998
Mixed media, 26 × 22 × 2 inches
Michael Harris
Cat. 22, pages 9, 69

Candy Box, 1999
Button-based mixed media, 2 × 9 × 10 inches
Ben Apfelbaum
Cat. 23, page 70

Duet (Anniversary Fan), 1999
Mixed media, 26 × 22 × 4 inches
Donna Jones Northington
Cat. 24, page 71

Les Enfants, 1999
Gelatin silver print with hand coloring, applied buttons and beads, 52¼ × 105 inches
High Museum of Art, Atlanta, purchase with funds raised in recognition of the 20th anniversary of Nexus Contemporary Art Center, Atlanta, Georgia, and gifts from the H. B. and Doris Massey Charitable Trust and Lucinda W. Bunnen and Robert L. Bunnen, 2000.14.a–c
Cat. 25, pages 72–73

Mixed Media, Southwest Memory #2, 1999
Mixed media, 15 × 9 × 4 inches
Courtesy the artist and Sandler Hudson Gallery
Cat. 26, page 74

Relics, 1999
Mixed media, 8 × 8 × 2½ inches
Courtesy the artist
Cat. 27, page 75

Treasure Box #1, 1999
Mixed media, 6 × 14 × 9 inches
Courtesy the artist
Cat. 28, page 76

Treasure Box #3, 1999
Mixed media, 6 × 14 × 9 inches
Courtesy the artist and Sandler Hudson Gallery
Cat. 29, page 77

Tzedakah Box, 1999
Mixed media, 6 × 14 × 9 inches
Courtesy the artist
Cat. 30, pages 78–79

Candy Box II, 2000
Mixed media, 1½ × 10 × 11 inches
Paul R. Jones Collection, University of Delaware
Cat. 31, page 80

Dark Chocolate, ca. 2000
Mixed media, 2½ × 12 × 10 inches
Courtesy the artist and Sandler Hudson Gallery
Cat. 32, page 81

Dreamer in a Cage #1, 2000
Mixed media, 11 × 10 × 3 inches
Debbie and Paul Hudson
Cat. 33, page 82

Dreamer in a Cage #2, 2000
Mixed media, 11 × 10 × 3 inches
Courtesy the artist and Sandler Hudson Gallery
Cat. 34, page 83

Lovers, 2000
Button-based mixed media, 26 × 22 × 4 inches
Courtesy the artist and Sandler Hudson Gallery
Cat. 35, page 84

Red Cap Fan #1, 2000
Buttons, photo, frame and postcard, 14 × 8 × 1 inches
Courtesy the artist and Sandler Hudson Gallery
Cat. 36, page 85

Southwest Souvenir Gaze, 2000
Mixed media, 28 × 24 × 4 inches
Courtesy the artist
Cat. 37, page 86

Three Crosses, 2000
Mixed media, 14 × 14 × 3 inches
Jeff and Sivan Hines
Cat. 38, pages 12, 87

Too Sweet, 2000
Mixed media, 3 × 9 × 12 inches
Ann and Ben Johnson
Cat. 39, page 88

Twosome, 2000
Button-based mixed media, 26 × 22 × 4 inches
Courtesy the artist and Sandler Hudson Gallery
Cat. 40, page 89

Bon Bon, 2001
Mixed media, 2 × 3 × 3 inches
Mr. and Mrs. Curtis Crockett Jr.
Cat. 41, page 90

Caramel Apple, 2001
Mixed media, 9½ × 7 × 6 inches
Thomas DiLorenzo
Cat. 43, page 91

Chocolate Centers, 2001
Mixed media, 10 × 12 × 10 inches
Courtesy the artist and Sandler Hudson Gallery
Cat. 44, page 92

Dollhouse, 2001
Button-based mixed media, 26 × 22 × 4 inches
Courtesy the artist
Cat. 45, pages 16, 93

Face It, 2001
Iris print, 20 × 52 inches
Private collection
Cat. 46, pages 94–95

Golden Nuggets, 2001
Mixed media, 2 × 10 × 10 inches
Courtesy the artist
Cat. 47, pages 4–5, 96–97

Gold Leaf, 2001
Mixed media, 3 × 4½ × 4½ inches
Paul R. Jones
Cat. 42, page 90

Grape Lollipops, 2001
Button-based mixed media, 3 × 6½ × 9 inches
Barbara Boone
Cat. 48, page 98

Holiday Sweets, 2001
Mixed media, 3 × 10 × 13 inches
Courtesy the artist
Cat. 49, pages 43, 99

I'd Rather Two-Step Than Waltz, 2001
Photo-based mixed media, 51 × 102 inches
Paul R. Jones
Cat. 50, pages 100–101, 126–127

Nuts and Chews, 2001
Mixed media, 3 × 9 × 9 inches
Paul R. Jones
Cat. 51, page 102

OK, Georgia, 2001
Mixed media, 20 × 15 × 4 inches
Courtesy the artist
Cat. 52, page 103

Original Treats, **2001**
Mixed media, 10 × 12 × 12 inches
Karol Mason
Cat. 53, page 104

Special Treats, **2001**
Mixed media, 14 × 12 × 12 inches
Louise Davis Stone
Cat. 54, page 105

Truffles (Delight), **2001**
Mixed media, 9 × 12 × 8 inches
State University of West Georgia
Cat. 56, page 107

Blink, **2002**
Iris print, 60 × 80 inches
Courtesy the artist
Cat. 57, pages 108–109

Dream Fan, **2002**
Mixed media, 12 × 8 inches
Ann and Ben Johnson
Cat. 55, page 106

If Wearing Feathers Does Not Make You Indian, Does Drinking Coffee Make You Black?, **2002**
Digital photograph, 60 × 80 inches
Courtesy the artist and Sandler Hudson Gallery
Cat. 58, pages 24, 110–111

Looker, **2002**
Iris print, 30 × 40 inches
Courtesy the artist
Cat. 59, pages 1–3, 112–113

Red, **2002**
Digitized photo on canvas, 36 × 198 inches
Courtesy the artist
Cat. 60, pages 114–115

Best Wishes, **2003**
Mixed media, 20 × 15 × 4 inches
Mr. and Mrs. Curtis Crockett Jr.
Cat. 61, page 116

Eagle, **2003**
Digitally manipulated photograph, 40 × 30 inches
Courtesy the artist and Sandler Hudson Gallery
Cat. 62, page 117

Heart Purse, **2003**
Mixed media, 6 × 6 × 2½ inches
Courtesy the artist and Sandler Hudson Gallery
Cat. 63, page 118

Kids Dancing in a Red Knowing, **2003**
Mixed media, 52 × 34½ inches
Florence B. Bonner
Cat. 66, pages 41, 119

Purse, **2003**
Mixed media, 6 × 6 × 6 inches
Courtesy the artist and Sandler Hudson Gallery
Cat. 64, page 118

Purse, **2003**
Mixed media, 6 × 6 × 2½ inches
Courtesy the artist and Sandler Hudson Gallery
Cat. 65, page 118

Treasure Box #2, **2003**
Mixed media, 6 × 14 × 9 inches
Mr. and Mrs. Curtis Crockett Jr.
Cat. 67, page 120

Blue Lady, **2004**
Color photograph, 28 × 30 inches
Courtesy the artist and Sandler Hudson Gallery
Cat. 69, cover and page 122

Brown Lady, **2004**
Color photograph, 29 × 19 inches
Courtesy the artist and Sandler Hudson Gallery
Cat. 71, page 124

Coconut Cake, **2004**
Mixed media, 13 × 14 inches
Courtesy the artist
Cat. 68, page 121

Purple Lady, **2004**
Color photograph, 29 × 21 inches
Courtesy the artist and Sandler Hudson Gallery
Cat. 72, page 125

When Time Stands Still, **2004**
Mixed media, 11½ × 12 × 3 inches
Raquel Gayle
Cat. 70, page 123

BLUE Gold Lady, **2005**
Color photograph, 29 × 50 inches
Courtesy the artist
Not pictured

Biography of the Artist

Amalia Amaki is Curator of the Paul R. Jones Collection and Assistant Professor in Art, Art History and Black American Studies at the University of Delaware, a position she has held since 2000. Over the last ten years, she has taught African American art, issues in women's art, American film history and art criticism at Spelman College, North Georgia College and State University, Kennesaw State University and the Atlanta College of Art. An artist and art historian, she has curated more than twenty exhibitions and is well-known for her essays, reviews and lectures on African American art, art by women, American film history and art theory and criticism. A Georgia native, Amaki currently divides her time between Newark, Delaware, and Atlanta, Georgia.

Education

1994 Ph.D., twentieth-century American art and culture, Emory University, Institute of the Liberal Arts, Atlanta, GA

1992 M.A., modern European and American art, Emory University, Institute of the Liberal Arts, Atlanta, GA

1980 B.A., photography and art history, University of New Mexico, Albuquerque, NM

1971 B.A., journalism and psychology, Georgia State University, Atlanta, GA

Recent Professional Honors

2002 Distinguished Alumni Award, Emory University, College of Arts and Sciences

1997 Georgia Women in the Visual Arts Award, State of Georgia

Award in Art, Delta Sigma Theta Sorority

Commissions and Grants

2001 Absolut Vodka, New York, NY

2000 Hartsfield-Jackson International Airport, Atlanta, GA

General Services Administration/Sam Nunn Federal Center, Atlanta, GA

1998 High Museum of Art and Creative Hearts Youth Art Community Quilt Project, Atlanta, GA

1997 Southern Christian Leadership Council/ Women, Atlanta, GA

1996 Hartsfield-Jackson International Airport, Atlanta, GA

Seagram's Gin, Inc., New York, NY

1995 National Endowment for the Arts, Regional Fellowship in Photography

Coca-Cola Enterprises, Atlanta, GA

1994 Roy Communications, Inc., Atlanta, GA

1993 Georgia Council for the Arts, Atlanta, GA

1991 Fulton County Arts Council, Atlanta, GA

Solo Exhibitions

2004 *Amalia Amaki: Family Jewels,* East
 Carolina University, Greenville, NC

2001 *Delights,* Sandler Hudson Gallery,
 Atlanta, GA

2000 *The Flip Side of the Mirror,* Gainesville
 College, Gainesville, GA

1999 *When Duty Whispers, Part 2,* Hammonds
 House Galleries, Atlanta, GA

1998 *Treasure House: Not By Bread Alone,*
 City Gallery East, Atlanta, GA
 I'd Rather Two-Step, Swan House Gallery,
 Atlanta History Center, Atlanta, GA

1997 *Amaki: Latest Works,* McIntosh Gallery,
 Atlanta, GA

1996 *Notions and Nostalgia,* Saint Mary's
 College, Notre Dame, IN

1995 *When Duty Whispers,* Houston Center
 for Photography, Houston, TX

1994 *Buttons and Blues,* Atlanta Financial
 Center, Atlanta, GA

Group Exhibitions

2004 *Telling Tales: Narratives Threads in
 Contemporary African American Art,*
 Delaware Center for Contemporary
 Art, Wilmington, DE (catalogue)

2003 *Color, Culture, Complexity,* Museum of
 Contemporary Art of Georgia, Atlanta,
 GA (catalogue)

2002 *Transitions,* Museum of Contemporary
 Art of Georgia, Atlanta, GA (catalogue)
 Anniversary Show, Houston Center for
 Photography, Houston, TX
 Four Score and Five, University Gallery,
 University of Delaware, Newark, DE
 New Harlem Renaissance, Indianapolis
 Art Center, Indianapolis, IN

Georgia Triennial, City Gallery East,
Atlanta, GA (catalogue)

2001 *Go Figure,* LewAllen Contemporary,
 Santa Fe, NM
 Repeated Images, Sandler Hudson Gallery,
 Atlanta, GA

2000 *Reflections in Black,* Anacostia Museum
 and Center for African American History
 and Culture, Smithsonian Institution,
 Washington, DC
 Can You Hear Me Shout, Museum of
 Arts and Sciences, Macon, GA

1998 *Stop Asking, We Exist,* Society for
 Contemporary Craft, Pittsburgh, PA
 (catalogue)
 Cross Cultures, LewAllen Contemporary,
 Santa Fe, NM

1996 *Self-Evident,* Nathan Cummings
 Foundation, New York, NY
 Bearing Witness, Spelman College Museum
 of Art, Atlanta, GA
 (catalogue)
 Tragic Wake, Spirit Square, Charlotte, NC
 (catalogue)
 SAF/NEA Fellows, Mississippi Museum of
 Art, Jackson, MS
 Georgia Sampler, Georgia Museum of
 Art, University of Georgia, Athens, GA
 (catalogue)
 *Hand Me Down: Innovation Within a
 Tradition,* African American Cultural
 Center, Charlotte, NC (catalogue)

1994 *National Black Arts Festival,* Atlanta, GA
 Points of Observation: Six Artists, Univer-
 sity of West Florida, Pensacola, FL
 (catalogue)

Selected Bibliography

2002 Feaster, Felicia. "Museum of Contemporary Art of Georgia ends year on a high note." *Creative Loafing,* December 18.
 Fox, Catherine. "Shades of racism." *The Atlanta Journal-Constitution,* December 6.
 ———. "Visual arts: From paintings to new media, The Georgia Triennial." *The Atlanta Journal-Constitution,* April 12.

2000 Willis-Kennedy, Deborah. *Reflections in Black: A History of Black Photography, 1840–Present.* New York: Norton.

1998 MacNeil, William. "Crossing cultures provides impetus for art show." *The Santa Fe New Mexican,* May 1.

1997 Leonard, Pamela Blume. "Shining shrines put women in center." *The Atlanta Journal-Constitution,* March 21.
 Roland, Marya. "Tragic Wake." *Art Papers* (March–April).

1996 Britton, Crystal. *African American Art: The Long Struggle.* New York: Smithmark Publishers.
 Cultural Affairs Bureau. "Gateway to the World: Art & Architecture of Concourse E." Atlanta: Hartsfield-Jackson International Airport, City of Atlanta.
 Houghton, Jim. "Two exhibits at colleges offer nostalgia, New Age." *The South Bend Tribune,* January 28.
 Patterson, Tom. "Wake: A potent look at slavery's legacy." *The Charlotte Observer,* December 29.
 Williams, Mara Rose. "Buttonholing the public." *The Atlanta Journal-Constitution,* February 8.

1994 Fox, Catherine. "Collages are not button-down art: Amalia Amaki savors the familial intimacy of common treasures." *The Atlanta Journal-Constitution,* March 20, N2.
 ———. "Georgia sampler." *The Atlanta Journal-Constitution,* February 19.
 Jinkner-Lloyd, Amy. "Strange fruit." *Creative Loafing,* March 12.
 Thompson, Mildred. "Amalia Amaki/ Liz Hampton." *Art Papers* (November–December).
 White, Clarence. "Amalia Amaki: American reminiscences, buttons and blues." *Art Papers* (May–June).

Public Collections

Albany Museum of Art, Albany, GA
Hartsfield-Jackson International Airport, Atlanta, GA
High Museum of Art, Atlanta, GA
Minnesota Museum of American Art, Saint Paul, MN
Museum of Fine Arts, Houston, TX
The Tubman Museum, Macon, GA
University of Delaware, Newark, DE

Contributors

Andrea D. Barnwell is an art historian, curator, writer and the Director of the Spelman College Museum of Fine Art. She has curated several exhibitions including *iona rozeal brown: a³ . . . black on both sides* (2004) and *Engaging the Camera: African Women, Portraits and the Photographs of Hector Acebes* (2004, co-curated with Isolde Brielmaier). *Charles White,* The David C. Driskell Series of African American Art, volume I (2001) is among her recent publications. She has received numerous professional awards including a Future Women Leadership Award from ArtTable (2005), the President's Award from Women's Caucus for Art (2005) and a MacArthur Curatorial Fellowship at The Art Institute of Chicago (1998–2000). Barnwell, an alumna of Spelman College, completed her masters and doctoral degrees in art history from Duke University. She currently serves on the boards of the Metropolitan Atlanta Art Fund and the Hambidge Center for the Creative Arts and Sciences.

Gloria Wade Gayles is the author of *No Crystal Stair: Visions of Race and Sex in Black Women's Fiction* (1984), *Pushed Back to Strength: A Black Woman's Journey Home* (1992), *Anointed to Fly* (1992) and *Rooted Against the Wind* (1996). She has edited four major anthologies including *Conversations with Gwendolyn Brooks* (2004), *My Soul Is a Witness: African American Women's Spirituality* (1995) and *Father Songs: Testimonials by African American Sons and Daughters* (1997).

A former DuBois Scholar at Harvard University, Gayles was named CASE Professor of Teaching Excellence for the State of Georgia in 1981. Currently, she is Eminent Scholar's Chair in Independent Study at Spelman College and founding director of The SIS Oral History Project, which produced *Their Memories, Our Treasure.*

Leslie King-Hammond completed her doctoral degree in art history at The Johns Hopkins University and was appointed Dean of Graduate Studies at The Maryland Institute College of Art in 1976. In addition to being a member of the art history faculty, she has served on several juries, boards, organizations and art commissions including Executive Board, International Association of Art Critics (2000–2003); President, College Art Association (1996–1998); Board of Overseers, Baltimore School for the Arts (1996–1999); Vice-President, Jacob Lawrence Catalogue Raisonne Project; Trustee, Baltimore Museum of Art (1981–1987); Alvin Ailey Dance Theatre Foundation of Maryland (1991–1994); and Advisory Board, Edna Manley School for the Visual Arts, Kingston, Jamaica (1988–present). *Three Generations of African American Women Artists: A Study in Paradox* (1996), *Sugar and Spice: The Art of Betye Saar* (2003), *The Art of Aminah Robinson* (2003) and *The Many Faces of Beverly McIver* (2004) are among the exhibition projects with which she has been involved.